"H. H. Bennett's photographs of Ho-Chunk people and landscapes enjoyed commercial success when he first began marketing them in the 1880s, shaping the way that tourists viewed and remembered the Wisconsin Dells. In *Picturing Indians*, Steven Hoelscher examines the rise and decline of Bennett's Indian photographic business against the larger backdrop of tourism and mass marketing, and in the history of the Ho-Chunk people and their efforts to remain on their lands in Wisconsin. With his commentary on contemporary Ho-Chunk photographer Tom Jones, Hoelscher deftly links Bennett's historic images to the present, celebrating the survivance of the Ho-Chunk people."

—SUSAN APPLEGATE KROUSE, Michigan State University,
author of *North American Indians in the Great War*

"Henry Hamilton Bennett discerned the potential profitability of making a link—through photography—between the burgeoning tourist industry of the Wisconsin Dells and native Ho-Chunk people. Steven Hoelscher, in turn, thoroughly examines the components of the conjunction to produce a rich history of a photographic endeavor, a fascinating locale, and the interaction between an important indigenous community and their settler neighbors. In a fully illustrated, well structured and nicely written account, he probes the ways in which Ho-Chunk individuals, while almost always the weaker party in these photographic transcultural encounters, used them to project their own identities."

—MICK GIDLEY, University of Leeds, author of *Edward S. Curtis and the
North American Indian, Incorporated*

"In this beautifully written book, Hoelscher considers H. H. Bennett's photographs of his Ho-Chunk neighbors as complex records of the past that illuminate the subjects' needs as well as the ambitions of the photographer. This deft analysis of Bennett's commercial pictures set within the context of tribal history as well as the nascent tourist industry of the Wisconsin Dells serves as a model for photographic research. The pictures here don't just document particular moments of the past, they serve as rich primary sources that illuminate a complicated moment in Indian-White relations in the late nineteenth century."

—MARTHA A. SANDWEISS, Amherst College, author of *Print the Legend:
Photography and the American West*

"*Picturing Indians* triangulates in brilliant fashion the cultural politics of Ho-Chunk life and labor, the imaginative and material shaping of the Wisconsin landscape, and the changing tourist landscape of photographs and curios at the turn of the twentieth century. Even as he centers Indian dispossession and resistance, Steven Hoelscher also captures the important moment when ordinary individuals like H. H. Bennett imbued the Midwest landscape with mystery and romance, creating one of America's first mass tourist enterprises. A fascinating and compelling book!"

—PHILIP DELORIA, University of Michigan, author of *Indians in Unexpected Places*

Picturing Indians

Picturing Indians

Photographic Encounters and Tourist Fantasies in
H. H. Bennett's Wisconsin Dells

Steven D. Hoelscher

THE UNIVERSITY OF WISCONSIN PRESS

This book was published with the support of the Anonymous Fund of the College of Letters and Science at the University of Wisconsin–Madison and a University Co-operative Society Subvention Grant awarded by the University of Texas at Austin.

The University of Wisconsin Press
1930 Monroe Street, 3rd Floor
Madison, Wisconsin 53711–2059

www.wisc.edu/wisconsinpress/

3 Henrietta Street
London WC2E 8LU, England

Hoelscher, Steven D.
 Picturing Indians : photographic encounters and tourist fantasies in H. H. Bennett's Wisconsin Dells / Steven D. Hoelscher.
 p. cm.—(Studies in American thought and culture)
 Includes bibliographical references and index.
 ISBN 978-0-299-22600-8 (cloth : alk. paper)—ISBN 978-0-299-22604-6 (pbk. : alk. paper)
 1. Ho Chunk Indians—Portraits. 2. Portrait photography—Wisconsin—Wisconsin Dells—History—19th century. 3. Bennett, H. H. (Henry Hamilton), 1843–1908—Criticism and interpretation. I. Title. II. Series.
 TR681.I58H64 2008
 770.89´975260775—dc22
 2008010919

to
Emma and Erika

When we are afraid, we shoot. But when we are nostalgic, we take pictures.

—SUSAN SONTAG, *On Photography*

∽⌒∽

It should hardly be a surprise that everything about being Indian has been shaped by the camera.

—PAUL CHAAT SMITH (Comanche), "Every Picture Tells a Story"

Contents

Illustrations

Attentive readers will detect the anachronistic nature of the titles of many of this book's illustrations. H. H. Bennett, for his part, bestowed titles to most of his photographs and, as a matter of the historic record, I have let these stand, even in those instances that might be offensive to contemporary sensibilities. For other photographers who themselves did not add titles to their photographs, I have added descriptive captions, often relying on the knowledge of previous archivists. In every case, I have tried to title or caption each illustration with fidelity to the photographer's original intention.

FIGURES

Maps

Chart

Foreword

PAUL S. BOYER

Steven Hoelscher's *Picturing Indians: Photographic Encounters and Tourist Fantasies in H. H. Bennett's Wisconsin Dells,* a noteworthy addition to the University of Wisconsin Press's Studies in American Thought and Culture Series, deepens our understanding of the fateful, centuries-long interaction of Native peoples and newcomers on the North American continent. From the earliest European settlements, visual representations played a role in shaping perceptions of the indigenous peoples the newcomers encountered. The watercolors painted by John White, a member of the 1585 English expedition to Roanoke Island in present-day North Carolina, published in Frankfurt in 1590 by the Flemish-born engraver and bookseller Theodor de Bry (after substantial alterations reflecting contemporary aesthetic conventions), offered Europeans their first visual images of the people Columbus had misnamed "Indians."

Throughout the colonial, revolutionary, and early national eras, many artists painted portraits of Indians and scenes of Indian life. These images often served propagandistic purposes. For example, Mason Chamberlin's 1766 portrait of Samson Occom, a Mohegan Indian who became a missionary to the Indians after his conversion to Christianity during the Great Awakening, represents him in the somber garb of a Presbyterian clergyman and pointing to an open Bible, suggesting the hope that all Indians would eventually be Christianized. By contrast, John Vanderlyn's famous and highly sexualized 1804 painting *The Death of Jane McCrea,* representing the 1777 killing near Saratoga, New York, of a beautiful young female captive by Huron Indians allied with the British forces commanded by General John Burgoyne during the American Revolution, reinforced the image of Indians as brutal and heartless savages—an image that would help justify their expulsion and extermination.

As the nineteenth century wore on, the museum-going public could view scenes of Indian life on the western plains and portraits of chiefs and warriors in full regalia painted by George Catlin, Karl Bodmer, Alfred Jacob Miller, George Caleb Bingham, Albert Bierstadt, and many others. Lithographic reproductions of their canvases in books and magazines spread these images still more widely. With the advent of photography, this new medium became yet another

means of conveying often-idealized representations of Native Americans to the larger public. Edward Curtis, William Henry Jackson, and others, visiting reservations and other sites of Native American settlement, compiled a vast photographic record of Indian life and individual portraits.

The career of H. H. Bennett, the subject of Steven Hoelscher's illuminating study, adds a significant new dimension to our understanding of the role of visual representation in the history of Indian-white cultural encounters in North America. Arriving in Kilbourn City, Wisconsin (known today as the Wisconsin Dells), in 1857, only nine years after Wisconsin had gained statehood, Bennett took up photography in 1865 following his Civil War service in the Union Army. While he made and marketed many now-iconic photographs of the Dells' steep gorges and fantastic rock formations, helping transform this scenic stretch of the Wisconsin River into a popular tourist destination, he also recorded images of the local Indian people, the Ho-Chunk.

Bennett's Indian photographs, although comparatively few in number, are of great interest, particularly when subjected to the analysis of a sensitive cultural interpreter. In *Picturing Indians,* Steven Hoelscher, the author of, among other works, a highly regarded study of how New Glarus, Wisconsin, transformed itself into the tourist-friendly "Little Switzerland," makes another impressive contribution to American cultural history. While closely analyzing what Bennett's Ho-Chunk photographs tell us about both him and his subjects, Hoelscher takes care to place these photographs in their broader historical context. Drawing upon letters, diaries, financial records, and contemporary periodicals, he views these images as products of a period of turbulent social change, as the Ho-Chunk warily confronted not only the white settlers pouring into Wisconsin but also local boosters eager to exploit the commercial potential of the Dells. For the Dells promoters—a group that intermittently included Bennett himself—the Ho-Chunk represented both a potential tourist attraction and vestiges of a civilization soon to be pushed aside. As Hoelscher makes clear, Bennett's photographs, and the uses he made of them, reflect this ambivalence.

Unlike more peripatetic Indian photographers such as Jackson and Curtis, who snapped their pictures and then moved on, Bennett lived for decades near the Ho-Chunk and came to know and interact with them as individuals. This rootedness adds another level of interest to *Picturing Indians,* as Hoelscher traces subtle changes in Bennett's circumstances, his view of the Ho-Chunk, and his relationship with them.

While centered on one individual in one specific site of Indian/non-Indian interaction, *Picturing Indians* illuminates key aspects of the larger cultural encounter between the continent's Native peoples and the tide of settlers spreading inexorably westward. Further, addressing a theme of current interest in the interdisciplinary fields of post-colonial, cross-cultural, and border studies, Hoelscher does not treat the Ho-Chunk as mere passive subjects of the camera's gaze but underscores the agency they exercised as they rebuffed, subverted, or, for reasons of their own and on their own terms, collaborated in his project. The interactions that Hoelscher documents between Bennett and the Ho-Chunk, and the photographs that resulted, suggest a relationship in which economic motives, promotional considerations, cautious friendship, a pandering to cultural stereotypes, and an impulse to preserve for posterity images of a vanishing way of life intermingled in complex ways that the participants perhaps only partially understood. In a particularly perceptive section, Hoelscher makes clear that Bennett, a small-town entrepreneur plagued

by cash-flow problems and outside competition, was, like his Ho-Chunk subjects, buffeted by the social and economic changes that were transforming late nineteenth- and early twentieth-century America—changes that would affect all of them profoundly, unsettling and ultimately sweeping away the world they knew.

Steven Hoelscher ends the book with a consideration of the work of a gifted contemporary Ho-Chunk photographer, Tom Jones. As we see how Jones records the lives of his own people today with irony, humor, and affection, we realize that his insider's perspective offers yet another interpretive vantage point from which we can reflect on H. H. Bennett's career and the images he created more than a century ago.

While this book will be of keen interest to Wisconsin readers, it casts a far wider net. Students of American culture, Indian history, and the history of tourism, and indeed anyone seeking a deeper understanding of the complex and fraught cross-cultural encounters that have so profoundly shaped American history, will find this insightful (and beautifully written) work full of arresting insights. I am delighted to welcome *Picturing Indians* to the growing list of outstanding titles in the American Thought and Culture Series.

MADISON, WISCONSIN
JUNE 2007

Acknowledgments

During the long process of writing this book, I have relied on the kindness and assistance of many people who have supported me in countless ways. It is a great pleasure to acknowledge my considerable intellectual debts here.

My deepest gratitude goes to the elders and members of the Ho-Chunk Nation who supported this project and who reflected on the complex relationship between H. H. Bennett's photographs and their ancestors. For asking the tough questions and demanding honest answers, I thank Rainbow Big Blackhawk (Donald Blackhawk), Montgomery Green Sr., Tom Hopinkah, Tom Jones, Susette LaMere, Amy Lonetree, Corina Lonetree, Willard Lonetree, Chloris Lowe Jr., Douglas Red Eagle Sr., Janice Rice, Preston Thompson, and Clayton Winneshiek. Paul Arentz (Navajo), editor of the *Hocak Worak* newspaper, and Jay Toth (Mohawk), tribal archaeologist of the Ho-Chunk Nation, helped at key moments of my research as did Patty Loew (Ojibwe), who first insisted on a collaborative research methodology that eventually became the foundation of this book. I am especially grateful to Janice Rice, Susette LaMere, and Chloris Lowe Jr. for their active encouragement and extensive assistance, and to Tom Jones, whose brilliant photographic art concludes this book; Tom taught me a great deal about both Ho-Chunk history and art photography during our long conversations.

From the very beginning, two Wisconsin-based institutions made this book possible. My first visit to the H. H. Bennett Studio in the Wisconsin Dells, in the winter of 1993, was marked by the unforgettable experience of viewing the glass-plate negatives and reading some of the remarkable correspondence between the photographer and his portrait subjects. Jean Reese, H. H. Bennett's granddaughter, and her late husband, Oliver Reese, opened the world of nineteenth-century photography to me when they opened their studio's doors during those cold winter days and for several years afterward; I greatly appreciate their generosity with time and stories about "the man with the camera." The Wisconsin Historical Society, now the custodian of the Bennett materials and the recently opened H. H. Bennett Studio Historic Site, equally supported my work. I am extremely grateful for the superb photographic prints made from Bennett's

original glass negatives that grace this book as well as for permission to reproduce them here. The Historical Society's extraordinary archivists and directors—especially Peter Gottlieb, Andy Kraushaar, Harry Miller, and Rick Pifer—make working at 816 State Street a productive and pleasurable experience. Nicolette Bromberg and Matthew Mason, no longer in Madison, were also very helpful in guiding me through the voluminous visual materials. Finally, I thank Kathy Borkowski, the Historical Society's editorial director, for her sustained interest in this project.

I wish to acknowledge several friends in Science Hall who encouraged me at important times. During frequent research trips to Madison, Bob Ostergren and Yi-Fu Tuan, my long-standing Wisconsin mentors, provided the sort of hospitality and intellectual support that seems to know no limits. I also thank Onno Brouwer, director of the Wisconsin Cartographic Laboratory, for creating the two original maps that, like photographs, tell such remarkable stories.

Closer to home, I have enjoyed the very good fortune of working in the most nurturing academic environment imaginable. For the past seven years, each of my colleagues in the Department of American Studies at the University of Texas—Bob Abzug, Janet Davis, Elizabeth Engelhardt, Shelley Fisher Fishkin (now at Stanford), Nhi Lieu, Jeff Meikle, Julia Mickenberg, Mark Smith, and Shirley Thompson—has sustained me with intellectual nourishment and good cheer. I have especially benefited from the insightful comments on earlier drafts by Bob Abzug, Janet Davis, Jeff Meikle, and Amy Ware. The larger intellectual community at UT has also embraced my scholarship, and I would especially like to thank Erika Bsumek and Pauline Strong, who took the time out of busy schedules to read the entire manuscript, and Leo Zonn and Paul Adams for their constant reminder of just how powerfully geography really does matter.

Beyond Texas, I have received important critical feedback from numerous colleagues, each of whom helped make this a better book. For their gracious invitations to speak to issues of transnational exchange and the role of American Indian photography in that process, I would like to thank Sabine Sielke and Claus Daufenbach at the University of Bonn, Gabriele Linke at the University of Rostock, Dorothea Steiner at the University of Salzburg, Markku Henriksson and Mikko Saikku at the University of Helsinki's Renvall Institute, and the John F. Kennedy Institut für Nordameriakstudien at the Freie Universität Berlin. Grant Arndt, Chris Boone, Bill Cronon, Mick Gidley, Frank Goodyear, Peter Bacon Hales, Theresa Harlan, Susan Applegate Krouse, Walter Metz, the late Peter Palmquist, Martha Sandweiss, Rich Schein, and Alan Trachtenberg helped me refine my thoughts on this project through conversations in friendly offices, via e-mail, and during conference presentations of this work. Both Phil Deloria and Amy Lonetree gave the manuscript a careful reading at a crucial stage and their thoughtful comments improved it immeasurably. And Nancy Lurie graciously welcomed me to her home, shared her deep knowledge of Ho-Chunk culture, and patiently answered my many questions—both in Milwaukee and across cyberspace.

A substantially revised portion of this book was previously published by the *American Indian Culture and Research Journal,* which I thank for permission to include here. I also thank the *AICRJ*'s fine editor, Duane Champagne, for his helpful comments as well as those of the three anonymous reviewers.

This book's publication has been assisted by several funding agencies and it is with pleasure that I acknowledge their support: the University of Texas at Austin's University Co-operative Society for a generous subvention grant; the Anonymous Fund of the College of Letters and Science at the University of Wisconsin–Madison; the Wisconsin Historical Society for a Geilfuss Fellowship in Economic History; and Office of the Vice President for Research at the University of Texas at Austin, which provided funds for photographic reproduction.

For roughly a decade now, the University of Wisconsin Press has patiently waited for a manuscript that I'm sure they thought would never arrive; I am thankful that they stuck with me. Mary Braun may no longer work for the Press, but her impact on this book is significant. I thank her not only for her early support, but also for joining me during archival trips to the Dells, and for her continuing friendship and encouragement. More recently, Gwen Walker has masterfully guided me through the complex maze of book publishing, and the Press's two reviewers provided insightful and helpful comments. Anyone who has benefited from Paul Boyer's editorial work knows what a sensitive and incisive reader he is. I am most grateful for his generous assistance in creating this book and for the honor of its inclusion in his series, Studies in American Thought and Culture.

My final thanks are reserved for those who have lived with this book, and me, over the years. My parents, Barbara and Douglas Hoelscher, have persistently offered me the loving support that helped keep things going, as has my wife, Kristen Nilsson. Never losing faith that someday "the book" would be finished, Kristen's encouragement came at all the right times. And to my two daughters, Emma and Erika, who inherited their father's love of books, this one is dedicated to you.

Picturing Indians

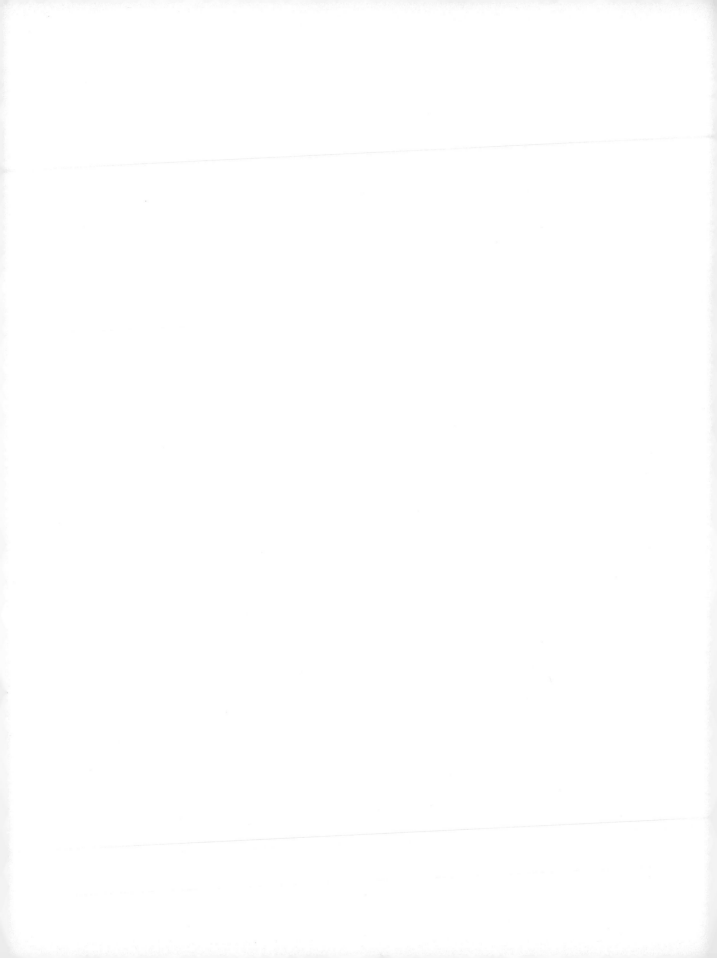

Prologue

Photographic Encounters

I‍N THE WINTER OF 1883, the photographer H. H. Bennett decided to embellish his descriptive catalogue of stereo views with something new. Several years earlier, a simple listing of his photographs—mostly landscape views of the area surrounding the Wisconsin River Dells—brought the small-town studio photographer considerable renown and enhanced sales. Now, after a sluggish business year, Bennett sought to recapture some of the trade that he saw slipping west with the frontier. Perhaps his imagination was triggered by a visit that year from Buffalo Bill Cody, who, as the local paper put it, was "attracted by Bennett, the man who shoots with a camera as well as Buffalo Bill does with a rifle." Maybe it was the particular success of one photograph taken ten years earlier in 1873—of Wah-con-ja-z-gah (Yellow Thunder)—that led Bennett to take a slightly new promotional approach (figure 1). Whatever the reason, the spice that Bennett used to flavor his photographic business relied on the region's Native Americans—the Ho-Chunk (or Winnebago) nation.[1]

The decision was an important one for both the photographer and the photographed. For Bennett, whose clientele consisted mostly of tourists to the Dells, cultivating a reputation of romance and adventure—for both the place and himself—played an increasingly important part in his business. Mass tourism came of age in the years around the turn of the twentieth century, and as the principal booster of the region's most significant tourist destination, Bennett stood to gain immeasurably from capitalizing on what he and other white promoters called "the Indian fad." Indeed, the photographs in his "Among the Winnebago" series eventually became some of his bestsellers. They seemed to offer proof that Bennett, who referred to himself as "Ho-Kee-Wah-gah-zah" (Ho-Chunk for "Man Who Makes Pictures"), possessed considerable knowledge of Native Americans. After seeing his stereographic views, more than one tourist vowed, in the words of Miss Carmel from Rockford, Illinois, "when I go to the Dells again, I am going to devote most of my time to Mr. Bennett's Indians."[2]

Images such as that of Wah-con-ja-z-gah were thus vital to building the photographer's reputation and to shaping ideas about American Indians for non-Native viewers like Miss Carmel.

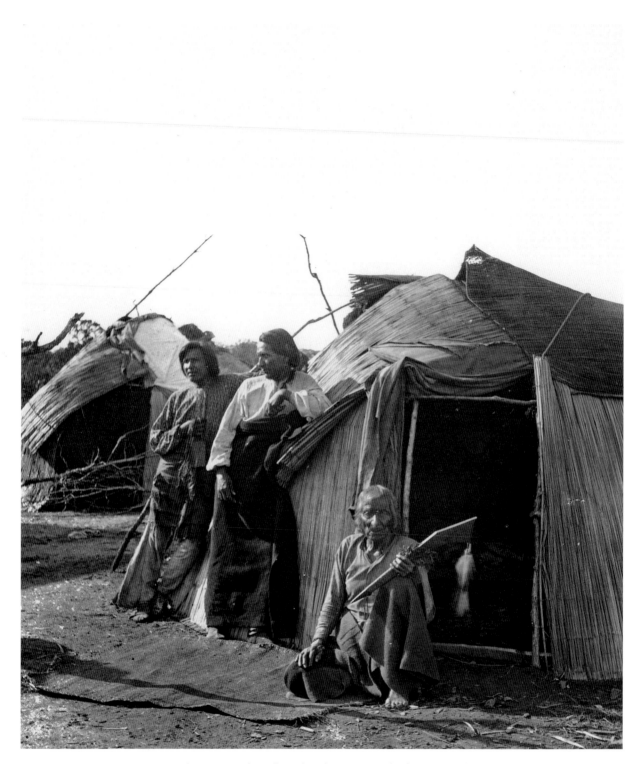

FIGURE 1. H. H. Bennett. "Wah-con-ja-z-gah (Yellow Thunder) Warrior Chief 120 years old." Wisconsin Dells. Modern print from original stereographic glass negative half, May 1873. Photograph courtesy of Wisconsin Historical Society, Image ID: 4757.

The photograph itself, although clearly posed and formal, seems documentary in its apparent candidness. Sitting comfortably in front of a traditional wigwam, Wah-con-ja-z-gah looks directly into the camera lens as two young men lean casually on the shelter waiting for the photographic moment to pass. The scene is sparse and unadorned by fanciful decoration.

What made it "romantic" to many nineteenth-century viewers was less what the image displayed than what Bennett and other tourist promoters chose to say about it. Deemed by non-Natives to be "superstitious" about the "mysterious operation of picture-taking," Wah-con-ja-z-gah eventually agreed to pose for Bennett's camera. The famous Dells photographer, whose "appetite for picture-taking is as relentless as the appetite for rum," was simply not to be denied, according to one writer in 1893:

> Like all Indians, the Winnebagoes had a great dread of photography. They could not understand the process, and what red men do not understand they dread. Hence, their belief that to be photographed meant an inevitable speedy dispatch to the hunting grounds of their fathers. The oldest child of the tribe, whose name was Wahkangazegah, or Yellow Thunder, consented after much persuasion to face the camera.[3]

Meant to titillate an American public fascinated with all things Indian, such tourist fantasies re-told familiar tales of Native superstition and white civilization, of one group's "influence and ingenuity" and the other's savagery, and of the clear racial hierarchy that such oppositions implied.

But what of Wah-con-ja-z-gah and the other American Indians who eventually agreed to pose for Bennett? Obviously, the Ho-Chunk leader would never have described himself or his people as the white tourism promoter did, but no evidence exists to suggest that he was coerced into sitting for the picture. Indeed, despite his alleged dread of being pictured, Wah-con-ja-z-gah had been photographed at least once before and had posed for several different portrait painters (figures 2 and 3). Did Wah-con-ja-z-gah truly not "understand the process" of photography? Was he really simply "superstitious" of being pictured? Is there not a way, in other words, that we might more accurately describe the encounter between non-Native photographers and Native subjects?

Such questions become especially relevant when we recognize that, within months of Bennett's 1873 photograph, the federal government was to embark upon its last major removal of Ho-Chunk from Wisconsin, forcibly rounding up more than a thousand people without warning and deporting them, during the cold winter months, to a new reservation hundreds of miles away. Seen in this light—that of a population under tremendous social pressure—the people in Bennett's photograph take on new meaning. No longer merely aged and infantile ("the oldest child of the tribe"), Wah-con-ja-z-gah is recognized as a powerful, dissident leader who refused to leave his homeland. The object that he grasps more clearly becomes a gunstock war club and the two men to his right could very well be positioned there for his protection. A photograph that would seem to capture a moment of timelessness and traditional life outside the stream of history, in fact, depicts three people caught in the throws of dramatic social and, at times, violent change.

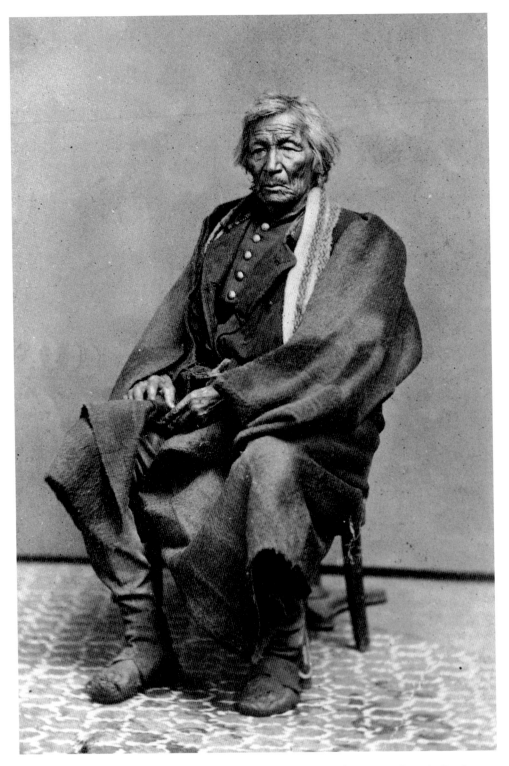

FIGURE 2. Unknown photographer. "Studio Portrait of Yellow Thunder, a Winnebago Indian." Photograph taken in Portage, Wisconsin, date unknown. Photograph courtesy of Wisconsin Historical Society, Image ID: 27886.

By sitting for H. H. Bennett's camera, Wah-con-ja-z-gah unwittingly provided a model for future Ho-Chunk people that continues into the present and that connects them with the region's political economy of tourism. For more than 130 years—long before the enormously successful Ho-Chunk Casino opened its doors to twenty-four-hour, seven-days-a-week gaming near the Dells (figure 4)—Native peoples have played a vital role in shaping the area's most important economic activity. Far from subsidiary to the story of regional tourism development, the Ho-Chunk Nation has been a crucial, if unequal, partner in transforming the Wisconsin Dells from small town into booming resort destination.[4] Pictures of Ho-Chunk are central to that story.

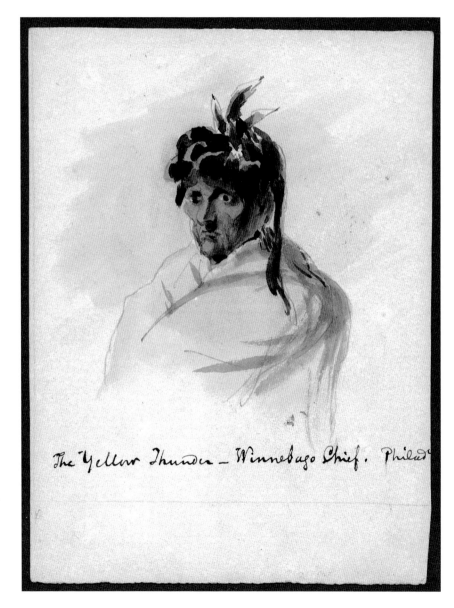

FIGURE 3. Robert Montgomery Bird. *The Yellow Thunder—Winnebago Chief.* Watercolor painting, ca. 1837. Reproduced by the Annenberg Rare Book and Manuscript Library, University of Pennsylvania, courtesy of the privately held Robert Bird Collection.

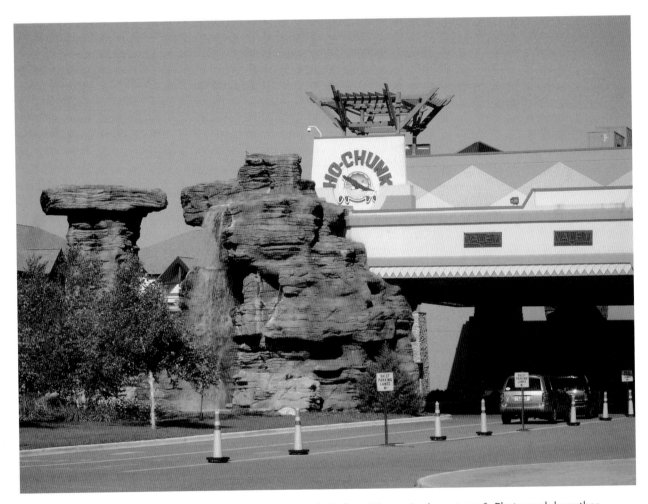

FIGURE 4. Ho-Chunk Casino and Convention Center. Lake Delton, Wisconsin, August 2006. Photograph by author.

I

Contact Zones

American Indians, Tourism, and Photography

T HIS BOOK TRACES THE BEGINNINGS of a significant relationship, one that unites Native Americans, tourism, and photography in U.S. culture. It charts an encounter between two very different people in one place that is at once fraught with misunderstandings and asymmetrical power relations as well as the source of exchange and opportunity. Entwined in remarkable and enduring ways, Indians and photography appear to be inseparable: for many non-Native people, photographs represent what is seen to be essentially Indian; while for many Native Americans, getting over the century-old legacy of having their pictures taken and used by outsiders for purposes they did not intend is an ongoing struggle. It is also a relationship that has its origins at a key moment in American cultural history. The rise of commercial photography, the emergence of mass tourism, and the final colonization of Native Americans all occurred simultaneously in the latter half of the nineteenth century, producing a historical intersection that is far from coincidental. "Photography became prominent at precisely the same moment that the American government was staging the take-over of the Great Plains," writes Tuscarora photographer and scholar Jolene Rickard. "The combination of these layered events created a powerful imaginary image in the mind of most Americans."[1]

One of the central claims of this book is that such imaginary images had a significant impact on weighty matters of politics and social relations: that visual culture helps shape the material world. My underlying premise for such a claim is that photographs of Native Americans often reveal as much about the photographers behind the camera—and about their underlying cultural assumptions—as about the people sitting in front of it. Photographic images do not "speak for themselves" or disclose unmediated truths about the world or its people; they are given meanings only through the specific contexts of their creation and subsequent circulation. Thus, in this book I am less interested in merely questions of historical authenticity—are the camera's subjects "correctly" dressed? are the photographs "accurate" depictions of Native life?—than in matters of representation: the aspects of the dominant white society that are represented in photographs of American Indians and that help shape the worlds of both. In this

way, *Picturing Indians* explores what Robert Berkhofer has called "the white man's Indian," or popular images of Native Americans in white society and their profound impact on both social policies and Native experience.[2]

Beginning from this elementary contention, this book explores the complex, and sometimes contradictory, interplay between photographic images, the political economy of tourism, and the formation of racial identities. I argue that there is more than what simply meets the eye in pictures of Native Americans such as Wah-con-ja-z-gah and of places such as the Wisconsin Dells. Photographs conceal as much as they reveal, especially about the sometimes friendly, sometimes tense, relationship between picture maker and photographic subject. What H. H. Bennett's Ho-Chunk pictures show about nineteenth-century white perceptions of Native Americans, about social tensions in a volatile American region, and about Native efforts to make a better world for themselves bears a close relationship to what they hide: federal policies of Indian removal, centuries of mutual distrust, and creative responses to novel situations. If a picture really is worth a thousand words, we must be careful to attend to all the voices speaking these words—to listen to all its stories, even if some of those stories are barely audible.

The pictures that this book attends to focus on two peoples—the Ho-Chunk Nation and Euro-Americans as represented by the photographer H. H. Bennett—in one place, the Dells of the Wisconsin River. Part portraiture and part "landscape" or "view photography," Bennett's Indian pictures are the images that have come to represent Ho-Chunk culture for many non-Native people. They have been seen by generations of tourists to the Wisconsin Dells and, more recently, have been widely reproduced in many important historical treatments of the Ho-Chunk Nation.[3] Today, the H. H. Bennett Studio Museum in the Wisconsin Dells, owned and operated by the Wisconsin Historical Society, prominently displays Ho-Chunk pictures in both the exhibits and through street-level advertising (figure 5). While the stories I tell about these pictures are decidedly local, they speak to larger-scale concerns of national, indeed international, relevance. Photography, I argue, has long served as a technology of domination to subdue indigenous peoples the world over, but it has also worked to provide those very peoples a medium for their own culture's survival, endurance, and renewal—for their survivance.

PHOTOGRAPHY AS TECHNOLOGY OF DOMINATION AND TOOL OF SURVIVANCE

Non-Native people have long held peculiar and complex views of American Indians, making their images staples of American popular culture. As Rick Hill, among others, has shown, these views are well documented in, and shaped by, the creative arts, especially photography. "The photographic image becomes the most subtle tool for manifesting those divergent beliefs," writes Hill. "Nearly every stereotype of Indians that existed in literature, painting, more popular writings, and newspaper articles can be seen in photographs." Searching the historical photographic record, Hill documents no fewer than ten such images, including the Indian as Warrior, as Chief or Medicine Man, as Naked Savage, as Sex Fantasy, as Prisoner, as Noble Savage, as Vanishing American, as Object of Study, as Tourist Prop, and as Victim. Such idealized imagery of Indians, though centuries in the making, reached its peak during the mid- to

late-nineteenth-century Indian removals—and with the amazing new technology of photographic picture making.[4]

Photography is prone to the same cultural influences and power struggles that shape other forms of representation, but its apparent realism and unmediated look give camera-produced images their "hidden political significance," as Walter Benjamin famously put it. What would appear natural and the product of an objective, mechanical process, is, in fact, affected by the same cultural biases that shape paintings and poems. "The photographic image possesses an incredible amount of control," Navajo/Creek/Seminole photographer Hulleah J. Tsinhnahjinnie argues. "Photography has the ability to control the direction of one's thinking by presenting itself as truth. Prejudices can be quickly confirmed by staged, manipulated, or misrepresented photographs. An imbalance of information is presented as truth."[5]

From this basic proposition, Susan Sontag became one of the first critics to see the camera as a "predatory weapon" in America's colonization, of which "the case of the American Indian

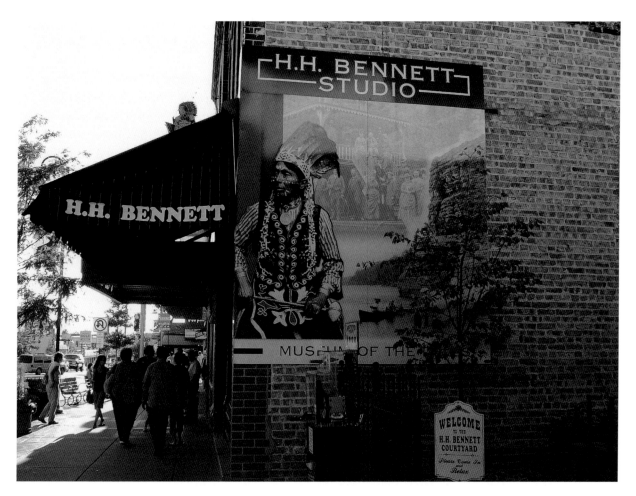

FIGURE 5. H. H. Bennett Studio Museum. Wisconsin Dells, August 2006. Photograph by author.

is most brutal." Similarly, Vine Deloria Jr. described turn-of-the-century photography as "a weapon in the final skirmishes of cultural warfare in which the natives of North America could be properly and finally embedded in their places in the cultural evolutionary incline." As a technology of domination, especially in the conquest of American Indians, photography achieved unparalleled success and became a means to justify and legitimate policies of American imperial expansion.[6]

Recent scholarship on American Indian photography has come a long way in helping us understand the central role of photography as a means of domination, and of dispelling the simplistic view of the visual medium as a transparent and innocent reflection of reality.[7] Certainly, H. H. Bennett, no less than his many western contemporaries, constructed popular images of Native peoples as "the vanishing race" that, when combined with print media, created a narrative of white American progress and Native American cultural decline. Bennett's Wisconsin Dells photographs depict a playful frontier, a place, as one contemporary booster put it, "where but a few years since savagery and solitude reigned unbroken, now annually swarm with gaily dressed seekers of health and pleasure."[8] Pictures of Indians—non-threatening and safe for white consumption—played a central role in telling this now-classic story and making it seem entirely natural.

Such a reading of Native American photography, however useful in it may be in challenging an earlier generation's assumptions about Indians as a "vanishing race," inevitably leaves several important questions unanswered. Is there a way to understand such representations from a perspective that more deliberately takes into account the point of view of the photographed? Can we treat the subjects in Native American photographs as people who interacted with the photographer, and not simply as objects of his camera's colonizing gaze? What would happen, in other words, if we take the logic of photographic domination as a starting point, rather than a presumptive conclusion? Such questions speak to important dilemmas of method in approaching nineteenth-century Native American photography. A consideration of these sorts of questions recognizes, with Benjamin, that by their very nature photographs "demand a specific kind of approach; free-floating contemplation is not appropriate to them."[9] Asking questions about how Native American subjects were involved in picture making, I would suggest, is central to any endeavor that seeks to explore the photographic encounters between these two very different cultures.

Here, the highly abstract realm of postcolonial theory meets the concrete world of nineteenth-century Wisconsin and provides a useful, introductory framework. Mary Louise Pratt describes such worlds as "contact zones," as spaces "of colonial encounters . . . in which peoples geographically and historically separated come into contact with each other and establish ongoing relations, usually involving conditions of coercion, radical inequality, and intractable conflict." Recognizing that photography documented—and even shaped—these worlds of "highly asymmetrical relations of domination and subordination," we begin to understand why free-floating contemplation of Native American pictures is worse than ineffectual. It obscures the social, political, and economic relationships that are at the heart of the photo-making process, especially the essential role that Native peoples played in the photographic encounter.[10] Pratt and other

postcolonial theorists are careful to point out that "while a subjugated people cannot readily control what emanates from the dominant culture, they do determine to varying extents what they absorb into their own, and what they use it for." The term that Pratt uses for such encounters in the contact zone—"transculturation"—describes how marginalized groups select and then make use of technologies transmitted to them from the dominant culture.[11]

One of the signal contributions of postcolonial theorists such as Pratt is in their recognition that colonialism and imperialism—of which the colonization of North America is a prime example—are never simple, unidirectional processes. It's far too uncomplicated to think of Indians as colonized "victims," as passive recipients of a dominant power, who were merely acted upon by an abstract, colonizing force. Rather, every step of the way, Native Americans found ways to withstand continual attempts to eradicate their culture—and themselves. Social, cultural, and political change were the inevitable results of such interaction, but change that occurred in *both* the indigenous and colonizing populations.[12]

Such complexity of interaction is evident in the representational practices surrounding photography. Although the photographer controlled the conditions surrounding transcultural picture making, this control was never absolute or unconditional. Portrait photography, Alan Trachtenberg notes, usually involves some sort of collaboration or mutuality between artist and portrait subject. Such encounters might be asymmetrical, and, indeed, they nearly always are, especially in contact zones like nineteenth-century Wisconsin, where a clear imbalance of power defines the relationship between Euro-American photographers and Indian portrait subjects. But recognizing the asymmetry of the transcultural photographic encounter should not blind us to the active role assumed by the sitter or the social interaction between sitter and portraitist. A truly candid photograph in the nineteenth century was extremely rare; due to bulky equipment and slow camera shutter speeds, photography took place in distinctly formal settings, even if that setting was outdoors.[13]

It is easy to forget the social exchange at the heart of historic Native American photography and merely to assume that Indians have been somehow "less rational about photography and less capable of handling its remarkable capabilities" than the dominant white culture. But neglecting the necessary interaction between whites and indigenous peoples not only perpetuates a patronizing dismissal of Native agency; it also elides one crucial side of the photographic encounter.[14] As Frank Goodyear has shown in his visual biography of the Lakota leader Red Cloud, some Native Americans *enthusiastically embraced* photography as a medium to pursue a range of political projects and personal goals. Far from fearing the camera, Red Cloud strategically exploited photography "to show not only the American public and his fellow tribespeople but also himself that he remained a vital presence within Oglala society."[15]

By vigorously embracing photographic technology, Native people such as Red Cloud were doing much more than just getting by; they were creatively and energetically asserting their active presence in a transcultural world rife with conflict. As Comanche writer Paul Chaat Smith notes about Native Americans generally, "we have been using photography for our own ends as long as we've been flying, which is to say as long as there have been cameras and airplanes. . . . Contrary to what most people (Indians and non-Indians alike) now believe, our true history is

one of constant change, technological innovation, and intense curiosity about the world." Such a history of change and curiosity, in which the camera is vitally central, is about creativity, dynamic resistance to oppression, and being fully engaged in the world. This history takes the postcolonial concept of transculturation one step further and places it in the special context of Native American experience. The word invoked by Anishinaabe writer Gerald Vizenor to describe such Native agency in the face of unremitting struggle is "survivance."[16]

For Vizenor, survivance "is more than survival, more than endurance or mere response; the stories of survivance are an active presence." Such stories, Vizenor continues, demonstrate that survivance "is an active repudiation of dominance, tragedy, and victimry."[17] Stories of survivance run through Native communities and are part of every group's cultural heritage; they recount the many ways in which Native Americans engaged in acts of self-definition and resistance, while simultaneously removing any lingering doubt about the pernicious falsehood of the "vanishing race" ideology. In recognition of its centrality to Native experience, the concept of survivance has become the interpretive framework of the Smithsonian Institution's National Museum of the American Indian (NMAI), which opened in September 2004. One text panel in the NMAI's *Our Peoples* gallery specifically describes it this way:

> Survivance: Native societies that survived the firestorm of Contact faced unique challenges. No two situations were the same, even for Native groups in the same area at the same time. But in nearly every case, Native people faced a contest for power and possessions that involved three forces—guns, churches, and governments. These forces shaped the lives of Indians who survived the massive rupture of the first century of Contact. By adopting the very tools that were used to change, control, and dispossess them, Native peoples shaped their cultures and societies to keep them alive. This strategy has been called survivance.[18]

Although the "guns, churches, and governments" framework oversimplifies the profound series of imperial forces that pressured Native communities in countless ways, the NMAI text points to a fundamental component of survivance. Persistently and with a knowing sensibility, Native peoples appropriated the instruments and institutions that were designed to colonize them. As both a material act in the physical world and a representational strategy, survivance enables resistance and builds a new world of possibilities. It undermines the master narratives that sustain imperial rule—Indians as the "vanishing race," westward expansion as divinely inspired and the product of manifest destiny, the cultural inferiority of indigenous peoples—and offers new opportunities for self-determination and cultural sovereignty. Thus, a central claim of this book is that one of the forces shaping the lives of Native peoples, and which they utilized as a technology of survivance, is the camera.

A Note on Methods

It is one thing to acknowledge the active role that many Native Americans must have played in transcultural photography, to assert that indigenous people learned to pose before the camera as

a matter of survivance. It is another matter entirely to explore that role in depth and to redress the one-sidedness that has long typified the transcultural encounter between Indian peoples and photography. A paucity of primary sources makes such an analysis difficult, of course, but in the Ho-Chunk case we are fortunate to have a wealth of archival material documenting the social and economic exchange between the Dells photographer and his Native American neighbors. H. H. Bennett's personal and professional correspondence, diaries, financial records, and guidebook publications collected and preserved from the 1860s through the first decade of the twentieth century provide a crucial window into the making of transcultural photographs in the Wisconsin contact zone.[19]

As important as these archival sources are to this book, they do not constitute its only source of information. The fact that they were written from Bennett's point of view naturally makes them far from unproblematic and suggestive of a concern voiced by Devon Mihesuah. She warns of the dangers inherent in a complete reliance on written documents, noting that historians often "refuse to use informants, believing modern Indians' versions of their tribes' histories are 'fantasies.'" Mihesuah then asks rhetorically, "Are not some written records fantasy? Are not some writings of army officers, missionaries, explorers, and pioneers who encountered Indians exaggerated and biased?"[20] Acknowledging the incomplete nature of written materials thus leads to a second critical source on which this book relies: the readings of and responses to Bennett's photographs by contemporary Ho-Chunk elders, language experts, archaeologists, journalists, artists, and historians. Informal and semi-structured interviews conducted over a course of five years and ranging in length from an hour to all day constitute a second set of sources that complement the first. Neither my informants nor I claim that they in any way speak for "the Ho-Chunk." Nevertheless, our conversations and their reflections on Bennett's photographs have significantly shaped my understanding of these important images, and this book. Who else can better ground a discussion of Native American photographs—who better to bring "free-floating contemplation" to earth—than their descendants?[21]

A third methodological component of this book expands beyond Bennett's photographs to examine them in comparative context. Here, I deploy what Shawn Michelle Smith calls a "critically comparative interpretive visual methodology." Although the focus of this book rests squarely on Bennett's Ho-Chunk photographs, these representations come ever more alive when juxtaposed with those of other photographers. Such a methodology, Smith argues, "reads visual archives against one another to find photographic meaning in the interstices between them, in the challenges they pose to one another, and in the competing claims they make on cultural import." H. H. Bennett, although a significant historic photographer of Midwestern Native peoples, is not the only one to direct his camera at the Ho-Chunk Nation. Reading his photographs alongside others tells us much about what is unique to his perspective, and what is more generally representative of Native American photography.[22]

Some of these comparative photographers were contemporaries of Bennett; Edward S. Curtis is the best known, but also important were regional rivals such as Charles Van Schaick of Black River Falls, Wisconsin. To these Euro-American photographers of Bennett's generation, I add Tom Jones, a contemporary Ho-Chunk artist whose color and black-and-white portraits of his

people are tinged with ironic wit and compassion. As documents of survivance, Tom Jones's Ho-Chunk pictures reveal much about Native life today and, when juxtaposed with Bennett's, shed critical light on Indian pictures of long ago.

These three sets of primary information—period-era written records, contemporary oral testimony, and comparative photographs—must, by necessity, be situated within the context of both Ho-Chunk and Euro-American history in the Wisconsin Dells region. Such a claim for the importance of historical-geographical context might seem self-evident, but the lingering tendency to view photographs apart from the circumstances of their creation, circulation, and reception remains deeply ingrained. Non-Native people most frequently encounter Indian photographs as stand-alone artwork in museums or as postcards in tourist shops (figure 6). Even when they are included in history books, Native American photographs tend to be treated as illustrations, as visually enticing images that serve merely to illustrate a point highlighted in the text. In this book, I take seriously Jolene Rickard's claim that juxtaposing the history of photography with

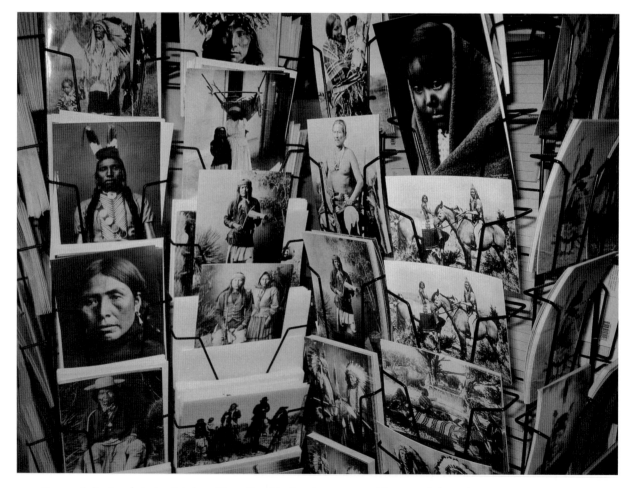

FIGURE 6. Postcards in tourist shop. Taos, New Mexico, August 2005. Photograph by author.

Native American history—that establishing historic context—is a prerequisite for interpreting images such as Bennett's Ho-Chunk pictures.[23]

The goal of *Picturing Indians* is to amend—at least partially—the imbalance of information that has long characterized the photographic encounter between Native American subjects and Euro-American picture makers. A complete recovery of this past, of course, is impossible, for all that remains of those early transcultural exchanges are scattered remnants: notes left in an archive, stories handed down through the generations, old pictures.[24] The inherent difficulty of uncovering photographic meaning is redoubled, moreover, when one writes across cultural boundaries. In this book, and throughout the research on which it is based, I am ever mindful of cultural chasm between myself—a Euro-American scholar writing in the twenty-first century—and the Ho-Chunk men and women pictured by H. H. Bennett more than one hundred years ago. Nevertheless, I believe that Bennett's Indian pictures in the Wisconsin Dells can tell us much about the people—*both* white and Native—who lived and struggled in this important American contact zone. And behind these pictures are the photographic encounters and tourist fantasies that shed light on the decisive role of visual images in shaping cultural understandings and misunderstandings.

A Place of Spiritual Retreat, or Scenery: The Wisconsin Dells as Contact Zone

For centuries, indeed for millennia, people have traveled to and through the Wisconsin Dells searching for better opportunities, putting down roots, or just wanting a break from everyday life. Today, the self-proclaimed "Waterpark Capital of the World" boasts over two hundred water-slides that complement a vast array of tourist attractions. Sprawling miniature golf courses, indoor and outdoor theme parks, riverboat tours, haunted houses, and roller coasters draw millions of annual visitors to the Midwest's tourist juggernaut. It might be a stretch to call Wisconsin Dells "the best of Disney next to Yellowstone," but that doesn't stop its promoters from creating an imaginative geography designed to allure (figure 7).[25]

The river itself, for a very long time, offered the primary attraction in a place now better known for its themed waterslides than anything remotely "natural." Hundreds of nearby effigy and burial mounds, rock art, picture writing, and wampum remains attest to a long history of human habitation and mobility in the region. Such physical evidence forces recognition that the river's allure for Native Americans was strong. More recent oral history among Ho-Chunk people describes the Dells as a place of "very strong spiritual as well as physical importance" for Wisconsin's earliest inhabitants. "Our people would camp here on their annual migrations from northern villages to the southern lodges," says Lance Tallmadge. "They would meet in the Wisconsin Dells because of the force of the river, the rocks, and they would utilize this area to renew themselves physically because of the hard journey, but also spiritually because of the force of nature here."[26] Tallmadge, a Ho-Chunk leader whose family has long been involved in the local tourism industry, echoes another Ho-Chunk man named Albert Yellow Thunder. The grandson of Wah-con-ja-z-gah (see figure 1), Yellow Thunder described in the 1940s how, for generations, "My people come here [to the Wisconsin Dells] because of the rock images, the enchantment

of the canyons, the evergreen banks, the winding river. . . . They come here because of the light: the dawn-light, the sunlight and the twilight and the moonlight. Their hearts are made free by the things they see and feel and smell" (figure 8).[27]

The force of nature, the river, and rocks also caught the attention of early non-Indian travelers. As early as the mid-1840s, the Dells of the Wisconsin River achieved a reputation as the region's greatest natural wonder. An 1847 geological survey described the Dells as possessing "singular and beautiful effects." Likening the riverscape to an architectural monument, J. G. Norwood raved about "the architraves, sculpted cornices, moulded capitals, scrolls, and fluted columns [that] are seen on every hand; presenting, altogether, a mixture of the grand, the beautiful, and

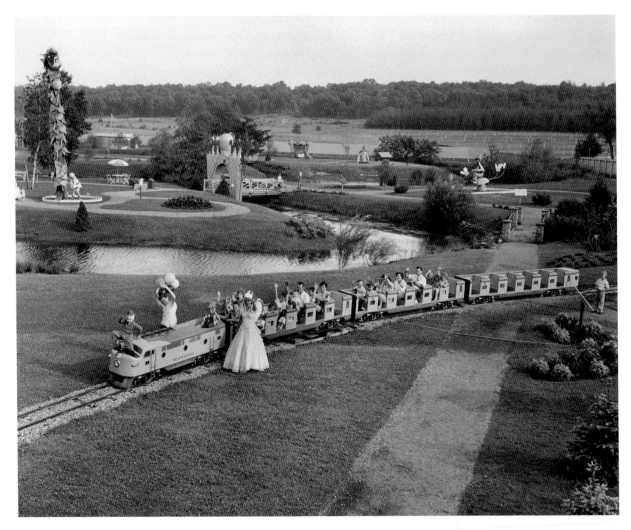

FIGURE 7. Oliver Reese. "Storybook Land Train." Elevated view of Fairy Godmother with kids on Storybook Land train, Wisconsin Dells. Modern print from original negative, June 1956. Photograph courtesy of the Wisconsin Historical Society, Image ID: 42204.

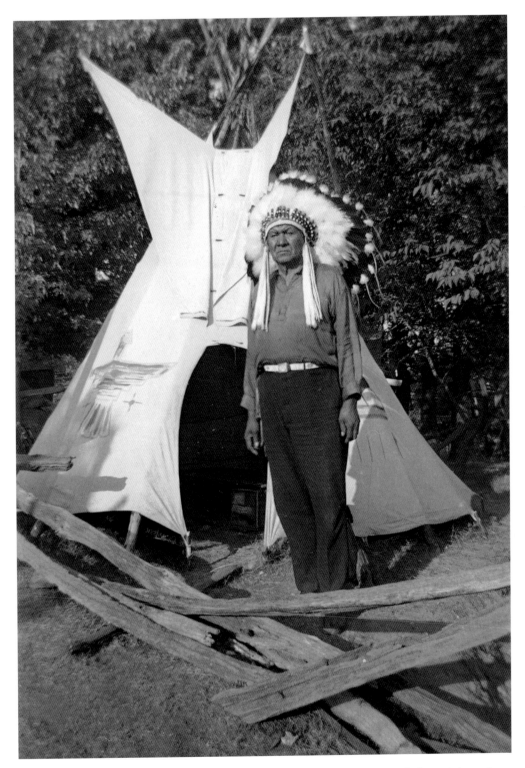

FIGURE 8. Helene Stratman-Thomas. "Chief Albert Yellow Thunder." Wisconsin Dells, 24 July 1946. Photograph courtesy of the Wisconsin Historical Society, Image ID: 25206.

the fantastic."[28] Two years later, in what was arguably the first recorded scenic tour of the Dells by a Euro-American, Increase A. Lapham traveled from the comfort of his Milwaukee home to view "the beautiful scenery of Wisconsin . . . our State." Lapham's tour to the Wisconsin Dells, like that of so many other educated elite men of his day, mixed the gathering of scientific data with the pleasure of seeing new and interesting landscapes (figure 9). The preeminent natural scientist of his day, Lapham encountered in "the Dreadful Dells" less a place of spirituality, as it was for local Native Americans, but instead "scenery that is grand and picturesque, resembling the gorge below the Falls of Niagara" (figure 10).[29]

The riverine landscape that had long attracted the region's indigenous peoples and, eventually, its non-Native inhabitants is unique within the American Midwest. The word "dells" originates from the French *dalles,* meaning "deep ravine" or "narrow passage." This is not very different in meaning than the Ho-Chunk name for the Dells, Nee-ah-ke-coonah-er-ah, which roughly translates as "where the rocks nearly strike together." Both Native and European words describe a seven-mile-long stretch of the Wisconsin River where it is constricted into a steep-sided gorge of fifty feet at its narrowest point. Here, in the river's main channel and in its many tributary ravines, reside a maze of twisting gorges and extraordinary sandstone rock formations that, collectively, are called the Wisconsin Dells (figure 11).[30]

The Dells are located at the juncture of three distinct geographic regions, and this location is a key to understanding its unique geological features and the human history that followed. To the west lie the well-drained, unglaciated landscapes of the Driftless Area, with its deep valleys

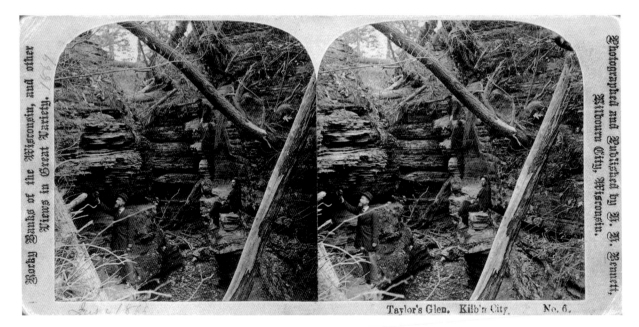

FIGURE 9. H. H. Bennett. "Taylor's Glen." Investigating the natural history of the Dells region, Increase A. Lapham stands in the foreground of a rock formation in Taylor's Glen. Albumen silver print, stereograph, ca. 1860s. Photograph courtesy of Wisconsin Historical Society, Image ID: 44911.

The Dells — Wisconsin River.
1849

FIGURE 10. Increase A. Lapham. *The Dells—Wisconsin River*. Pencil sketch, 1849. Drawing courtesy of the Wisconsin Historical Society, from the Lapham Papers, "Geological Notes of a Tour to the Dells . . . ," Box 2, 1844–1849, Image ID: 49569.

and extensive Paleozoic-era outcrops; to the east are the gently rolling, pastoral landscapes of glaciated Wisconsin. To the north is the flat expanse of the Central Plain, a sizable region of poorly drained, sandy soils and marshes that at one time was covered by a glacial lake. That lake—known to geologists as Glacial Lake Wisconsin—occupied much of central Wisconsin and, at its greatest extent, was about the size of Utah's Great Salt Lake. Created from the Wisconsin River when the glacier from the east abutted the resistant rocks of the Driftless Area (the Baraboo Hills) to the west, Glacial Lake Wisconsin rose steadily for hundreds of years. When the ice dam holding back Glacial Lake Wisconsin eventually broke some fourteen thousand years ago, it set forth a torrent of flooding waters through the narrow opening just downstream from the Dells. In probably just a matter of days or weeks, Glacial Lake Wisconsin was drained,

having passed through what would become the Dells. There, in this most narrow portion of the river channel, the torrential floodwaters cut through the lake and glacial sediment from the surface of the sandstones, slicing a complex network of deep gorges.[31]

If the Dells' position at the junction of three different geographic regions played a decisive role in its geologic formation, its human history is no less dependent on its relative location. For early Ho-Chunk—certainly those people living during the seventeenth, eighteenth, and early nineteenth centuries, a period after first contact with whites but before Europeans were able to dominate the region—its setting along well-traveled routes made the Dells a perfect stopping point for spiritual and physical renewal and for nourishment. Such travels through the Dells were not a series of random wanderings, as whites later described them. Rather, they were part of a

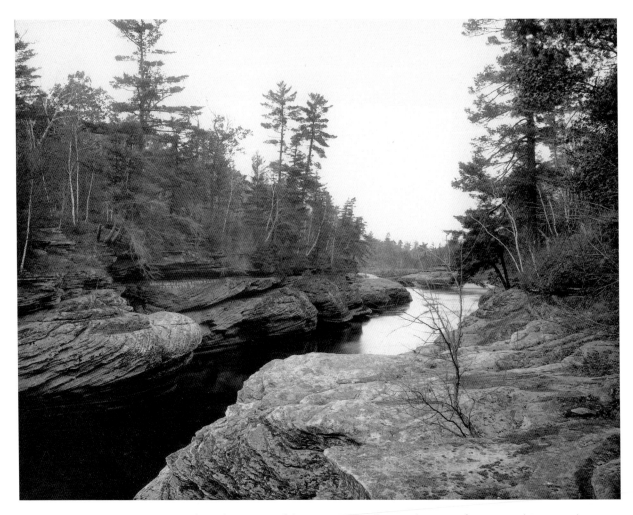

FIGURE 11. H. H. Bennett. "Up through Narrows of the Wisconsin Dells." Modern print from original 8 × 10 inch negative, date unknown. Photograph courtesy of the Wisconsin Historical Society, Bennett Collection, Image ID: 7901.

complex set of annual migrations, closely tied to seasonal variations in agricultural production and the availability of game and other wild foodstuffs. Alternating between seasons of intensive agricultural work that centered on maize cultivation in the north and of hunting and fishing further to the south, traditional Ho-Chunk life emphasized both mobility and rootedness. A central point between the northern lodges and southern hunting grounds were the Dells.[32]

Closely related to matters of food production were spiritual beliefs that emphasized this most narrow portion of the Wisconsin River; here, recent oral tradition further attests to the importance of the Dells for Ho-Chunk seasonal migrations. As recounted by Albert Yellow Thunder, the Ho-Chunk leader actively involved in the mid-twentieth-century tourism industry, the Dells were created out of need for sustenance during a period of change. When the People prayed to the Earthmaker many years ago to provide them with better hunting grounds, the Earthmaker sent a green Water-spirit to the land of snow and ice, where not a living thing could be found. As the Water-spirit stopped to rest, his beating heart melted the ice, and as he crawled southward, the waters of the melting ice filled the groove worn by his wiggling body. The resultant body of water—what we now call the Wisconsin River—narrowed considerably at the place where the rocks strike together. Using tooth and claw, the Water-spirit then cut the solid rock into deep gorges and side channels. The Water-spirit concluded his great work by churning up from his body all the game and wild foodstuffs that the People would ever need.[33] In Yellow Thunder's telling, the Dells originate at the nexus of spirituality and the material sustenance necessary for life itself.

For those non-Native people who followed, the abundance of game mattered less than the Dell's proximity to and easy access from the region's burgeoning urban industrial centers. Less than ten years after Increase Lapham's scenic tour of the Dells, the La Crosse and Milwaukee Railroad built the first railroad bridge to span the Wisconsin River, and by 1873 the local newspaper celebrated the arrival of the first passenger steamships with barely restrained enthusiasm, proclaiming, "Hurrah for the steamer and jolly excursions through the Dells!" The decades that followed the arrival of the railroad and excursion steamboats witnessed the inauguration of mass scenic tourism along the river and the small city on its bank, Kilbourn City—a town later renamed Wisconsin Dells to identify more clearly with its prime attraction. In 1874, more than six thousand sightseers—mainly from the Midwest, but also from places as far away as New York, Boston, and New Orleans—toured the Dells. That number was to increase ten-fold over the next thirty years, and by the mid-1880s the Wisconsin Dells was within an easy day's train ride from all the major cities of the Midwest (map 1).[34] The 1909 dam that irrevocably changed the course of the river might have submerged some of those geological features that once lured tourists, but it did little to stem the tide of visitors "looking for diversion and recreation."[35]

Euro-American writers marveled at the speed with which "fashionable tourism" had displaced the "world of the savage" during these early heady years of social transformation. "Jaunty excursion steamers puff," noted one enthusiastic guidebook writer in 1887, "merry-laden with troops of youth and beauty, along the wild streams and amid islands and crags which, but within the memory of a child, were in a barbarian land."[36] Paul Lear, three years later, echoed these sentiments. Writing in *Wildwood's Magazine*, he expressed astonishment how only

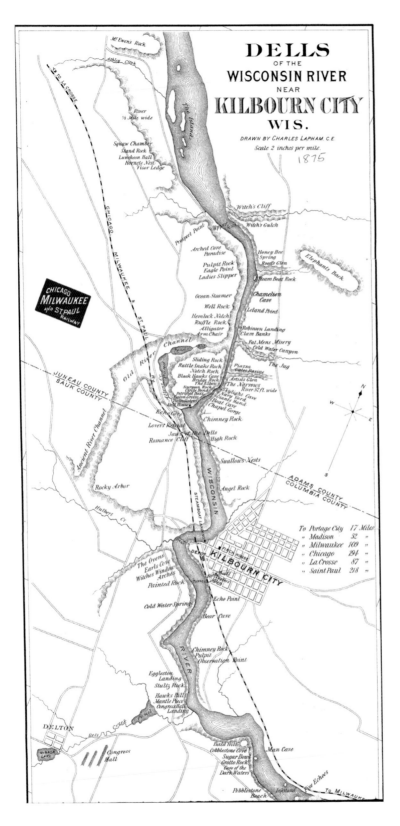

MAP 1. Dells of the Wisconsin River near Kilbourn City, Wisconsin. Published by the Chicago, Milwaukee, and St. Paul Railway, 1875. Cartography by Charles Lapham. Reprinted courtesy of the Wisconsin Historical Society, Image ID: 39790.

Twenty-five years ago, the Dells had scarcely been heard of outside of their immediate vicinity. The tawny Algonquin [sic] roamed unmolested among the wooded gulches, or in his light canoe coursed noiselessly from point to cove intent only on pursuit of the wild fowl and sturgeon which furnished him his substance. . . . Now all this is changed. The Dells are universally recognized as the wonderland of Wisconsin and the north. They are the Mecca of the wandering tourist.[37]

What is revealing about such tourist fantasies—beyond their authors' none-too-subtle racism and undaunted sense of superiority—is acknowledgment that, at one time, the "wonderland of Wisconsin" was the homeland of indigenous people. Importantly, it still is.

FROM "WINNEBAGO" TO HO-CHUNK

The people of the Ho-Chunk Nation (HCN) have lived in the territory that is now known as Wisconsin for as long as they can remember.[38] For thousands of years—well before first contact with Europeans in the early seventeenth century—Ho-Chunk people made their homes in the western Great Lakes region. According to oral history, the Ho-Chunk, or Hochungra people, originated at Moga-Shooch (Red Banks), on the south shore of Green Bay. There, archeologists concur, they had a large, permanent village with extensive gardens, as well as seasonal settlements all the way to the Mississippi River. With a homeland that stretched from Upper Michigan to southern Wisconsin and northern Illinois, they were the most powerful nation in the region.[39]

Ho-Chunk are a Siouan-speaking people who are closely related to the Iowa, Oto, and Missouri tribes and, more distantly, to the Osage, Quapaw, Omaha, Kansa, Ponca, and Mandan peoples. Their common linguistic heritage with all these peoples, as well as their relative geographic centrality, gives credence to the Ho-Chunk claim that they are the original people from whom all Siouan speakers are derived. Hochungra or Hocąk—translated roughly as "the people of the sacred language" or "the people of the big voice"—is the name that Ho-Chunk people use to describe themselves and to articulate this sense of original peoples. In the early 1990s, HCN leaders formally changed their tribal name from "Winnebago," a Mesquakie word meaning "people of the stinking or dirty water," to Ho-Chunk. Although not originally intended to be derogatory—it referred to the turbid and muddy waters of the Fox River and Lake Winnebago, where many Ho-Chunk lived—"Winnebago" took on negative connotations when the French mistranslated it as "stinking people." This name, for understandable reasons, was never embraced by Ho-Chunk people themselves.

The Ho-Chunk living in the Upper Midwest today are descendants of these earliest Wisconsin residents who stubbornly refused to leave the state despite repeated federal efforts to remove them by military force. After ceding tribal homelands in several treaties negotiated between 1828 and 1837, Ho-Chunk people found themselves cast as fugitives living "illegally" in the region they had always known to be home. For decades afterward they evaded federal troops and repeatedly returned to Wisconsin every time they were sent to unfamiliar western reservations. Such obstinate acts of resistance earned the Ho-Chunk contempt from their local white neighbors,

who frequently vented frustration at the "roaming" and "vagabond" Indians of their region. Not until special legislation was passed in the 1870s and 1880s were Ho-Chunk people allowed to take up homesteads in Wisconsin, some of which became the basis for contemporary settlement.

A Native people without a reservation, more than six thousand Ho-Chunk men, women, and children today live on individually held tracts of land scattered across more than a dozen Wisconsin counties. They live in cities across the region, from Minneapolis to Madison to Chicago, and on communally held tribal land in the central part of Wisconsin: Black River Falls, the Wisconsin Dells, Wittenberg, Wisconsin Rapids, Tomah, and La Crosse are the main centers today. As Ojibwe writer Patty Loew has reported, many contemporary Ho-Chunk people find that their greatest challenge was, and remains, their lack of a substantial land base. Of the two thousand acres of land held by members of the Ho-Chunk Nation, almost all of it is widely dispersed, making the provision of tribal services cumbersome and costly.[40]

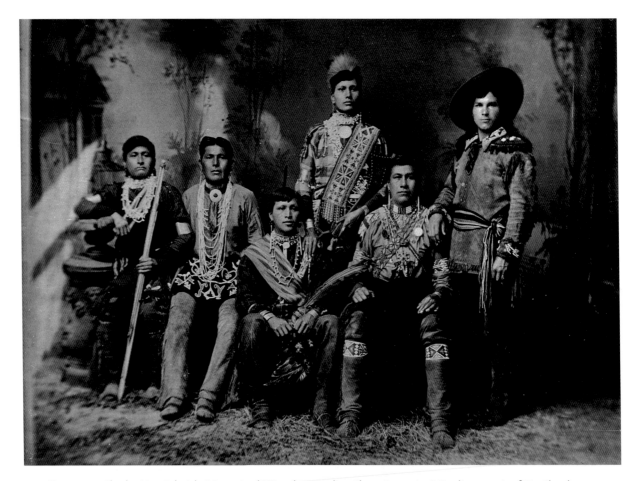

FIGURE 12. Charles Van Schaick. "Organized Winnebago Indian Show Company." Studio portrait of Ho-Chunk men in traditional dress, joined by the white promoter Thomas Roddy (far right). Black River Falls, Wisconsin. Modern print from copy negative, ca. 1890. Photograph courtesy of the Wisconsin Historical Society, Image ID: 49570.

Lack of an adequate land base has also made economic self-sufficiency extremely difficult to achieve. Generally, by the time that Ho-Chunk people were able to homestead land, the best properties had long been acquired by white settlers. What remained was the most marginal land in Wisconsin's Central Plain, a region known for its poorly drained soils and short growing season. As a result, beginning in the nineteenth century and continuing well into the twentieth, Ho-Chunk families practiced a seasonal, itinerant economy that relied on cash earned from agricultural wage labor that, in turn, supplemented subsistence gardening, hunting, and trapping. Such a practice, the anthropologist Nancy Lurie has found, enabled Ho-Chunk people to retain many of the traditional village and overall tribal structures longer than other groups who were forced onto large-scale reservations in an alien territory. But the arrangement also presented severe difficulties as a great many Ho-Chunk lived in "caste-like" poverty relative to their white neighbors.[41]

Another way to earn badly needed cash for scores of Ho-Chunk was to turn to tourism. As we shall see, once the removal period had passed and armed resistance no longer posed a threat,

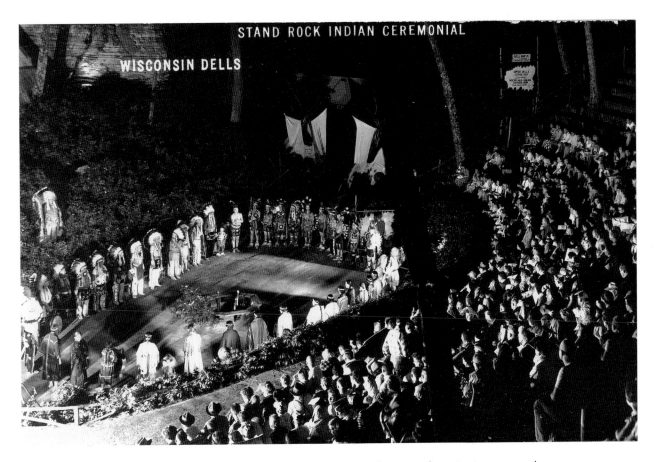

FIGURE 13. Unknown photographer. "Stand Rock Indian Ceremonial." Moen Photo Services postcard, ca. 1950s. Author's collection, reprinted courtesy of Moen Photo, La Crosse, Wisconsin.

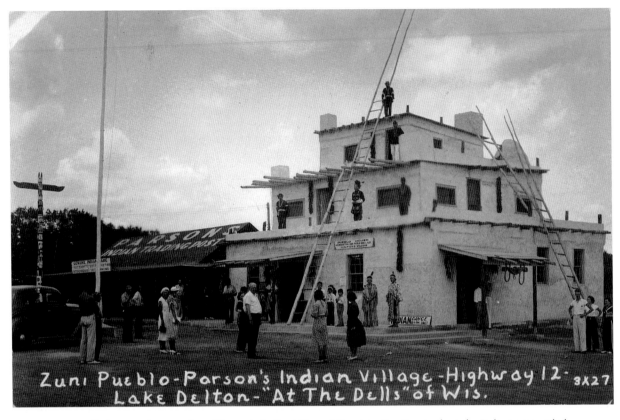

Zuni Pueblo-Parson's Indian Village-Highway 12-3x27
Lake Delton-"At The Dells" of Wis.

FIGURE 14. Unknown photographer. "Parson's Indian Village." Tourist attraction in the Lake Delton area styled after a Zuni pueblo. Postcard from the Wisconsin Historical Society, Image ID: 49571.

whites began to perceive Ho-Chunk and other Native peoples differently. Instead of hearing further calls for their removal—as they had for most of the nineteenth century—Ho-Chunk people learned that their culture might have symbolic as well as economic value for non-Indians. Nostalgia replaced fear as the principal lens through which local whites saw Indians, a sentiment on which some Ho-Chunk were able to capitalize as a matter of survivance. A number began working as "show Indians," traveling throughout the country in circuses and Wild West shows (figure 12), while others adapted to a local tourist economy.[42]

In the long run, the local tourist economy proved more important as it provided income and the opportunity for many Ho-Chunk to maintain a culture of seasonal mobility. Every summer, hundreds of Ho-Chunk men, women, and children from around the state would travel to the Wisconsin Dells in search of work. One of the most promising opportunities began in 1918 and continued more or less regularly for the next eighty years in the form of cultural performance called the Stand Rock Ceremonial (figure 13).[43] The combined brainchild of a local white entrepreneur named "Captain" Glen Parsons and two Ho-Chunk men named Russell Decorah and Winslow White Eagle, the Stand Rock Ceremonial evolved from a small, five-day event into a

major tourist attraction performed nightly over a two-month period. Ten years after it began, more than twenty thousand tourists were taking in the performance, which was staged at one of the Dells' most visited tourist sites—Stand Rock—and which could easily be reached by one of the many boats plying the river.[44]

Other Ho-Chunk who traveled to the Dells during the summer months worked in the Indian crafts trade. Parson's Indian Trading Post, a "Zuni Pueblo"–style structure established in the early 1920s that became the Dells' first themed shopping mall, employed dozens of artists (figure 14).[45] Still others set up a temporary, recurring camp outside the city limits. There, Ho-Chunk families would construct traditional dwelling structures, make communal meals, and provide a living display of Native culture (figure 15). As a drama of the quotidian, in Barbara

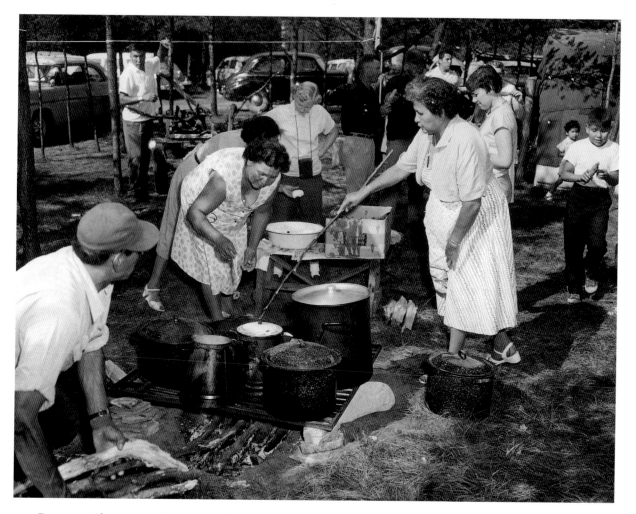

FIGURE 15. Oliver Reese. "Dedication of Winnebago Indian Village." Women making fry bread at the dedication of the Winnebago Indian Village, Wisconsin Dells. Modern print from original negative, July 1956. Photograph courtesy of the Wisconsin Historical Society, Image ID: 42192.

FIGURE 16. Unknown photographer (possibly Oliver Reese). "The Beautiful Wisconsin Dells." The back of this postcard calls the Dells the Midwest's "foremost vacationland," which "has been visited by millions since 1856 and is noted for its scenic boat trips and Indian pageantry." H. H. Bennett Studio postcard, ca. 1960s. Author's collection.

Kirshenblatt-Gimblett's terms, in which people performed ordinary aspects of their everyday lives—cooking, tending a fire, washing, carving, weaving, basket making—the Indian village served a crucial economic as well as cultural role for its participants. Not only did the temporary camp allow them the flexibility of seasonal mobility, but it became the source of vital income as women, who had spent a large portion of the winter making white-ash baskets and intricate beadwork, were able to sell their artwork in a setting largely of their own creation.[46]

By the 1950s, tourism in the Wisconsin Dells rested on the twin pillars of scenic boat tours of the river and performances of cultural identity by Ho-Chunk people. Not only had the Stand Rock Ceremonial become one of the area's most popular attractions, but the very identity of the riverscape had become tied to its Native American inhabitants. Guidebooks from the middle decades of the twentieth century invariably highlighted the close relationship between the Indians and the river, as did postcards and other tourist souvenirs (figure 16). This is a connection, as we shall see, that began in the late nineteenth century and became increasingly important during the first several decades of the twentieth century. As one tourist guide concluded in 1954, "today the descendants of old Chief Yellow Thunder and his fellow tribesmen are one of the most interesting features of the Dells scene."[47]

A great deal of work was naturally required to turn Native people, many of whom were living in "caste-like" poverty, into an "interesting feature of the Dells scene" for tourist consumption. It required boosters to reconfigure old perceptions of the place and, in turn, to create an imaginative geography of the Wisconsin contact zone that emphasized recreation, pleasure, and leisure at the expense of indigenous ways of knowing the world.[48] Photography was the key medium to produce such tourist fantasies, and none proved more influential than the pictures manufactured by the H. H. Bennett Studio in downtown Wisconsin Dells.

H. H. Bennett's Early Years in the Dells

Tourism development, in any location, typically relies on a complex set of interlocking industries—transportation, accommodation, and advertising—that provide its necessary infrastructure. This basic point was not lost on early tourist promoters of the Wisconsin Dells, who championed the efforts of Captain John Bell, whose "jaunty little steamer" guided visitors to "all points of interest"; of William H. Finch, whose "dainty little hotel" offered "clean and airy rooms, snowy linen, delicious cookery and no mosquitoes"; and, most significantly of all, of Henry Hamilton Bennett, the "enthusiastic artist" who "deserves to be canonized as the tallest patron saint in the calendar of the Wisconsin Dells." Patrick Donan, writing in 1879 on behalf of the Chicago, Milwaukee, and St. Paul Railroad, insisted that the "marvelously picturesque and beautiful Dell scenes" deserved to "take rank among the world's most famed resorts for lovers of nature in her wildest moods." But unlike a destination such as Niagara Falls, a place central to the American imagination well before it became a tourist destination, the Wisconsin Dells remained "utterly unknown [since] none but the untutored eyes of the Winnebago Indians or wilder raftsmen and hunters have ever beheld them." What was needed, from the perspective of tourism development, was a new imaginative geography of the Dells region. In the course of five short years, such a process was underway, thanks largely to Bennett: "his romantic region is growing in fame, and he himself is rapidly becoming known as a master of his art" (figure 17).[49]

Positioned at the confluence of art and commerce, H. H. Bennett and his photographs rapidly became synonymous with tourism in the Dells. More than one hundred years after Patrick Donan celebrated Bennett's "exquisite views of natural scenery" and their role in directing public attention to the region, the Milwaukee Art Museum praised his "commercial efforts to bring the beauty of the Wisconsin Dells before a national audience. Bennett succeeded in placing this distinctive region in the pantheon of American natural beauties."[50] With his pictures exhibited at major art museums across the country, from the Amon Carter in Fort Worth to the Museum of Modern Art in New York, H. H. Bennett has earned a place within the canon of American photography.[51] And at a more regional level, Bennett's famous stop-action photograph of his son, Ashley, leaping the Chasm at Stand Rock (figure 18) has become an icon of the state—and one frequently rephotographed by tourists today (figure 19).

Nothing about Bennett's earliest years would foretell such artistic success.[52] Born in 1843 as the eldest of twelve children, Henry H. Bennett came from Vermont to Wisconsin with his uncle and father when he was fourteen years old. The Bennett family's move to Wisconsin—

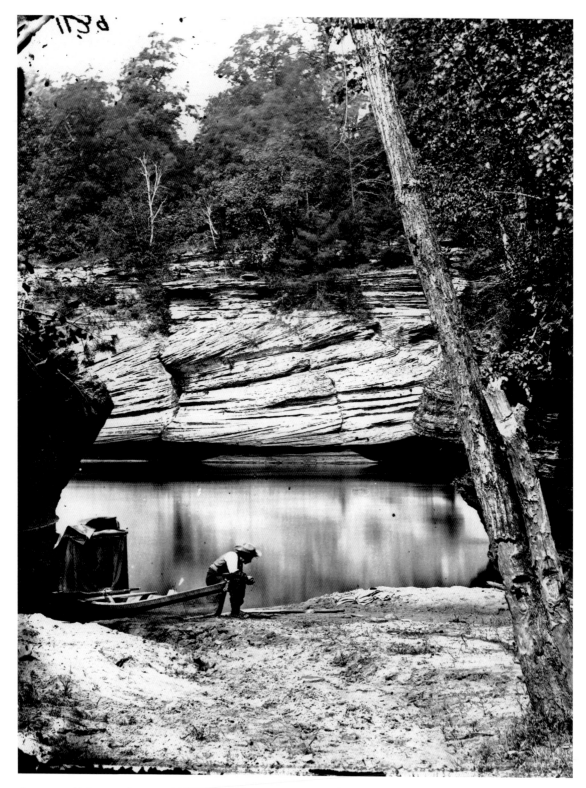

FIGURE 17. Unknown photographer. "H. H. Bennett and Dark Tent at Gates Ravine." Bennett sits on a boat at the river's edge behind Gates Ravine. Modern print from original stereographic negative half, ca. 1870s. Photograph courtesy of Wisconsin Historical Society, Image ID: 7568.

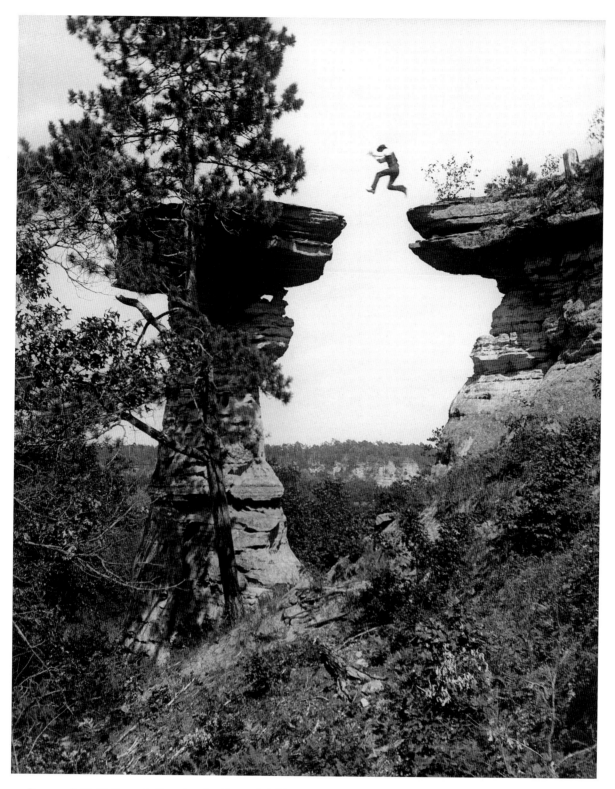

FIGURE 18. H. H. Bennett. "Leaping the Chasm." Ashley Bennett, son of H. H. Bennett, jumping to Stand Rock, caught in midair by the instantaneous shutter. Modern print from original stereographic negative half, 1886. Photograph courtesy of the Wisconsin Historical Society, Image ID: 2101.

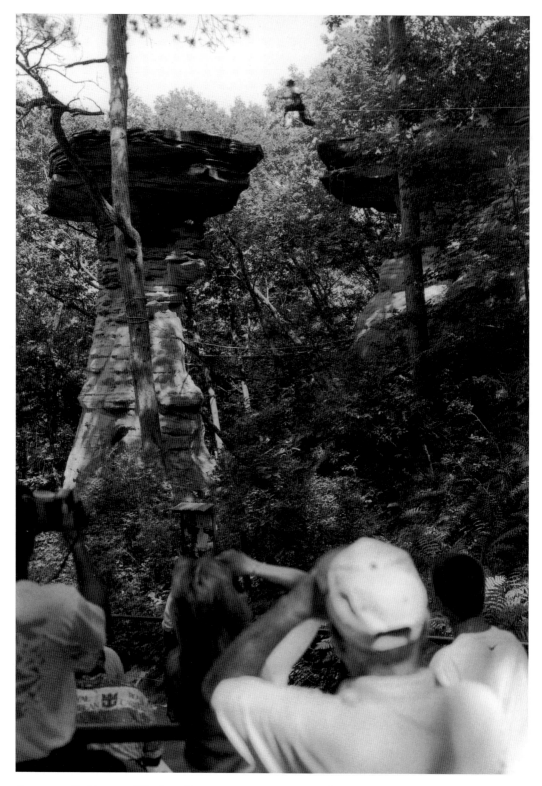

FIGURE 19. Earl Iversen. "The Leap." Reenacting H. H. Bennett's famous stop-action photograph is a featured attraction in the Wisconsin Dells today, captured here in a rephotograph of that scene. July 1997. Photograph courtesy of the Wisconsin Historical Society, Image ID: 49573. Copyright held by Earl Iversen.

they were later joined, at different times, by various members of the extended family—was part of a larger migration pattern that emptied hundreds of New England towns as Euro-Americans moved westward to this newly opened contact zone. As Bennett recalled many years later, the financial panic of 1857 sent his family to Wisconsin, "hoping to 'spy out a land' where there was better hope for prosperity than our eastern home gave."[53] What they stumbled upon was a town, Kilbourn City, which had been founded only the year before amid scandal and deception by a Milwaukee railroad baron and land speculator named Byron Kilbourn. Like many early residents, the Bennetts worked in carpentry and picked up occasional jobs on the railroad, as they struggled to make ends meet.[54]

Over the next half century, the Bennett family maintained an ambivalent relationship with its adopted town. Some, like Henry's brother George, disparaged Kilbourn City as "that little one-horse Godforsaken town [that failed] to give us a decent living" (figure 20). Having returned to Vermont a decade after the family move, he questioned the suitability of the Wisconsin frontier

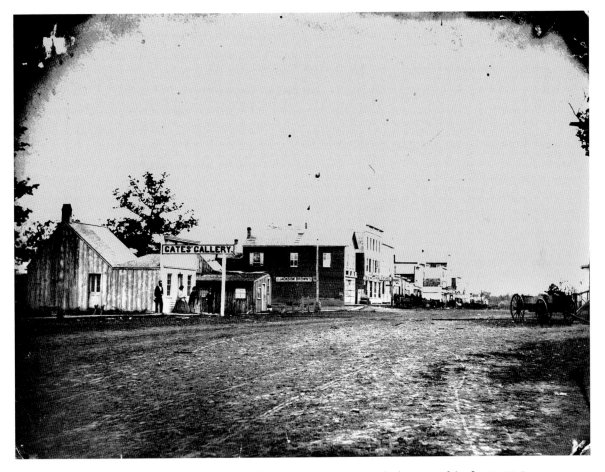

FIGURE 20. Unknown photographer. "Gates' Gallery." Gates' Gallery was the location of the first H. H. Bennett studio. Kilbourn City, 1865. Photograph courtesy of the Wisconsin Historical Society, Image ID: 40713.

town to support its new residents: "You say that business is very dull there, Father. Hasn't it always been just so, since we first went there? I think that the best thing that the family of Bennetts can do is to get-back to their old starting place, Vermont."[55] Other siblings remained in Kilbourn City somewhat longer but eventually relocated as well: brother Edward to New Mexico, brother Charlie to Wyoming, brother John to California, brother Arthur to Minneapolis, and sister Isabel to California. Apart from three years as a soldier during the Civil War, Henry cut a different path, one rooted in place. Occasionally tempted to join his brothers in the West, especially by Charlie's suggestion that he set up shop in the recently created Yellowstone National Park, Henry Bennett maintained that he was too committed to his work in Wisconsin to risk such a move.[56]

That work centered on the new profession of photography. In 1865, upon returning to Wisconsin after the Civil War, Bennett purchased a local photographic business that had belonged to an early tourism promoter named Leroy Gates. Such a venture, although risky, was not unusual as small towns across the country—even in remote "frontier" locations—invariably supported a photographic studio. Moreover, the Bennetts knew something about this new technology and its business. Henry's uncle, George Houghton, had opened the first photographic studio in Kilbourn City the year after their arrival in Wisconsin. Although he gave up the business the following year and returned with his photographic equipment to Vermont, he maintained regular correspondence with Henry, offering encouragement and advice. Finally, it was work that Bennett could do. The young Civil War soldier was fortunate to have survived several battles, including the bloody siege of Vicksburg, but toward the end of the war Bennett suffered a severe injury after accidentally shooting himself in the right hand. Fortunately, his hand was not amputated; nevertheless, even after the injury had healed, Bennett regained use of only his thumb and third finger, thus making his previous work of carpentry unfeasible (figure 21).[57]

Diary entries and letters to relatives from these earliest years indicate that the young veteran found photography neither remunerative nor rewarding. Working predominantly in portrait photography, he frequently wrote of the "victims" who posed for his camera. "I had a lady victim this afternoon," he noted in early 1866. "Brought a little baby to have its picture made; but the camera, chemicals, and sun refused to make a sharp picture when the little one wouldn't keep still. The blame, of course, fell on the unlucky artist." A week later, frustrated by his poor business prospects, Bennett reflected on the day's earnings: "received: $0000000000000000, paid: $000000000000000." As for his adopted town of Kilbourn City, Bennett saw the place as a *little, insignificant, dull, out of the way*, place," one that he doubted could support "business enough to give more than one person a decent living."[58] A depressed Bennett staved off economic destitution only by supplementing his meager income with construction work on the railroad, woodcutting, and lathing work and with his war pension.

The young photographer saw his fortunes change with the shift from portrait photography toward "viewing" the nearby Wisconsin River (figure 22). The Dells of the river had attracted the Bennett family since they first moved to Wisconsin; if the "city" neighboring its banks failed to impress, the deep gorge of the river incited awe. "We have just got back from a ride up the river through the Dells," Bennett's uncle George wrote to his Vermont family during that first

FIGURE 21. Unknown photographer. "H. H. Bennett." Full-length studio portrait of Bennett in Civil War uniform. Modern print from original 3 × 4 inch negative, ca. 1867. Photograph courtesy of the Wisconsin Historical Society, Image ID: 8112.

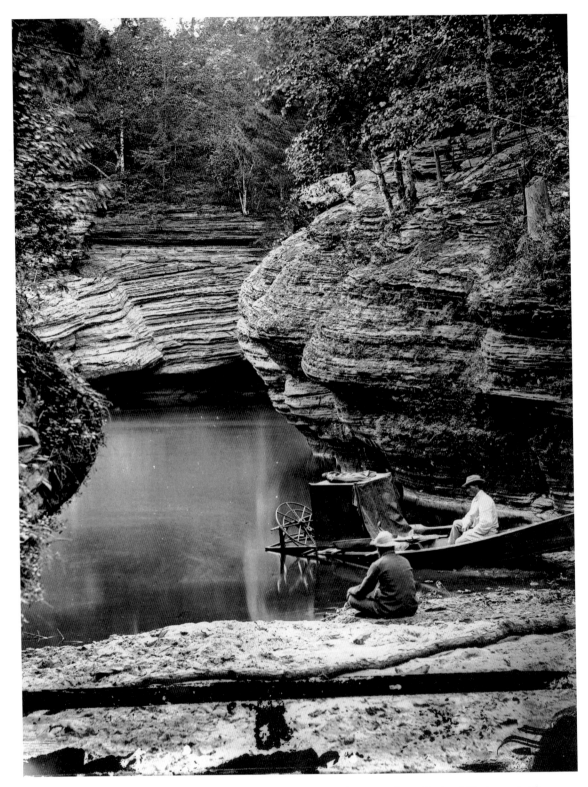

FIGURE 22. Unknown photographer. "H. H. Bennett's Boat and Dark Tent at Gates Ravine." Modern print from original stereographic negative half, ca. 1860s. Photograph courtesy of the Wisconsin Historical Society, Image ID: 8073.

Wisconsin summer, "and it is quite a prospect to ride on the smooth surface of the river and look up and see the high cliffs and overhanging rocks and in some places caverns worn out by the water. Oh how I wish you were here with me now to see for your selves and enjoy the beautiful and mild scenery of the Wisconsin River."[59] At other times, "mild scenery" turned wild. Taking a break from his unprofitable photographic business during the spring of 1866, Henry Bennett rafted through the Dells, where he found "the water the highest it's been for a great many years. It's terrible, awful, sublime, majestic, and grand."[60] A quick learner, Bennett did not take long to make the connection between photography, the nearby riverscape of the Dells, and tourism. Within a few years, he began guiding visitors through the Dells (as had the photographer from whom he purchased his studio), and with his hand-built stereographic camera and portable dark tent, Bennett began picturing the views of the river (figure 23).

<p style="text-align:center">☙ ❧</p>

It was not only the unique geological features along the Wisconsin River that caught Bennett's attention; the local inhabitants seemed equally interesting. One month after his 1866 rafting trip through the Dells, he traveled further upstream to Stand Rock, the dramatic rocky crag that would become the subject of some of his best-known landscape views. There, Bennett describes a local guide who "ferried us over the river and after much wading through the swamps we arrived where we started for: an Indian camp. [We] gained admittance to the 'Big wigwam,' heard some splendid speeches, any quantity of grunting and a little dancing. Got home at four o'clock. Done some singing on the way."[61]

Bennett did not bring a camera on this fun-filled excursion, and one wonders what the Ho-Chunk people who welcomed the white photographer into their homes made of him. Would they have imagined that this young Civil War veteran, who seemed so ignorant about their culture, would eventually become an influential partner in their social and economic futures? Could he possibly have known that they would be instrumental in salvaging his flagging photographic venture? H. H. Bennett may not have brought a camera along during this early transcultural encounter, but that was to change.

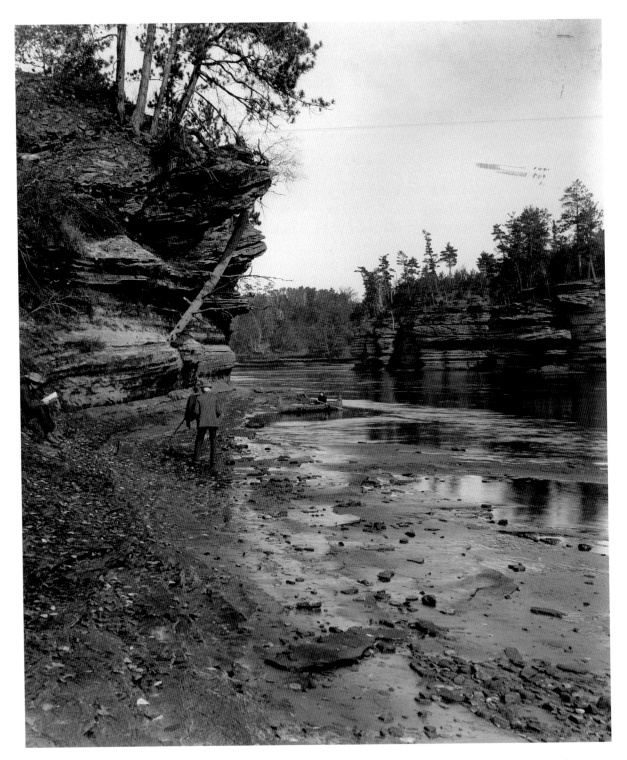

FIGURE 23. Unknown photographer. "H. H. Bennett and Camera Near Steamboat Rock." This photograph, taken near the end of his life, shows Bennett at work, with view camera mounted on tripod, picturing the dramatic Dells riverscape as it is enjoyed by an outdoor enthusiast. Modern print from original stereographic negative half, ca. 1890s. Photograph courtesy of the Wisconsin Historical Society, Image ID: 8260.

2

"Viewing" Indians and Landscape in Nineteenth-Century Wisconsin

I T WAS NOT LONG AFTER the French theatrical designer and inventor Louis-Jacques-Mandé Daguerre publicized to the world "one of the most wonderful discoveries" that his new photographic invention was directed at Native Americans.[1] As early as 1843, four years after Daguerre's invention, the Hawaiian chief Timoteo Ha'alilio sat for a daguerreotype portrait in Paris, while that same year saw an unknown number of Cherokee leaders, recently displaced to present-day Oklahoma, pose for "the Daguerotype [sic] apparatus."[2] Beginning in the 1850s and while negotiating treaties in Washington, D.C., dozens of Indian leaders from many tribes sat for formal delegation portraits (figure 24). And after the Civil War, scores of photographers on government-sponsored surveys of the American West produced countless pictures of Native Americans as part of the national effort to document this increasingly important, and contentious, contact zone. Photography was not the first medium to portray the indigenous peoples of North America, of course; woodcuts, engravings, drawings, lithographs, and paintings had long pictured the continent's Native inhabitants (figure 25). But the camera, surpassing all previous picture-making technologies, produced images laden with exciting new possibilities.[3]

Those possibilities—the promise of verisimilitude, of an apparently "objective" portrayal through mechanical means coupled with the unlimited number of copies that could be produced—overlapped, in the late nineteenth century, with a tremendous surge of interest in American Indian life and culture. Indeed, photography, along with other media like Wild West shows, international expositions, dime novels, and eventually motion pictures, helped generate ever-increasing curiosity among non-Native Americans about the original inhabitants of the country. White Americans were curious for a variety of reasons: because these images offered picturesque views of exotic peoples; because they seemed to supply unbiased information about these peoples; because they embodied sentimental notions about the "vanishing American"; and because they ostensibly recalled a lost innocence in America. What many non-Indian viewers saw in photographs—that remarkable new visual medium of the nineteenth century—seemed to confirm long-held understandings of their indigenous neighbors.[4]

41

Those centuries-old ideas inevitably centered on the supposed primitivism of indigenous peoples, especially when compared to modern, European "civilization." Visual images rarely remain static, however, and American Indian photographs proved no exception. An essential historic change in representations of Indians engendered by photography, from "savage" enemy to Native or "first" American, occurred during the mid- to late-nineteenth century and in response to a series of apparent national crises: mass immigration, unparalleled urbanization and industrialization, and attendant questions of American nationhood. Native peoples, no longer a physical threat and now confined to reservations and scattered across the western landscape, could be safely romanticized during the Gilded Age. "A fabric of fantasy, nostalgia, and idealization appeared toward the end of the nineteenth century as a kind of shroud for the 'vanishing

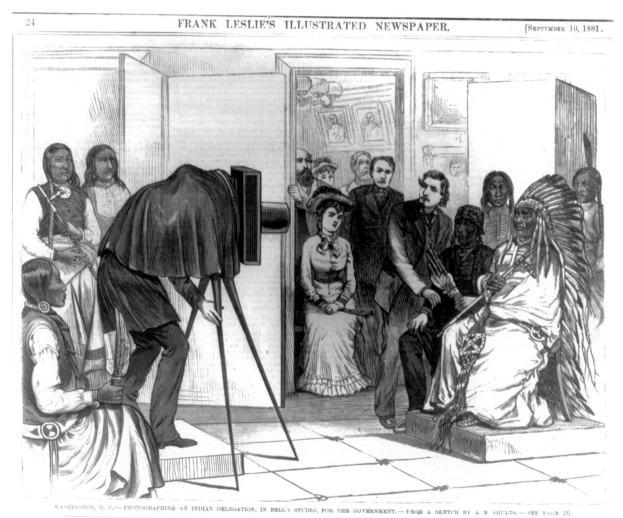

FRANK LESLIE'S ILLUSTRATED NEWSPAPER.

WASHINGTON, D. C.—PHOTOGRAPHING AN INDIAN DELEGATION, IN BELL'S STUDIO, FOR THE GOVERNMENT.—FROM A SKETCH BY A. B. SHULTS.—SEE PAGE 26.

FIGURE 24. *Photographing an Indian Delegation, in Bell's Studio, for the Government.—From a Sketch by A. B. Shults.* Published in *Frank Leslie's Illustrated Newspaper*, 10 September 1881. Library of Congress, Washington, DC (230270).

RED - BIRD,

A WINNEBAGO

Lith⁴ Col⁴ & Published by J.T. Bowen, Philad⁴

FIGURE 25. Thomas McKenney and James Hall. *Red-Bird (Zitkaduta), a Winnebago.* Red Bird, a Ho-Chunk military leader, following his surrender after an attack on Prairie du Chien in 1827. Reprinted from McKenney and Hall's three-volume *History of the Indian Tribes of North America* (1836–41). Wisconsin Historical Society Rare Books Collection, Image ID: 3911.

American,'" Alan Trachtenberg writes. Cameras had replaced guns as the technology of domination among most non-Native Americans and, in the satirical view of one *New York World* cartoonist, the best means "to settle the Indian troubles" (figure 26).[5] As a photographer/businessman, H. H. Bennett took advantage of this curiosity and nostalgia as he used his Indian photographs both to expand his own, personal business and to promote the region more generally.

VIEW PHOTOGRAPHY AND THE NATURAL LANDSCAPE

Bennett's career as a commercial view photographer—stretching from the end of the Civil War through the first decade of the twentieth century—coincided not only with this growing fascination with Native peoples, but also with what has been called the "golden age of landscape photography."[6] Picturing natural landscapes and the people who had long inhabited them was a common practice among nineteenth-century view photographers, a connection that I develop

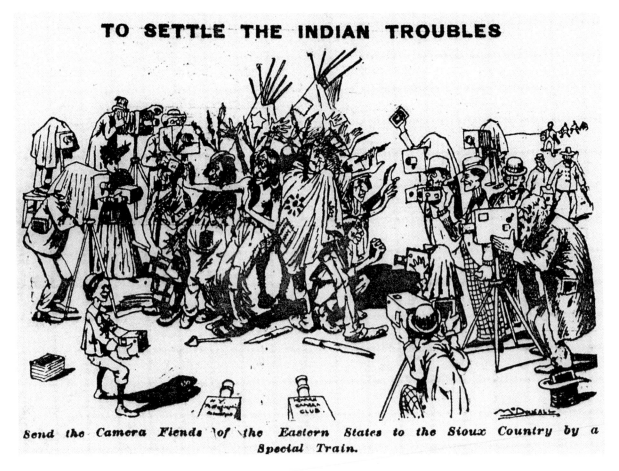

FIGURE 26. Unknown cartoonist. *To Settle the Indian Troubles.* Published in *New York World,* 30 November 1890. Reprinted from microfilm copy, Perry-Castañeda Library, the University of Texas at Austin.

shortly. First, however, it should be remembered that photography itself emerged as a technology of picture making during an international Romantic movement, in which spiritual meaning was often attached to nature. So entwined were spirituality and the natural world that, as Barbara Novak has observed, in the early to mid-nineteenth century "the terms 'God' and 'nature' were often the same thing, and could be used interchangeably."[7]

The young country's majestic natural landscapes—Niagara Falls and Mammoth Cave in the East, and later Yellowstone and the Grand Canyon in the West—became important sites of pilgrimage for thousands of white Americans seeking glimpses of the divine in nature. Travel to such "sacred places" began first with America's cultural and economic elite but eventually became the province of an emerging middle class. While literary luminaries such as Nathaniel Hawthorne might have described the sublime wonders of Niagara Falls in deeply religious terms, more humble tourists to the Wisconsin Dells recorded their impressions as well. Emma Shaw, a school teacher from Rhode Island, expressed how, during a walk through a Dells canyon, "the walls contract, till, with each step, comes the feeling, 'We surely can go no farther.' Pausing involuntarily, we look up and stand awe-stricken and spell-bound in Nature's own art gallery." Shaw was not alone in such sentiment. Another tourist from nearby Columbus, Wisconsin, described how "the hands of Deity touched that region with the fantastic and the picturesque. The angel of the quaint presided over its formation. The scale is perhaps not of the grandest, but the Great Architect has adorned it with a gem-like delicacy of beauty."[8]

First painting, then photography, became the principal visual art for revealing nature as God's handiwork. Although painters held at least three advantages over photographers in their depictions of "Nature's own art gallery"—they could paint in dramatic color, they could add or subtract imagery in the view before them, and their enormous canvasses dwarfed the small photographic prints—photographers quickly discovered their own medium's principal strength: the photograph's apparent transparency. As one of photography's earliest proponents, Edward L. Wilson, put it, landscape photography had the capacity to "elevate the heart and soul, and make one bless and praise the Great Creator." An experienced landscape photographer—called a "view-hunter" by Wilson—strives to find those divine but difficult-to-reach places, taking special care "not to falsify and distort the work of the Creator."[9]

From this now-classic perspective, the signal virtue of the landscape photograph lay in its seeming ability to provide a literal view of reality, a transparent window into Nature itself. By replacing the artist's hand with the so-called pencil of nature, the photograph seemed objective, true, and undistorted by artistic convention. Of course, a great deal of active reconnaissance and selective framing went into creating a photograph, making it no less an act of artifice than a painting. Nonetheless, the notion that a photographic image repeats its original, that it is less a copy than a simulacrum, made photography an especially influential visual medium at a time when the landscapes of the trans–Mississippi West increasingly symbolized American national identity.[10]

Such landscapes, whether part of an official government survey or from the camera of a commercial photographer such as H. H. Bennett, were part of a distinct photographic practice that Peter Bacon Hales has called the view tradition.[11] Many of the still-dominant approaches to landscape photography (as we see, for example, in the Sierra Club work of Ansel Adams or Elliot

Porter) were invented and refined during the three decades following the Civil War. More than merely a pretty picture of outdoor scenery, the photographic view became a powerful American tradition, rivaling portraiture in cultural importance. This distinct mode of visual culture—alternatively called the "view," the "landscape," and the "outdoor photograph"—was tightly bound to larger forces of American capitalism and imperialism as the country stretched into new territories, organized and measured the land, colonized space, and transformed the landscape.[12]

View photography was called upon to make sense of these dramatic new spaces, especially in the West. There, commercial photographers and those working for either a railroad company or the federal government created photographs that dazzled audiences with spectacular views of Yosemite, Yellowstone, and the region's grand rivers. Naturally, the purposes for which a photograph was made matter a great deal; images produced for a government or scientific survey were called upon to do different "work" than those produced by a commercial photographer interested in selling photographs as works of art. Nevertheless, even governmental survey photographers asked to document the scientific details of a newly acquired western territory created images that followed distinct aesthetic conventions. And in the twentieth century, the view photography of Timothy O'Sullivan, William Henry Jackson, and Carleton Watkins, among others, "has become one of the great traditions of photography," as Ansel Adams once put it.[13] Working out of the considerably less grand midwestern landscape of the Wisconsin Dells, H. H. Bennett proved to be a most competent peer of the western landscapists.

H. H. Bennett's Photographic Construction of the Dells

If survey photographers such as O'Sullivan documented useful geographic information about little-known regions of the American West, and if early photographers such as Jackson pictured the wonders of Yellowstone to assist in the national park's creation, Bennett's work performed a rather different function. His landscape photographs, to be sure, supplied geographic information about the Dells. But this was a region already surveyed, mapped, and "cleansed" of many of its Native American tribes. By 1900, southern Wisconsin had already witnessed a half-century of intensive change, in which a vast urban-focused network of railroads, markets, and capital transformed the countryside. Bennett's task was to turn an ordinary midwestern space into a distinctive place of excitement and beauty and one worthy of a tourist stop.[14]

"These Dells are a great curiosity, as marvelous in their way as anything that can be found in the United States," proclaimed the anonymous author of the 1880 *History of Columbia County, Wisconsin*. But there was a problem: "Until within a few years, they were not . . . thought of as worthy of attention." Fortunately, there was a solution:

> Some years since then, a photographer living at Kilbourn City, began looking about him, finding something wonderful and beautiful everyday, until at last he was inspired to take his camera and produce pictures. Men would not believe what he said, but when they saw the pictures, which were a reflection of nature, then they began to be convinced, and to express themselves as willing to believe that there was something about the Dells more than usually attractive. Meanwhile, he kept on with

his work, rowing up the Wisconsin into the nooks and crannies, setting his three-legged contrivance up, and obtaining views, which people began to want. As these pictures went into circulation about the country, attracting through the eye, the minds of men and women, people began to turn their steps toward the Dells to look at the beautiful scenery.[15]

This anonymous historian recognized—in real time—something very important. Thousands of years of geological work may have created the place where the rocks meet on the Wisconsin River, but in a very real sense, Bennett, too, constructed the Dells. Photography alone cannot mold nature. But it can direct our attention to things formerly overlooked—invisible and therefore nonexistent—as it simultaneously organizes insignificant entities into significant composite wholes. Bennett's visual project focused on narrating a significant composite whole out of the disparate geological formations of the Dells and translating them into a coherent image of genteel retreat. A working river with a long history of lumber rafting, saw milling, and Native American life—and of anarchy, violence, and Indian removal—was transformed into a picturesque riverscape largely through the photographs of H. H. Bennett.[16]

Although Bennett never became wealthy, the project of view photography provided him a modest livelihood, a path similar to many of his contemporaries in landscape work.[17] His busiest and most productive years occurred during the Dells' rise to regional and national prominence, and his photographic views contributed substantially to making the river a site of scenic tourism. No longer a "dull, out of the way place," as the region seemed to Bennett in 1866, the Dells were increasingly recognized, by 1880, as "the most interesting point in the state of Wisconsin. Here the tourist halts to visit the Dells of the Wisconsin River," noted one especially enthusiastic guidebook writer, and discovers "a treasure-house of the wildest scenery." These were landscapes—visually constructed tourist fantasies—allegedly at least as remarkable as "the famed beauties of the Canons [sic] of the Yellowstone or the picturesque Watkins Glen in New York."[18]

During the 1870s, the number of photographs that his studio could offer of such scenic views expanded tenfold, from 200 in 1872 to more than 2,500 by the end of the decade. Moreover, with increased technical capacity for photomechanical reproduction in the 1880s, his family could produce 40,000 prints per month. By this time, Bennett's business had expanded well beyond stop-by visitors to his studio as he was filling orders from places as far away as New York, Boston, and St. Louis.[19]

Not coincidentally, these decades also witnessed the formation of a significant local tourist economy. Not only did the number of hotel rooms triple between 1886 and 1903, but numerous "improvements" were made throughout the Dells including trout ponds, billiard tables, and croquet grounds in Cold Water Canyon; regularly scheduled steamer excursions; orchestra music aboard the boats for moonlight excursions; and a walk of logs and boards up Witches' Gulch.[20] As different entrepreneurs entered the scene, new amenities were added, so that by the turn of the twentieth century, boosters could brag about a new four-hundred-acre city park; stone walks and terraces around precipices; wire suspension bridges over chasms; rustic seats throughout the canyons; vistas opened through forest groves; an eating house and dance pavilion; a large, landscaped park by the train station; a new pavilion at the boat landing with "large and

commodious waiting rooms;" and an intercounty carnival (figure 27). Perhaps the most outrageous "improvement upon nature" was the addition of sea lions held captive in underwater cages for the bemusement of sightseers.[21] Anchored to the great inland metropolis of Chicago by a half-day train ride, the Dells of the Wisconsin River had become its recreational hinterland by the 1880s (figure 28).[22]

Like other view photographers, Bennett maintained long-term employment with the railroad, for which he produced stereo views and mammoth prints for train stations. In 1876, for instance, the Chicago, Milwaukee, and St. Paul Railroad distributed six thousand of Bennett's stereographs to libraries in the South to bolster tourism, and in 1890 the Wisconsin Central commissioned Bennett to photograph Wisconsin resorts along its lines.[23] Mostly, however, he operated independently out of his small, tourist-oriented studio, where he sold a variety of photo

FIGURE 27. H. H. Bennett. "Tourists at Dells Landing." Modern print from original 8 × 10 inch negative, ca. 1900. Photograph courtesy of Wisconsin Historical Society, Image ID: 7918.

souvenirs, including stereo views, guidebooks, and card photos. The Bennett Studio, located conveniently near the railroad depot and boat docks, became an unofficial chamber of commerce where tourists could obtain information about lodging and places to see and hear Bennett's lantern slide talks on the Dells scenery and Ho-Chunk history.[24]

H. H. Bennett's importance extends beyond his role as an early tourist promoter of the Wisconsin Dells, however. In an age well before modern advertising and glossy magazines, before television and the Internet, his photographs actively shaped the expectations and experiences of visitors to the region. Bennett's photographic views—in both stereographic and framed print formats—taught tourists what to observe during a visit to the Dells and how to see the river as a consumable and pleasurable place; in a very real sense, these photographs created the Dells. This new imaginative geography—as novel to the Victorian experience as the exploding metropolis

FIGURE 28. *Kilbourn and the Dells of the Wisconsin.* Promotional brochure issued by the Chicago, Milwaukee, and St. Paul Railway, 1906; cover photograph by H. H. Bennett. Courtesy of the Wisconsin Historical Society, Image ID: 24990.

itself—relied on the rich combination of pseudo-wild scenery and a cultured life in semi-formal dress. Tourist fantasies came to life in Bennett's technically refined photographic views.

In his skilled hands, the Wisconsin Dells contact zone became a playful frontier, "a fairy-story landscape, rugged and wild in half-scale, with enchanted miniature mountains and cool dark caves." Losing their occasional threatening demeanor and stripped of any hint of social or environmental tension, Bennett's Dells assumed an air of tranquility and calm (figure 29). The sculpted sandstone formations along the river became subjects for an outdoor portraiture, which, when purchased as a series, mimicked a boating trip up the Wisconsin River. The sublimity with which Bennett was first struck upon his earliest encounter with the Dells melted into a picturesque and semi-wild riverscape seemingly designed for recreation: "a sweet and not too dangerous place during the good months," John Szarkowski notes, "adventurous in aspect, but mapped and settled and free of wild Indians."[25]

FROM CONTACT ZONE TO PLAYFUL FRONTIER: INDIANS AS LANDSCAPE ELEMENTS

But, of course, the Dells were not free of Native Americans, a point obvious to Bennett and anyone else who lived in the region. As early as 1873—less than seven years after his first encounter with the Indian camp near Stand Rock and the opening of his photographic studio—Bennett began photographically "viewing" his Ho-Chunk neighbors. The connection between picturing the sandstone rock formations along the river and its earliest inhabitants probably seemed natural for Bennett who, like most western photographers of his day, undoubtedly "viewed Indians as an exotic and even frightening, but ultimately doomed, segment of the western landscape."[26] Virtually without exception, photographers well known for their landscape views of the American West—William Henry Jackson, Timothy O'Sullivan, John Hillers, Andrew Joseph Russell, Carleton Watkins, Eadweard Muybridge—also and repeatedly photographed American Indians.

Lucy Lippard notes how Indians, around the beginning of the twentieth century, "were the photogenic counterparts of today's 'lookouts'—roadside scenic vistas, ready-made 'views.'" In transforming the Central Wisconsin contact zone into a playful frontier of genteel recreation, Bennett did not ignore Ho-Chunk people. Rather, he pictured them as uncomfortable elements of the Dells landscape, quite distinguishable from how he "viewed" non-Indian people.[27] This distinction deserves elaboration.

A central feature of Bennett's view photographs, on the one hand, is his frequent inclusion of human figures in the landscape. Such figures—invariably well-dressed Victorian men, women, and children—did more than add a picturesque element to the photograph. Art historians have typically understood such figures as *surrogate viewers* who signal a range of messages, from inspiration of God's wonders to the human mastery over the natural world to a celebration of the "ideology of expansionist thought."[28] Such readings might be applied to Bennett's views, but there is something additional at work. The presence of well-heeled figures perched on overhanging rocks high above the river, picnicking on a sandbar, contemplating the grandeur of nature from a point of solitude, or floating lazily downstream conveyed the message that this leisure landscape could be experienced safely—and therefore inspirationally (figure 30).

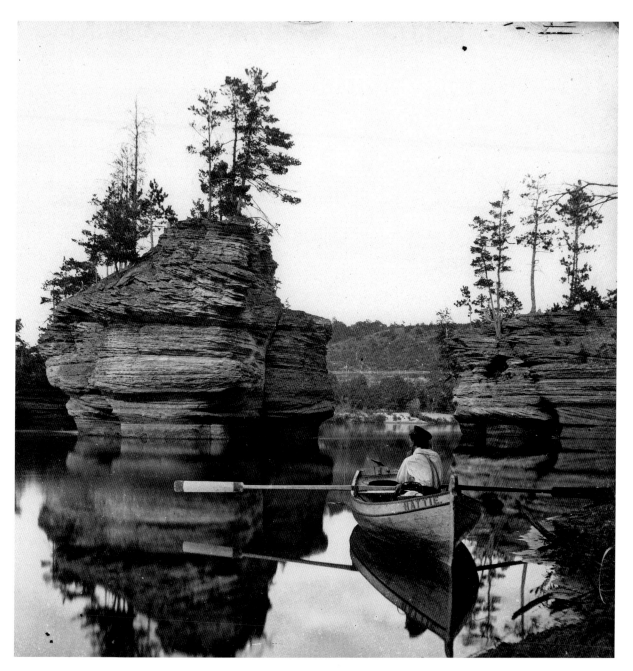

Figure 29. H. H. Bennett. "Sugar Bowl." Modern print from original stereographic glass negative half, ca. 1870s/1880s. Photograph courtesy of Wisconsin Historical Society, Image ID: 7365.

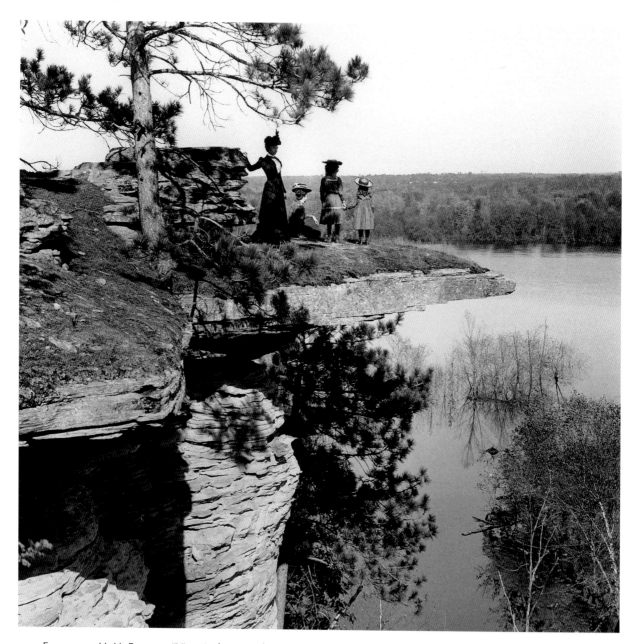

FIGURE 30. H. H. Bennett. "Visor Ledge." Modern print from original stereographic glass negative half, ca. 1900. Photograph courtesy of Wisconsin Historical Society, Image ID: 7282.

Considerable ideological freight is carried by those vacationing Victorians: people don't work in Bennett's Dells. The nearby farmers, storekeepers, and merchants are nowhere to be seen on the playful frontier. Tourists—people whose only function in the landscape is to fantasize, to look and admire its beauty—claim the place as their own.

On the other hand, and as we shall see in the chapters that follow, Native people appear in Bennett's photographs less as surrogate viewers than as *elements of the landscape itself.* When pictured outdoors, Ho-Chunk are foregrounded, frequently named, and given a prominence that, in other photographs, typically centers on geological features (figure 31). White viewing audiences were encouraged not to imagine themselves in such scenes, as in Bennett's typical landscape photographs, but to gaze at them. "Natural scenery" in nineteenth-century view photographs meant rocks and water—and Native people as well.

ᨆᨆ ᨆᨆ

H. H. Bennett's photographic views depicted two very different realities: a playful frontier illustrating the pleasures of vacationing Victorians amid a fairy story landscape; and Ho-Chunk people pictured at the moment before their assumed cultural demise. For all their differences— and certainly their visual appearance is foremost—Bennett's landscape photographs and his Ho-Chunk pictures shared a common thread. Both encapsulated a tourist sense of fantasy by presenting their subjects as odd curiosities, as exotic marvels of something somehow Other than everyday life. In one, white viewing audiences could imagine the role they might play in the photograph—as the tourist—while, with the other, they could only watch the "natural" decline of indigenous peoples.

For his part, Bennett was well aware of such distinctions. In response to a letter and a collection of photographs from George Brown of Baltimore, Maryland, the Dells photographer noted appreciation for receiving "your views of Gypsy life and those of animals very much. The former are entirely new to me. We have plenty of Indians in this region, though."[29] Gypsies, Indians, animals, and rocks may seem rather different, but when viewed together from stereographs across the country they added up to something that was quite distinctive: a flight from the everyday world of work, mass immigration, and tense labor relations into the realm of imaginary images and fantasy. Between the viewing public and the photographers behind the camera lens were often people, standing and sitting, waiting for the shutter to open and close: the Ho-Chunk people of central Wisconsin.

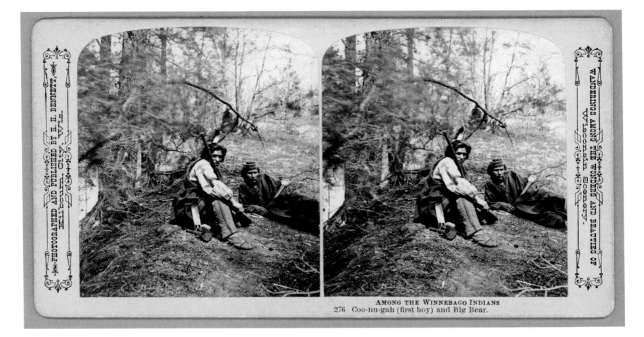

AMONG THE WINNEBAGO INDIANS
276 Coo-nu-gah (first boy) and Big Bear.

FIGURE 31. H. H. Bennett. "Coo-nu-gah (First Boy) and Big Bear." Albumen silver print, stereograph, ca. 1880. Photograph courtesy of the National Anthropological Archives, Smithsonian Institution (NAA inv. 09833100).

3

Ho-Chunk Removals, Returns, and Survivance

THE PEOPLE WHOM BENNETT DESCRIBED to inquisitive tourists and correspondents, and who became his photographic subjects over the years, were members of a transitional generation: many had known life both before and after the full weight of comprehensive government programs to eradicate Native life. Those policies, vividly condemned in Helen Hunt Jackson's 1881 *A Century of Dishonor*, put Wisconsin's Ho-Chunk in ever worsening social and economic circumstances.[1] That they have survived, and prospered, in a state that treated them first as illegal fugitives and then as second-class citizens without the physical security of a reservation environment is a testament to Ho-Chunk survivance in the face of severe hardship and systematic oppression.

Before one can appreciate the power of Native survivance, however, it is first necessary to examine those hardships and oppression. There are two related reasons why this is so. First, describing some of the historical context of Ho-Chunk removals from Wisconsin, and their incessant returns, provides a window into the experiences of those men and women pictured by H. H. Bennett. Many of the people facing his camera had been violently uprooted from their ancestral lands and transported to a distant location, from which they eventually returned. And for those who had escaped the government's armed troops, all were aware of these experiences through hearing firsthand accounts. Knowing something about those experiences gets us closer—however incompletely—to their lives.

The second reason is closely related to the first. Survivance might highlight agency and the creative response to novel situations, but one must not forget that those situations involved violent struggle and organized subjugation. Indigenous scholar Sonya Atalay puts it this way: "the concept of survivance is not about avoiding or minimizing the horrors and tragedy of colonization. It includes agency and Native presence but does not refuse stories of struggle, particularly those that create a context for understanding and appreciating the creative methods of resistance and survival in the face of such unimaginable turmoil."[2] This chapter seeks to provide some of that necessary context.

Changing Balances of Power in Nineteenth-Century Wisconsin

The story of Ho-Chunk struggle and survivance both mirrors the experience of other Native groups in the region and displays singularity born of unique circumstances. Early European contact introduced devastating epidemics as well as a decisive shifting balance of power with attendant warfare to the area's most powerful nation. Interaction with whites during the fur-trade period brought a measure of "revitalization and renewed optimism," a "middle ground," if not stability, to the Ho-Chunk, according to Richard White.[3] However, once one side—the American—was able to achieve its ends through force, the precarious balance of power shifted rapidly and conclusively.

Increasing American influence in the region brought even greater changes in Ho-Chunk life, none more significant than those created by the new power's insatiable appetite for land. "Between 1800 and 1850," writes Robert Bieder, "through subterfuge, retaliation, and sale, Americans in Wisconsin wrested land from Indians until they [the Ho-Chunk Nation] occupied with uncertainty lands they once owned."[4] The lead-mining rush to the southwestern part of the territory during the 1820s marked the beginning of the end for Ho-Chunk control over their land. They were forced to cede Lead District land in 1829 and land further east in 1832; the final and largest cession came five years later in a treaty considered by the entire Ho-Chunk Nation to be fraudulent (map 2).

The 1837 treaty was signed by a delegation that went to Washington specifically to stress their need to *keep* this land: so cautious were the Ho-Chunk leaders that they explicitly declined to send members of the Bear Clan—the leaders who would have had the requisite authority to sell land. It soon became apparent that Washington officials never intended to allow the delegation to return home without signing. With winter approaching and vivid memories of a smallpox epidemic that had killed hundreds two years earlier, the delegation finally signed. They did so under duress and with the expectation that, since the Ho-Chunk delegation did not have the authority to sell land, the U.S. government could not expect the tribe to abide by the treaty.

The expectations of Ho-Chunk leaders—namely, to be allowed to remain on the land and use it as their ancestors had for generations—were never part of the American plan, however. One British traveler to the Wisconsin territory, a former navy captain and popular writer and diarist, Captain Frederick Marryat, described what he saw in 1837:

> [T]he American Government, as it only paid the [Ho-Chunk] Indians at the rate of one cent and a fraction per acre, will make an enormous profit by the speculation. Well may the Indians be said, like Esau, to part with their birthright for a mess of pottage; but, in truth, they are *compelled* to sell—the purchase-money being a mere subterfuge, by which it may *appear* as if their lands were not wrested from them, although, in fact, it is.[5]

By invoking the biblical story (Genesis 25:29–34) of Esau being tricked by Jacob into giving up his birthright (leadership of Israel) for a "mess of pottage" (a meal of lentils), Marryat was writing in an idiom that would have been familiar to early nineteenth-century readers. They would

have recognized that "Esau" metaphorically stood for someone who is tricked into a worthless bargain. Even then, the Ho-Chunk delegation apparently believed the federal government's verbal assurances that the treaty, however fraudulent, guaranteed eight more years' residency in Wisconsin; in fact, it stipulated eight months.[6]

Thus began a new and especially distressing chapter in Ho-Chunk history, when thousands of people were forcibly removed, in varying stages, first to territories in Iowa and in Minnesota, and then to the Dakota Territory. Eventually, federal authorities—buttressed by the ever-increasing military power of nearby Fort Crawford, Fort Winnebago, and Fort Howard in Wisconsin and

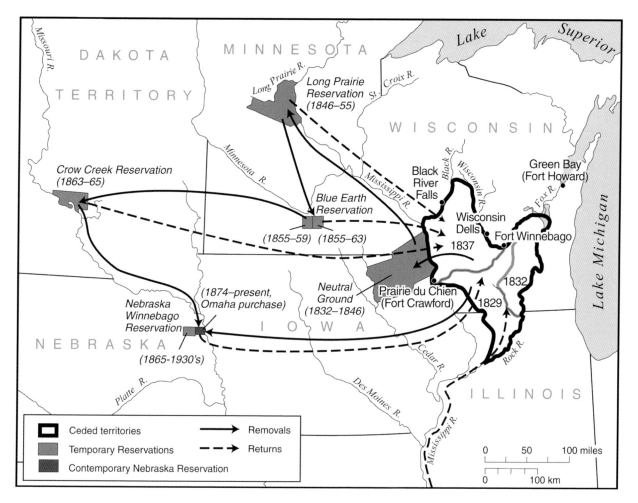

MAP 2. Nineteenth-century Ho-Chunk removals from and returns to Wisconsin. Sources: Zoltan Grossman, "The Ho-Chunk and Dakota Nations," in *Wisconsin's Past and Present: A Historical Atlas*, ed. Wisconsin Cartographers Guild, 8–9 (Madison: University of Wisconsin Press, 1998); Nancy Oestreich Lurie, "The Winnebago Indians: A Study in Cultural Change," unpublished Ph.D. diss., Northwestern University, 1952; and Nancy Oestreich Lurie, "Winnebago," in *Handbook of North American Indians*, ed. Bruce Trigger, 690–707 (Washington, DC: Smithsonian Institution Press, 1978).

Fort Snelling in Minnesota—relocated Ho-Chunk to a new reservation in northeast Nebraska (map 2). Those who agreed to removal, however reluctantly and bitterly, became known as the "Treaty-Abiding Faction" and quickly broke with those who refused to move west, the "Disaffected Bands."[7] These "renegades" or "rebel faction" led a fugitive existence, "illegally" residing in their own ancestral lands. Every so often—in 1840, 1844, 1848, 1850, 1863, 1871, and 1873–74—federal troops were called into the region to coerce recalcitrant Ho-Chunk into joining their relatives further west. And just as often, in the words of a tribal leader named Walking Cloud who was forcibly removed in 1850 to Minnesota and in 1873 to Nebraska, the Wisconsin Ho-Chunk "went there and did not like it, so returned home that same fall."[8]

Each removal further weakened the nation: the 1863 removal alone killed more than 550 of nearly 2,000 Ho-Chunk men, women, and children during the long winter march from southern Minnesota to the Dakota Territory.[9] Military action such as this could only be accomplished with force, and the young American government was up to the challenge. One white settler of Jefferson County recalled how his Ho-Chunk neighbors "hated to leave the land of their fathers. They refused to go." Such a response brought forth, in 1841, "a company of United States dragoons, about a hundred strong [that] gathered up all the Indians they could find. They appeared very formidable. Their mission was accomplished and a large number of Indians were removed, although stragglers continued to return." John T. De La Ronde, a trader in Portage, offered an even more vivid description of that year's removal. As an interpreter hired to assist the dragoons in the capture and removal of Wisconsin Ho-Chunk, La Ronde recounted how, in one destroyed camp, three elderly women "came up, throwing themselves on their knees, crying and beseeching Captain Sumner to kill them; that they were old, and would rather die, and be buried with their fathers, mothers, and children, than be taken away; and that they were ready to receive their death blows."[10] Reflecting in his later years about the removals that he helped orchestrate, the former Minnesota senator Henry Rice put it bluntly: "Wisconsin was always the region they desired and it is doubtful if the generation of that day would have ever been content elsewhere."[11]

Ho-Chunk Removal as Imperial Policy

Wresting Ho-Chunk from their Wisconsin homeland and removing them to the West became one episode in a complex series of federal policies designed to conquer the continent's First Nations. The first several decades of the nineteenth century were crucial ones for both Indians and whites in the United States, amounting to what Francis Paul Prucha called "a crisis" in Indian affairs. Several developments were of signal importance: the decisive shift in the balance of power between these two groups, the belief that Indians were not being absorbed into the dominant white society, and mounting pressure for land in the newly acquired territories. Together, they culminated in a growing consensus that all eastern Indian nations should be removed beyond the Mississippi River.[12] Such a radical proposal—of uprooting an entire people, removing them to a particular space in an entirely different part of the imperial territory, and resettling them under a program of major social transformation and assimilation—became

federal policy with passage of the 1830 Indian Removal Act. Reflecting on the immediate effects of such policy on his people, the Ho-Chunk leader Spoon Decorah recalled in an 1887 interview that "when the whites began to come among the mines [of southwestern Wisconsin], the Big Father said to his Winnebago children: 'I want this land and will have my own people to work it, and whenever you go out hunting come by this way, and you will be supplied with lead.'"[13]

The paternal metaphor described by Spoon Decorah—of the American president described as the "Big Father," with Ho-Chunk as "children"—was a favored image among white Americans as it humanized an abstract concept of political authority. The extent to which it accurately characterized Decorah's lived experience or, just as likely, was convenient shorthand deployed by the Ho-Chunk leader's English-language translator, is unknown. What is clear, from Spoon Decorah's perspective, is that if the language of paternalism was appealing, the relationship it described was an abusive one. As he further explained, the policy of Indian removal

> was a very great sorrow to our people. For many years there was much sorrowful talk among the Winnebagoes, at the manner in which the Big Father had treated them, with regard to the mines. No, we never saw any of our lead again, except what we paid dearly for; and we never will have any given to us, unless it be fired at us out of white men's guns, to kill us off.[14]

Implicit in Decorah's account is another concept that better described the actual relationship between the United States government and Indian peoples: the language of empire and imperialism. As D. W. Meinig makes clear, the "American conquest, subordination, and management of Indian peoples as a distinct people with the national polity" represents an unmistakable example of empire building.[15]

Envisioning Indian removal as an imperial policy might cut against the deeply rooted American tradition of seeing the West—including the early Wisconsin Territory—as a Turnerian frontier, as a space for continuous settlement of a democratic and divinely inspired people. But, as Decorah and countless other Native Americans well knew all too well from personal experience, the young United States was, at its very core, defined by imperial rule. Standing in the way of a rapidly expanding white population, which was pressing ever westward in search of new lands for diversified agriculture, were the Ho-Chunk Nation and the other Indian nations of the Upper Mississippi region—the Menominee, Ojibwe, Potawatomi, Sauk and Fox, Sioux, and Ottawa. A federal policy of removal was deemed necessary for the simple reason that American Indians—long thought to be a vanishing race—were not vanishing quickly enough.

At times, neighboring whites challenged such treatment, as, for instance, in Reedsburg, where citizens physically blocked federal soldiers from putting a Ho-Chunk family on a westbound train in 1873. Similarly, one year later, some white residents of Black River Falls reportedly organized themselves to resist the military in the event of another attempted removal.[16] Most, however, either quietly supported such policies as inevitable or vigorously championed removal. Andrew Jackson Turner, editor of the newspaper in nearby Portage, and father of the famous frontier historian Frederick Jackson Turner, clearly articulated the view held by many in the region:

When all this is considered, we think there is very little occasion for shedding any tears over the cruelty of removing them. They will be vastly better off than they now are, leading a strolling, vagabond life among the whites, getting a muskrat for Monday, a turtle for Tuesday, a few berries for Wednesday, begging for Thursday, strapping up their belt for their Friday's meal and going hungry Saturday with the possibilities of a catfish for Sunday. . . . It is manifestly for their interest that they be removed for a reservation.[17]

And sometimes, local support of forced relocation triggered government action; such was the case during the early years of the 1870s. Spurred on by deep-seated fears of Indian uprisings, by politically influential owners of cranberry marshes who were anxious about unauthorized harvesting by Ho-Chunk, and by pervasive racial prejudice, the removal effort received widespread support. The near toxic levels of racial prejudice at the time are well documented and not necessary to reproduce thoroughly here. One example from an "early pioneer" in Wisconsin, writing in 1876, will do:

The Indian by nature is cruel, treacherous, and revengeful. He is a creature of impulse, outside of his daily routine of life; reason is rarely called into action, unless the cunning of the fox can be termed reason; a coward by nature, rarely attacking his equal in strength or numbers, without some great advantage in position or circumstances. He can endure fatigue, hunger and exposure, because his manner of life leads to those results; but place him and the white man in the same circumstances, and the latter is his superior in every respect.

Such were the sentiments that Ho-Chunk had to confront in face of systematic removals. As the commissioner of Indian affairs noted in his 1874 report, "The wandering bands of Wisconsin Winnebagoes at the earnest solicitation of the citizens of the state [of Wisconsin] have been removed to Nebraska."[18]

Less than three months after Bennett photographed Wah-con-ja-z-gah (see figure 1), the town's local newspaper ran a lengthy article calling for Ho-Chunk removal. Next to a travel account reprinted from the *Pecatonica News* extolling the Dells as a place for "pleasure seekers" with "some taste for the romantic," editor Frank Wisner railed against those "in our state whose sympathies are stirred up for 'the poor Winnebago.'" The article, characteristic of its day, is revealing and worth quoting at length:

The Winnebagos are rich—richer today than almost any equal number of farmers in the west. They have a million and one thousand dollars in clear trust funds, drawing five per cent annuity. Their reservations and improvements are worth half a million more. Our . . . white men are glad to hunt homes on our Western border; to find their teams, buy their own lands, build their own houses and raise their own families as best they can. Our native Wisconsin Winnebago has a better thing. Our Government takes him from his barren huckleberry ridges, transports him with his ponies and pappooses [sic] to Nebraska; gives him land; feeds him; clothes him; builds him houses; finds him teams; plows his fields; puts up his fences; educates his children and puts him in the way of being

something. If dirt, poverty, ignorance, drunkenness, and strolling vagabondism is better than wealth, industry, sobriety, education, and refinement, then our good people have occasion to deplore the hard fate that seems to crowd the pathway of our Wisconsin Winnebago.

The editorial concludes by arguing that the government should cease

fooling around with the muskrat Indians, and [issue] orders for their removal without delay. The Winnebagoes still cling to their huckleberry fields, and intimate fight. The decision is made. Now will the Indians go quietly or will the First Regiment Wisconsin Militia be called out? The lava beds of Wisconsin may be in this vicinity. Who knows![19]

Wisconsin did not erupt in armed conflict that year, but the threat was certainly real. The "lava beds" to which Wisner refers are those of the region around Tule Lake, California—the site of the Modoc Indian War of 1872–73, a bloody confrontation that captured national attention when a small band of Modocs (numbering between 55 and 70) held off more than 1,000 U.S. Army troops for seven months. This confrontation was called "California's most spectacular Indian War," and the prospect of Native American resistance to white aggression would surely have been on the minds of those calling for Ho-Chunk removal at the time.[20]

Thus, despite the well-known Ho-Chunk "repugnancy at contemplated removal," federal troops scoured the state, rounded up about 1,000 Ho-Chunk without warning, and forced them to make the long winter journey to Nebraska on foot. Characteristically, of the 860 Ho-Chunk who arrived at the new reservation, only 204 remained the following year, as some 656 returned to Wisconsin despite the hardships of travel during their removal.[21]

❧ ❦

Wah-con-ja-z-gah died just before the final removal. His stubborn refusal to leave after the 1837 treaty, of which he was a reluctant signer, added to his important role of peace chief. As a way to evade further removal, in 1849 Wah-con-ja-z-gah persuaded a white trader to go with him to the land office in Mineral Point, Wisconsin, to purchase forty acres near the Dells. The ingenious move made him not only a "legal" resident once again, but also an even more important figure in Ho-Chunk history. His homestead became a haven for the refugees avoiding white pressure and a site of the Medicine Dances and other ceremonies that helped maintain traditional culture. Eventually, his act of survivance became a model for others to emulate, as more than 600 hundred Ho-Chunk families took advantage of federal legislation in 1881 permitting them to purchase forty-acre tracts. The land was scattered throughout central Wisconsin generally among the region's poorest acreage—the best land had long since disappeared from the market—and it remained tax free and inalienable for twenty-five years. Although dispersed over a ten-county area and thus not conducive to maintaining close communal life, the homesteads provided a welcome measure of security from the threat of removal. They also ensured that Ho-Chunk would have a place in modern Wisconsin.[22]

4

Visual Dimensions of Bennett's Ho-Chunk Photographs

L IVING LESS THAN FIVE MILES FROM Wah-con-ja-z-gah's homestead during the final removal period, Bennett was well aware of the state's treatment of its Ho-Chunk inhabitants. Indeed, he pointed out in his catalogues that many local Indians were "sent repeatedly to reservations in the Far West," and a few years later, he wrote blandly that Ho-Chunk "seem loth [sic] to leave this region."[1] And although Bennett rarely commented directly on the removals, evidence suggests that he was a committed assimilationist, certain of the inevitable decline of American Indian cultures. He wrote to one correspondent in South Dakota that, if "well taken care of and thoroughly instructed, [Ho-Chunk] would learn the ways and have the ambitions of white people." Bennett went on to opine "that a few generations must come and go before all the Indians will be absorbed and become present day Americans."[2]

In this statement, of course, Bennett was merely repeating conventional wisdom among white Americans about Indians as a "vanishing race," an ideology expressed most famously through the photography of his contemporary, Edward S. Curtis. The prevailing notion of Indians as a dying people underlies both Bennett's and Curtis's photographic work, and from this recognition arise several questions that I address in this chapter: How do Bennett's photographs represent the Ho-Chunk peoples that he knew to be under cultural and social stress and, ultimately, that he believed to be on the path from "savagery" to "civilization"? How does this ideology shape—and, in turn, how is it shaped by—such visual dimensions as aesthetic composition, presentational format, interpretive codes, and semiotic context. And, ultimately, what are the consequences of a picture-making practice premised on seeing Native Americans as a vanishing race?[3]

INDIANS IN THREE DIMENSIONS

Compared with several of his Midwestern contemporaries who also photographed Native Americans, Bennett's output was decidedly modest. Unlike, say, T. W. Ingersoll from St. Paul or

Charles Van Schaick of Black River Falls, Wisconsin—commercial photographers who produced hundreds of Native American pictures—Bennett could boast of only a handful of "authentic" Indian views: eleven in 1883, and several dozen more by the time of his death in 1908.[4] What Bennett lacked in productivity, he made up for in technical skill and, what's more, in tireless promotion that his heirs carried on throughout the twentieth century.

By far the most common format Bennett used for his Ho-Chunk photographs was the stereograph: two photographs, taken just inches apart and then pasted onto a thin board, appear in three dimensions when viewed through an optical device called a stereoscope (figure 32). By creating a convincing illusion of reality, making this illusion the platform for "flights of imagination," fantasy, and middle-class education, and seeming to transport viewers from their parlor to some distant and more adventuresome place, the stereograph achieved tremendous popularity in the latter half of the nineteenth century. So widespread had stereographs become by the early 1870s that, nationwide, the majority of Indian pictures were produced in stereo format.[5] That Bennett photographed Ho-Chunk subjects repeatedly in stereographic format goes a long way to explain his motives: he wanted to sell his images to tourists, both visitors to the Dells and armchair travelers throughout the nation who gazed upon his Indian view through a stereoscope.

Later in his career, Bennett expanded his output by the use of larger-format negatives in order to create 8 × 10 inch and mammoth-plate 18 × 22 inch prints. These larger prints, though not meant to be viewed through a stereoscope but instead to be hung on the walls of a home or place of business, were intended for a similar non-Native viewership. Thus, the first dimension of

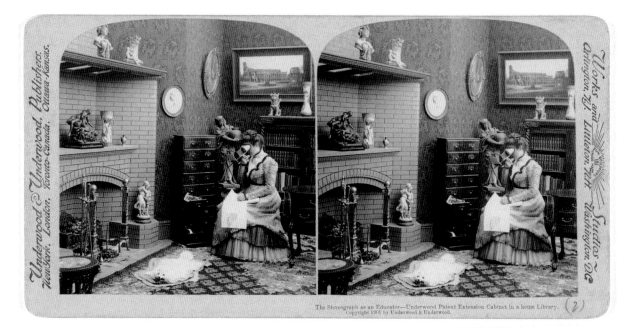

FIGURE 32. Unknown photographer. "The Stereograph as an Educator." Stereographic card, 1901. Published by Underwood and Underwood. Library of Congress Prints and Photographs Division, Stereograph Cards collection. LC-DIG-ppmsca-08781.

Bennett's Ho-Chunk pictures can be defined by both presentation format and function: they are, and have always been, public images, made explicitly for public consumption. Beyond this important starting point, Bennett's Indian pictures fall into three distinct categories: studio portraiture, *in situ* portraits, and what might be called "hidden trace" landscapes.

STUDIO PORTRAITURE

Some of the studio portraits, such as a stereo view from the 1870s of a woman named He-noo-ke-ku (or Youngest Girl), are set against a plain canvas backdrop that Bennett customarily used in his Kilbourn City studio (figure 33).[6] In an otherwise conventional pose at a three-quarters angle and her eyes following the line of her head, the young woman's dark skin, blanket, intricately patterned shirt, and ornate jewelry—together with the printed series caption, "Among the Winnebago Indians"—confirm her "Indianness" in a way that the pose itself does not. Here, He-noo-ke-ku—a person named, as in all of Bennett's Ho-Chunk portraits—poses in a studio setting that is notable for its simplicity.[7]

The comparison between this portrait and one taken nearly thirty years later, in 1905, is revealing. Here, a young man, Ha-zah-zoch-kah (Branching Horns), sits before a painted backdrop of a Wisconsin River Dells landscape (figure 34). Photographed by several cameras in one sitting—multiple exposures in stereographic, 8 × 10 inch, and 18 × 22 inch formats—Ha-zah-zoch-kah turns ever so slightly to the right. Unlike He-noo-ke-ku's portrait, which ends abruptly at her waist, here the photographer has expanded the field of vision to include the entire portrait subject to his knees. In doing so, viewers see a richer ethnographic portrait of a man whose attire is an amalgam of styles: store-bought, manufactured shirt; vaguely Sioux-like headdress; possibly Ho-Chunk, possibly Canadian, vest; German silver bracelet; handcrafted war club; and elaborate face painting. Completing the view, Ha-zah-zoch-kah rests, somewhat stiffly, against a Navajo blanket that Bennett had recently acquired from an Indian trader in New Mexico.[8]

The Navajo blanket functions as more than just a vibrant prop in this picture; it's a declaration by Bennett of a pan-tribal Indianness. Few Indian craft objects were more recognizable to non-Natives than the Navajo blanket, which, due to early twentieth-century national market demands, evolved rapidly from a garment into a floor covering and wall hanging. The Navajo weaving shown in this picture had come a long way from its origins in Arizona to reach Bennett's Wisconsin studio, and as we shall see in chapter 6, acquiring such goods became a crucial part of his effort to diversify his business.[9]

This photograph shows that Indian craft objects also diversified his Indian pictures. But what it does not show are the props that were determinedly *not* chosen for inclusion. One such item was the Apache war bonnet that Bennett had also obtained one year earlier from a trader in New Mexico. Significantly, the decision to exclude the war bonnet—an equally potent symbol of pan-Indianness, and not Ho-Chunk culture—belonged to the man in the photograph, Ha-zah-zoch-kah. As Bennett made clear in a letter to his son, he very much wanted to make this portrait and others "in costume, if they will consent." Ha-zah-zoch-kah refused to grant such consent, choosing, instead, to put on a self-made headdress of turkey feathers.[10]

FIGURE 33. H. H. Bennett. "He-noo-ke-ku (Youngest Girl)." Modern print from original stereographic glass negative half, ca. 1870s. Photograph courtesy of Wisconsin Historical Society, Image ID: 7269.

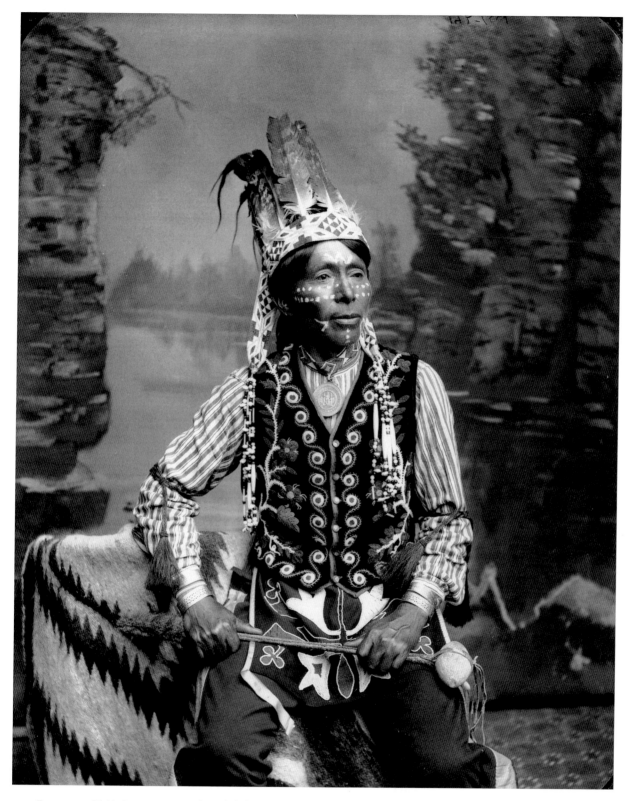

FIGURE 34. H. H. Bennett. "Ha-zah-zoch-kah (Branching Horns)." Modern print from original 8 × 10 inch glass negative, 1905. Photograph courtesy of Wisconsin Historical Society, Image ID: 7271.

Some contemporary Ho-Chunk regard this photograph and others like it as "pictures of show Indians"—and, indeed, it probably is. Ha-zah-zoch-kah very possibly found employment in the various Wild West shows, as did a number of Dells-area Ho-Chunk.[11] I am not sure that calling this portrait a "show Indian" should be taken purely as condescension, however: if Ha-zah-zoch-kah did perform with a Wild West show, such a designation, as L. G. Moses has argued, might be best understood as a marker of occupational status. Certainly, by the time Ha-zah-zoch-kah posed for this portrait, such stylized images of Indians circulated widely, and Bennett was simply capitalizing on what he saw to be a national trend. Moreover, he hoped to use this image differently than earlier portraits. In addition to stereos, the mammoth-plate (18 × 22 inch) prints found their way into train stations along the Chicago, Milwaukee, and St. Paul lines, and the 8 × 10 inch prints were framed and sold as stand-alone artwork. So taken was Bennett by this photograph that, in May 1905, he sought to copyright it.[12]

For his part, Ha-zah-zoch-kah, by refusing Bennett's insistence that he wear an "Appacheee [sic] war bonnet," exercised no small control over his representation. His clothing—a synthesis of a variety of styles that he brought to the studio—should be seen as a reflection of his personal taste; it is also a reflection of the hybridity that naturally develops in contact zones like early twentieth-century Wisconsin. Ha-zah-zoch-kah must have been highly conscious of his own participation in the stylized and theatricalized version of Indian culture that his and like photographs project. He might very well have been performing "Indianness" for white viewing audiences and, in this way, reinforcing previous stereotypes. But, in steadfastly denying Bennett the opportunity to photograph him in clothes other than his own, Ha-zah-zoch-kah is more of an active agent than a manipulated and passive object. However fabricated it might be, some Ho-Chunk today see this photograph and others like it as a long way removed from the more blatantly stereotypical representations of Plains Indians that eventually came to dominate in the Dells and elsewhere (figure 35).[13]

This image, a Bennett Studio postcard from the 1950s, is one of many portraits from a later period that seems to conform to all the stereotypes commonly associated with Indian pictures. A nameless man wearing no shirt—but decked out in buckskin leggings, a fanciful feather headdress, and a menacing scowl—stares, with squinting eyes, into the far distance. With elbow casually resting on bent knee, he holds what appears to be a hand-made lance and shield, each pointing in the same direction as his facial paint. Lest these heavy-handed visual clues fail to convey the image's message, the printed caption removes any lingering ambiguity: here is an Indian "On the War Path, Wisconsin Dells." The image, photographed by one of Bennett's heirs long after his death, is riddled with contradictions: What is someone dressed like a Plains Indian doing among the pine trees of southern Wisconsin? Why would anyone be "on the war path" more than a half century after the conclusion to the Indian wars?

The Native American man pictured in this postcard most certainly understood and felt those contradictions. Although not identified on the postcard, local residents would have recognized him as Roger Little Eagle Tallmadge, the head of a prominent family that long operated the Winnebago Museum in the Dells. Although Tallmadge was born into a Minnesota Sioux family, he married a Ho-Chunk woman named Bernadine Miner and, over the years, became something

of a spokesman for Ho-Chunk concerns. Bernadine Tallmadge recalled that her late husband used to joke about playing the part of what he humorously called "postcard Indians."[14]

H. H. Bennett's Ho-Chunk portraits, by contrast, never quite make the leap to the Plains Indian stereotype or "postcard Indian." But neither do we find Ho-Chunk family portraits, like the thousands taken in his studio of Kilbourn's white residents. As Gerald Vizenor notes, "The pictures of *indians* as the other, the wounded fugitives of the camera, are not the same as those nostalgic photographs of homesteaders and their families in a new constitutional democracy."[15] What is missing is the ordinariness, the quotidian element of the everyday, which customarily infuses family photography—even those formal portraits taken by professional photographers in studio settings. Instead, as Vizenor reminds us, conventional Indian portraits are marked by an unbridgeable otherness, a pervasive sense that those pictured are somehow different, exotic, and the product of fantasy.

Here, the contrast with Bennett's rival, Charles Van Schaick, is striking. Like Bennett, Van Schaick was his town's major commercial photographer and someone who regularly interacted with Ho-Chunk people. Beginning in 1879 and over the course of a sixty-year career, he chronicled the lives of Wisconsin residents in and around Black River Falls, photographing them in his studio, in their homes, at work, and at play. In this regard, and in most, he was a typical

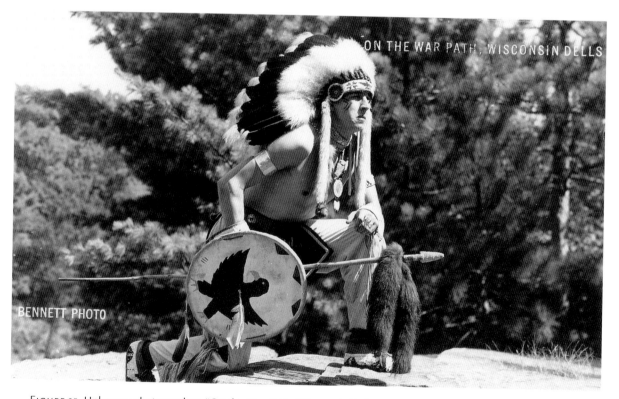

FIGURE 35. Unknown photographer. "On the War Path, Wisconsin Dells." H. H. Bennett Studio postcard, ca. 1950s. Author's collection.

small-town commercial photographer, providing local residents with affordable family portraits that became memorable heirlooms.[16] He also photographed—on commission—Black River Falls businesses, important social events, and ordinary people working on farms, in fields, and in shops. A prodigious worker, Van Schaick produced over thirty thousand glass plate negatives; of the extant negatives, six thousand of which are part of the Wisconsin Historical Society's collections, more than seven hundred images picture Native Americans. But the crucial difference between Bennett and Van Schaick does not lie in the latter's greater output, but rather in the contrasting look and the uses of Indian pictures.[17]

Compared with Bennett, the Black River Falls photographer quite often pictured Ho-Chunk families less as wounded fugitives and more in the manner of nostalgic white homesteaders: Van Shaick's Indian pictures are distinguished by their very ordinariness. Take two examples from the early twentieth century. As in nearly all of Van Schaick's couple portraits, Joe Monegar and his unnamed wife are positioned following distinct conventions of Victorian portraiture, with one partner seated—here, the husband—next to a standing family member (figure 36). The couple looks squarely into the camera lens with the sort of relaxed expressions of people at ease with their surroundings. Each, in a different way, has come to the studio fashionably and neatly dressed: although her clothing signifies an adherence to tradition, his clearly represents a shift toward assimilation. More significantly, the decision to dress this way was most likely that of the portrait subjects, not the photographer, as the Monegars purchased this portrait for their own personal use.

In a second photograph from around the same time, a young woman also sits comfortably in Van Schaick's studio (figure 37). Mountain Wolf Woman holds her two daughters, Lena and Josephine, as any mother would—wrapped in her arms, with one fast asleep. The mother's strong hands surround her daughters, enveloping them with security. One wonders if the lines on the young mother's face derive from the extra responsibility that comes from holding two children, without the support of a helping hand. These commonplace photographs, no different in most respects from hundreds of other turn-of-the-century small town studio portraits in Wisconsin and elsewhere, indicate the value that some Native people placed on personal photography.[18]

Van Schaick's Monegar and Mountain Wolf Woman portraits not only look different from Bennett's studio portraits; they functioned differently as well. As *private photographs,* intended for the sitters themselves, they stand in contradistinction to *public photographs* that were meant to be viewed by people with no connection to the portrait subject. Martha Sandweiss argues that such a distinction between private and public pictures is central to nineteenth-century photography, especially with photographs of American Indians. Most nineteenth-century portraits were private documents, made explicitly for the portrait subjects. People then, as today, maintained such private mementoes as *lieux de mémoire,* as "sites" of personal memory to recall family members and friends and to serve as a visual connection to a direct past. Photographs of nineteenth-century Indians departed from this general rule, however, becoming almost immediately public documents that slipped beyond the control of portrait subjects. As Sandweiss notes, the emergence of an "expanded market for photographic views of Indian life made it far less likely that a photograph of a Native American person would be made for the subject him- or herself, and

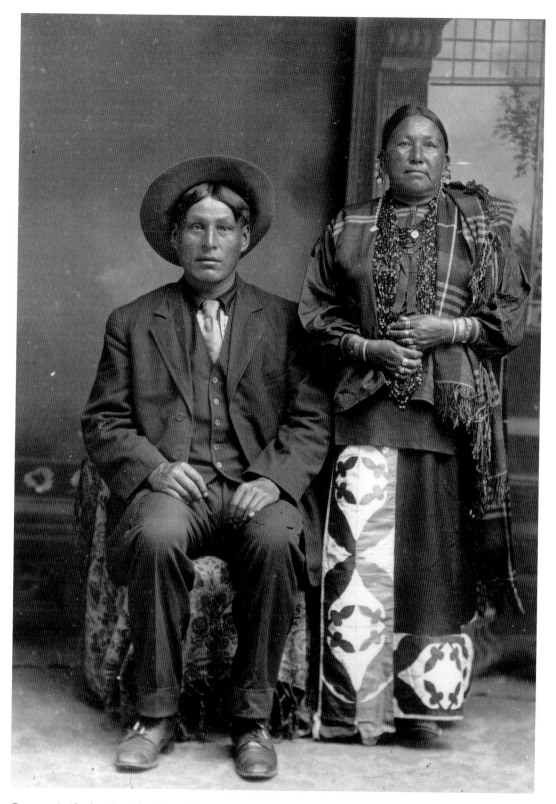

FIGURE 36. Charles Van Schaick. Studio portrait of Mr. and Mrs. Joe Monegar. Modern print from copy negative, ca. 1900. Photograph courtesy of Wisconsin Historical Society, Image ID: 2313.

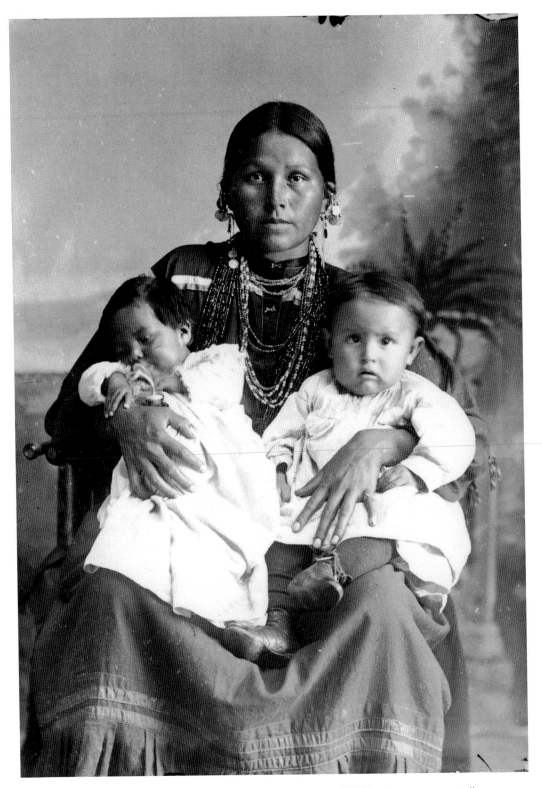

FIGURE 37. Charles Van Schaick. Studio portrait of Mountain Wolf Woman, also known as Stella (Blowsnake) Whitepine, with her two daughters, Lena Whitepine and Josephine Whitepine. Modern print from copy negative, ca. 1908. Photograph courtesy of the Wisconsin Historical Society, Image ID: 9385.

correspondingly more probable that the picture would be made as an object of commerce, intended not as a private remembrance, but as a piece of a public story."[19]

Seen in this way, Bennett's portraits are more representative of the genre than Van Schaick's. As clients in the Black River Falls photographic studio, the Monegars and Mountain Wolf Woman posed for pictures that were meant to become part of a family album or a portrait hung on a wall within the confines of a private home. They would have served as private mementos for their families, perhaps triggering stories about their courtship, marriage, and life together—biographical stories of the most immediate and personal kind. Conversely, the photographs of Ha-zah-zoch-kah, He-noo-ke-ku, or Ma-bes-e-da-he-gah (Bear that Digs a Hole) (figure 38) were to be seen, from the very beginning, as public pictures by countless (white) strangers in newspapers, through stereoscopes, on travel brochures, and at train stations. The stories told about *these* pictures—photographs that circulated through the overlapping worlds of white commerce, regional politics, and fantasy—were instantly public, metaphorical, and intended to benefit their non-Native creators.

Another kind of common portrait that benefited non-Native creators, but that also stands apart from Bennett's commercial photographs, were those produced to serve scientific and governing interests. Beginning first with the U.S. Geological Survey (USGS) and especially with the establishment of the Bureau of American Ethnology (BAE) in 1879, the federal government collaborated with the budding science of anthropology in its efforts to create what it hoped would be a systematic and scientific record of America's First Nations. That record was to include the collection and preservation of Native artifacts and oral testimony and the production of photographic portraits. Given its sense of perceived realism, photography proved especially important during the BAE's first several decades as photographers such as John K. Hillers, Charles Bell, and De Lancey Gill sought to document vital data about Native Americans. At first, those data centered on cultural traits such as clothing, ornamentation, and the historical record. By the 1890s, however, an interest in ethnology gave way to physical anthropology, and in particular to an emphasis on what was known as the "anthropometry" of the physical traits of racial types. Grounded in the spurious, but widespread, belief that physiognomy provided decisive information about the relative intelligence and a human hierarchy of different racial types, anthropometric images proved irresistible for those seeking to maintain distinctions between groups and to "prove" one group's superiority over another.[20]

Anthropometric photographs demanded different aesthetic composition than portraits intended for either commercial or personal uses. As early as 1877, the director of the USGS, Ferdinand V. Hayden, noted that "as a rule, front and profile views have been secured whenever practical."[21] Such photographs were better taken in a controlled setting, like those during the many visiting delegations to Washington, D.C. There, in the clinical confines of the BAE laboratory and against a plain backdrop, photographers such as De Lancey Gill could photograph "the wilder tribes, who would ordinarily resist ordinary physical measurement on fiducial or other grounds." Such settings worked best, according to the BAE director, William Henry Holmes, because of the necessity of "photographing individuals in exact portrait, profile and full face, with the view of permitting measurement of the facial angle, form of cranium, and other anthropometric elements."[22]

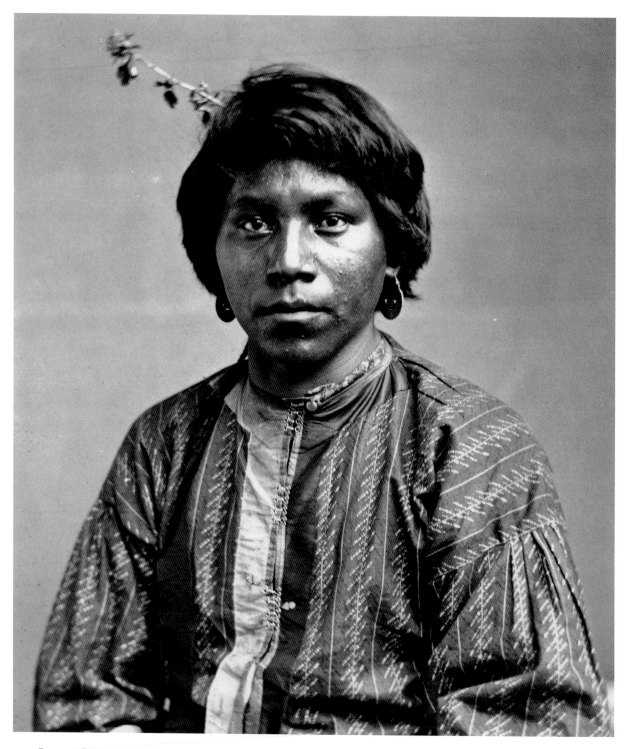

FIGURE 38. H. H. Bennett. "Ma-bes-e-da he-gah (Bear that Digs a Hole)." Modern print from original stereographic glass negative half, ca. 1880. Photograph courtesy of Wisconsin Historical Society, Image ID: 7357.

Such photographs, like Gill's 1899 twin portraits of Red Eagle, a Ho-Chunk chief from the Nebraska Winnebago Reservation, became part of Paul Radin's efforts to display what he called "Winnebago Types." Anthropometric photographs often take on a "mug shot" appearance similar to those taken by police photographers (figure 39a and b). Although created for ostensibly different purposes, the full-profile and full-frontal paired BAE Indian portraits and police "mug shots" shared more than simply aesthetics; as John Tagg argues, both were photographs based on relations of "coercion and authoritarian control" that relied on new "techniques of surveillance." It should come as no surprise that, as Hayden put it in 1877, "it is only when an Indian is subjected to confinement that those measurements of his person which are suitable for anthropological purposes can be secured."[23]

By contrast and as later chapters make evident, in a commercial studio setting such as Bennett's, photographic relations were based less on coercion and authoritarian control than on a complex and ever-changing matrix of negotiation and persuasion. Accordingly, the photographs look quite different than those produced in the BAE laboratory. Bennett's studio portrait of Nah-ju-ze-gah (or Brown Eyes), for example, pictures a Ho-Chunk woman seemingly at home in the Wisconsin Dells studio (figure 40). Taken sometime shortly before 1883 in stereographic format, it became part of Bennett's 1900 tourist booklet, *The Wisconsin Dells*. In contrast with Gill's severe frontal and side profile views, Bennett's portrait subject sits ever-so-slightly off center, with one arm resting casually on an upholstered armchair and with eyes looking faintly to the left. The Dells photographer would have appreciated her decision to wear a traditional headdress, even if it did obscure part of her head; Bennett wasn't measuring anything apart from potential sales.

Nothing is said about Nah-ju-ze-gah herself in the tourist booklet, but adjacent to this picture viewers learn of the supposed Native belief that "a part of their life goes into a picture taken of themselves," hence making it difficult to obtain such photographs. Such stories, told endlessly and without consideration why Native peoples might resent the camera's intrusive gaze, were meant to fuel white viewers' interest in the general character of the region's indigenous inhabitants. Displaying little interest in the personal experiences and memories of Nah-ju-ze-gah, the photograph is called upon to show that Ho-Chunk "are an interesting people, full of tradition, superstition and beliefs that will amuse" non-Native tourists in the Dells.[24]

In Situ Portraits

Even before they were photographed in the studio, Ho-Chunk became portrait subjects outdoors. The 24 May 1873 issue of the *Wisconsin Mirror* reported that "Henry H. Bennett, the artist, has taken some fine views of the Indian Camp" (see figure 1). A second type of photograph, then, shows Ho-Chunk people as either engaged in a number of activities or, as in the case of Wah-con-ja-z-gah, simply posed for the camera at, or near, their own homes. None of these photographs is "candid." Every person and scene depicted is carefully positioned and presented to the camera as if sitting for a painted portrait. Such a practice, common among professional photographers until technical innovations made "instantaneous" and more candid "documentary" pictures possible, is not necessarily something to condemn.[25] Rather, it hints at a revealing

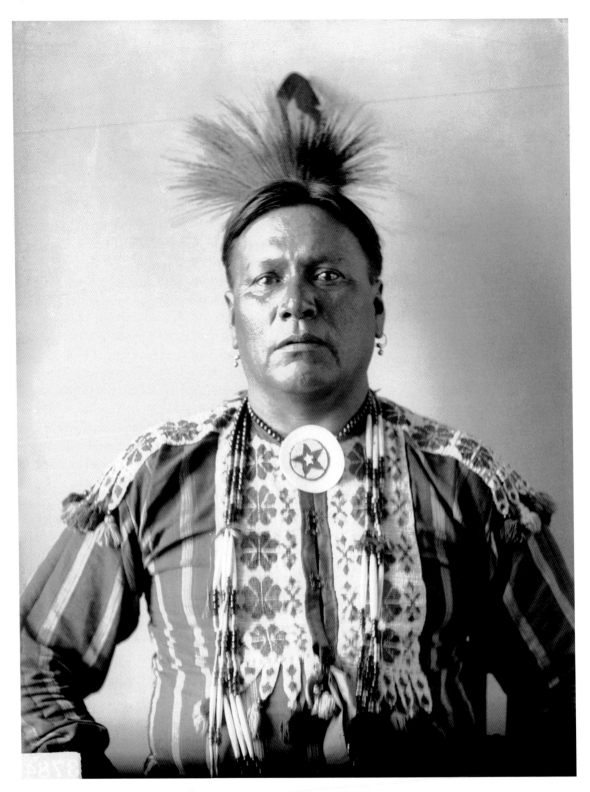

FIGURE 39a and b. De Lancey W. Gill. "Portrait (front and side) of Winnebago man, Charkshepshutsker (Red Eagle), Chief." Modern scan from 8 × 10 inch negative, March 1899. Photograph courtesy of the Smithsonian Institution, National Anthropological Archives, Bureau of American Ethnology (NAA 06607700 and NAA 10074800).

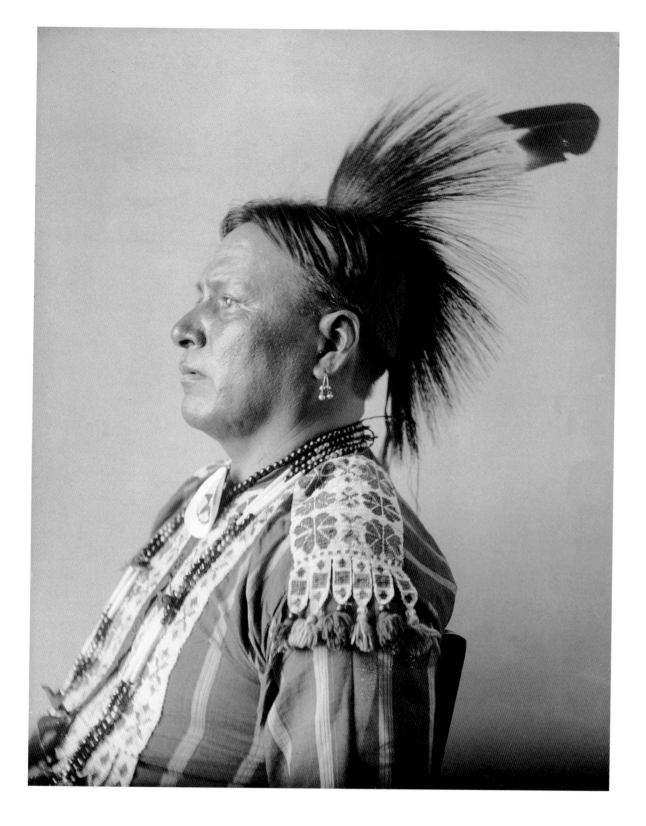

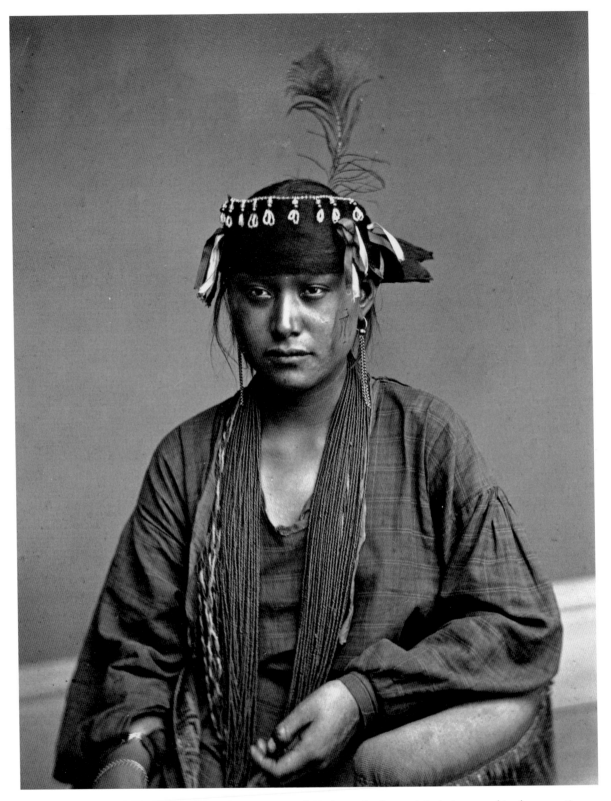

FIGURE 40. H. H. Bennett. "Nah-ju-ze-gah (Brown Eyes)." Modern print from original stereographic glass negative half, ca. 1870s. Photograph courtesy of Wisconsin Historical Society, Image ID: 7531.

paradox central to Bennett's Ho-Chunk pictures: in his search for saleable Indian images, and despite continuous interaction between photographer and portrait subject, there remained an unbridgeable social distance.

The geographical distance between Bennett and Ho-Chunk peoples was not nearly as great as social distance, however, at least during the summer months. Although Black River Falls—located some seventy miles from the Wisconsin Dells—became a focal area for Ho-Chunk settlement, families and clans were dispersed widely throughout central Wisconsin, including several near the budding tourist destination. The small-scale Ho-Chunk "camps" or homesteads, like that of Wah-con-ja-z-gah, were used mainly as headquarters for establishing small gardens and constructing wigwams to store belongings. Since most of the community practiced a seasonal, itinerant economy, summertime meant tending gardens, working as farm laborers in cranberry bogs, and harvesting wild blueberries, which were then sold to local whites. Then, later in the fall, many families moved to winter along the Mississippi River near La Crosse, where they would hunt and trap, only to return to the Dells in the spring. Such practices caused consternation among many whites, who equated mobility—what newspaperman Frank Wisner called "strolling vagabondism"—with vestiges of savagery. For many Ho-Chunk people, however, seasonable mobility proved an effective means of coping with the dual stresses of both poor land and the ever-changing market economy. It also offered the means—however modest—to a relatively independent life.[26]

Of especial importance was seasonal, agricultural labor in local cranberry marshes, where Ho-Chunk families often worked under close managerial supervision of white business interests. Such labor-intensive work resembled that deployed in sharecropping regions throughout the American South, in which an unambiguous racial hierarchy was the enforceable norm. In the Jim Crow South's cotton-, tobacco-, and sugar-producing districts, extended African American families labored to produce the crops that brought landowners economic profit.[27] So, too, in Wisconsin's cranberry bogs, but with a key difference: geographic mobility remained the norm among Wisconsin's Ho-Chunk, much to the chagrin of local whites. Newspapers, such as the *Black River Falls Badger State Banner,* frequently railed against those Ho-Chunks who walked "away from the only labor they know how to perform," thus depriving local whites their critical labor during cranberry-harvesting season. Figure 41 nicely depicts the everyday nature of this work arrangement, with large groups of Ho-Chunk men, women, and children laboring in cranberry bogs under the watchful eye of attentive white managers. Taken most likely by a local dentist named Robert Charles Gebhardt, an amateur photographer and businessman with extensive holdings in nearby cranberry lands, it presents an accurate, if unflattering, portrait of white–Ho-Chunk economic relations at the beginning of the twentieth century.[28]

By contrast, all of the activities and scenes that Bennett pictured in Ho-Chunk country are suggestive of traditional culture and bear only minimal traces of non-Native influences. Wigwams, not frame houses, provide a backdrop; men play traditional games, not labor in a field; women sit amid nature, not stand on city streets—such scenes stress the *picturesque* quality of these portraits. As we shall see, Bennett's emphasis on the picturesque, and the exclusion of the merely mundane, has important implications for how we might interpret his oeuvre.

One of his best-known stereographs portrays six men playing Wah-koo-chad-ah (Moccasin), a favorite game (figure 42). The photograph, pictured before a wigwam lodge made of reed matting, depicts the setting nicely. Seated in a semi-circle around a blanket, four men create a symmetrical foreground that is offset by two standing players. The man seated at the center, the sole player without a hat and looking directly into the camera, becomes the picture's focal point. The player on the far right, the "guesser," holds the long stick that he will use to point to the moccasin that he believes holds a hidden object. In order to make certain that viewers know this to be a guessing game, the player on the far left covers a moccasin with both hands.

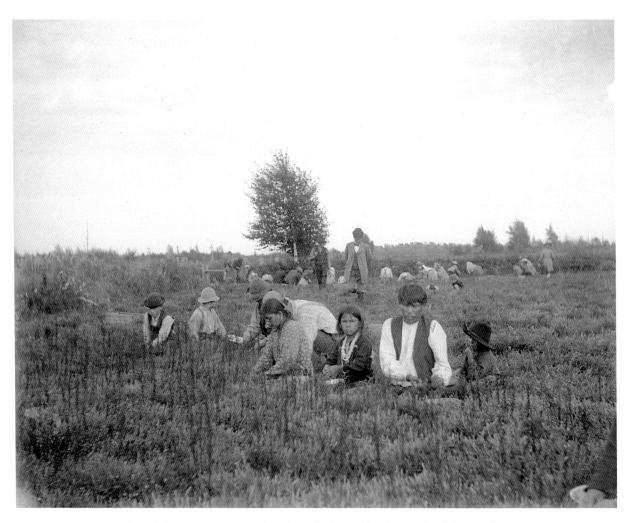

FIGURE 41. Unattributed photographer, probably Robert Charles Gebhardt. Ho-Chunk families harvesting cranberries. Working in central Wisconsin's cranberry marshes provided Ho-Chunk families with not only important income but also a welcome measure of geographic mobility. Modern scan from original glass negative, 1900. Photograph courtesy of the Smithsonian Institution, National Anthropological Archives, Bureau of American Ethnology (BAE GN 4423).

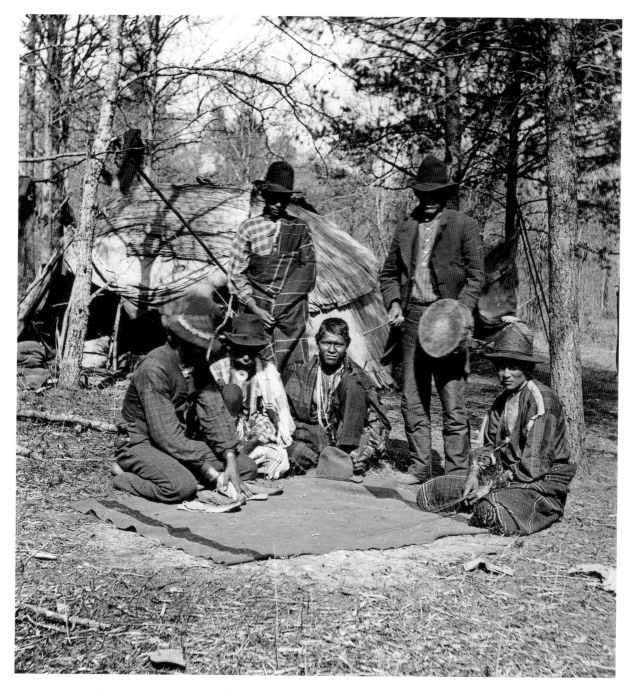

FIGURE 42. H. H. Bennett. "Playing Wah-koo-chad-ah (Moccasin), a Favorite Game." Modern print from original stereographic glass negative half, August 1880. Photograph courtesy of Wisconsin Historical Society, Image ID: 4752.

The photograph, for all its apparent realism and attention to detail, is nonetheless carefully composed and is as indebted to the genre of portraiture as it to the promise of documentary evidence. Its posed quality is reflected in the fact that the game customarily is played with two groups of five men sitting directly opposite each other.[29] Bennett's photograph not only leaves out four of the ten players, but by positioning his subjects in a semi-circle, having two of the party stand, and locating the game neatly before a traditional wigwam, he achieves a well-composed picture, if not an entirely accurate ethnographic record. Compare Bennett's stereograph with plate 39 in Paul Radin's important 1916 study, *The Winnebago Tribe* (figure 43). One might surmise that Radin's "Moccasin Game" more correctly records the game as it must have been played around the turn of the twentieth century, with two groups of players facing each other across a blanket. Certainly, it is no less posed than Bennett's. Indeed, it looks stiffer, providing little sense of action and movement. Radin's photograph might depict the Ho-Chunk game more precisely, and thus serves its purpose as a scientific document, but as a picture, it seems compositionally bland as it obscures two of the players.

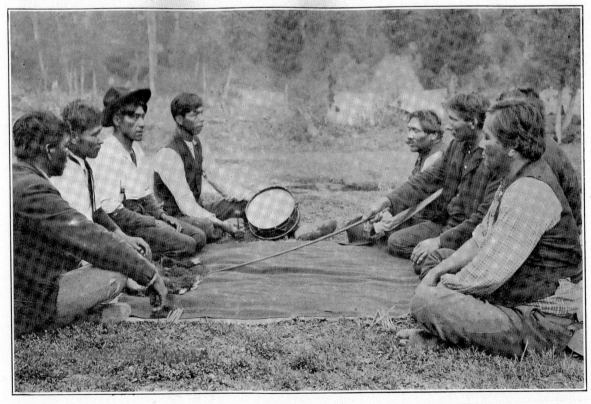

BUREAU OF AMERICAN ETHNOLOGY THIRTY-SEVENTH ANNUAL REPORT PLATE 39

MOCCASIN GAME

FIGURE 43. Unknown photographer. "Moccasin Game." Reprinted from Paul Radin, *The Winnebago Tribe*, plate 39.

As with his landscape views, Bennett was careful to make more than one negative of his most important outdoor Ho-Chunk subjects. He also strove to compose all his in situ portraits in front of wigwams, a point of pride noted in his correspondence with customers interested in his pictures.[30] In one, "Ha-noo-gah Chun-hut-ah-rah (Second Boy and Pony)," a confident-looking young man stands before a wigwam in traditional clothing (figure 44). His pose is casual, with one arm draped comfortably over his horse and legs crossed at the ankles, and he looks unflinchingly at the camera. Unfortunately, we learn little about this young man in Bennett's letters except that he was considered "a good specimen of an Indian as they used to dress."[31]

We learn even less about the four women sitting comfortably in the shade of a summer shelter: "Wong-chig-ah Che-da (Indian Tent) and Squaws [sic]" is another photograph made in multiple exposures with different cameras.[32] With traps, wrapped bundles, a bucket hung in the trees behind the shelter, and a lone shoe casually left in the foreground, the setting appears tranquil, relaxed (figure 45). The informal nature of the scene is accented by the woman on the far right, who leans comfortably aside her companion. Neatly positioning the portrait subjects between the poles of the shelter and cast with an eye-catching play of light and shadow, the photograph is fine example of outdoor composition. But given the position of the women and the structure of the shelter, it is also conceivably much more, as it possibly depicts a menstrual lodge. If that were indeed so, it would surely have been an indication that some Ho-Chunk genuinely trusted Bennett, as such lodges were closely guarded spaces, off limits to most men—at least "the intrusion of unworthy men," as Radin put it.[33]

Such speculation is not idle. This is the only photograph in Bennett's collection suggestive of social customs; nowhere does he picture elements of religious life.[34] Here, again, he departs from Charles Van Schaick, who successfully documented events such as powwows, tribal ceremonies, weddings, and funerals (figure 46). Although he repeatedly tried to photograph such events, in no case was he granted permission to do so. This was a source of frustration for Bennett, who knew that pictures of "traditional activities," when sold as stereographs, could become profitable items in his studio.[35] Moreover, and also unlike Van Schaick, all of Bennett's Indian pictures depict some version of "traditional" life, apart from modern intrusions. It was commonplace for the Black River Falls photographer, by contrast, to record street scenes and ordinary moments of daily life in the small town. Some Van Schaick street photographs give the appearance of snapshots, mundane scenes of people walking or milling about with an apparent unawareness of the camera (figure 47).

In other instances, Van Schaick documented recurring events that, although important in the everyday lives of his Ho-Chunk subjects, made for a less than picturesque scene. One such view depicts a group of neatly dressed Ho-Chunk men, women, and children who had traveled to Black River Falls to collect annuity checks from the federal government (figure 48).[36] The busy street scene—with trash strewn along an unpaved street, one dog scavenging for food while the other is cropped by the photograph's right margin, human figures obscured by street signage or hidden by shadows—presents a contrasting setting for the tidy group at its center. Amid the scene's busy clutter, at the photograph's focal point, stands a man holding a child in a strikingly modern pose adjacent to signs that read "Drug Store" in the English, Norwegian, and Ho-Chunk

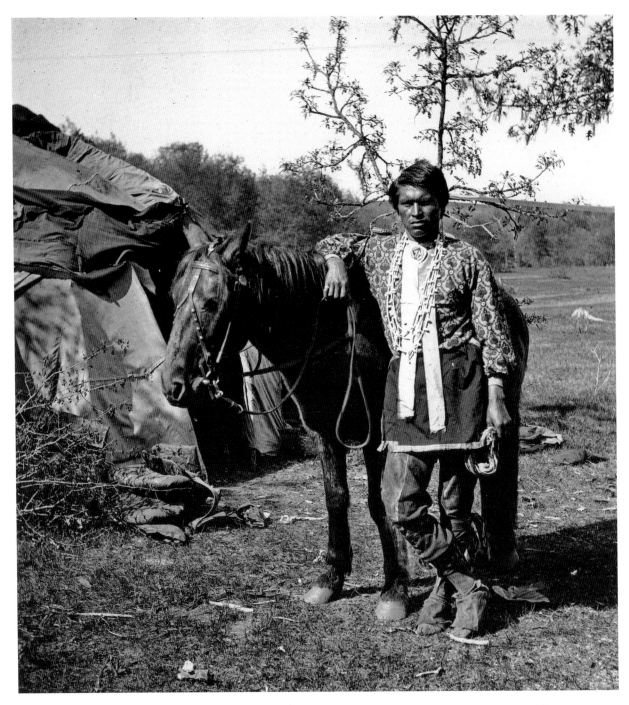

FIGURE 44. H. H. Bennett. "Ha-noo-gah Chun-hut-ah-rah (Second Boy and Pony Indian)." Modern print from original stereographic glass negative half, ca. 1880. Photograph courtesy of Wisconsin Historical Society, Image ID: 7277.

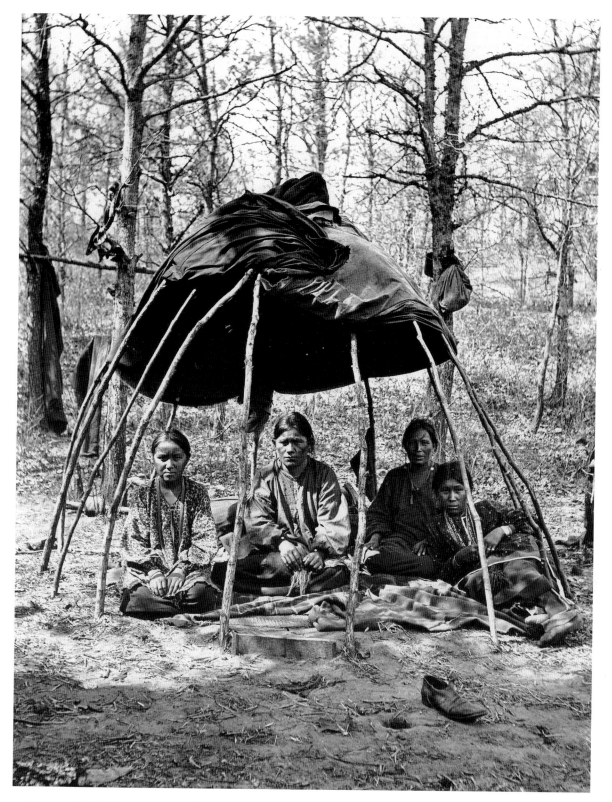

FIGURE 45. H. H. Bennett. "Wong-chig-ah Che-da (Indian Tent) and Squaws [*sic*]." Modern print from original stereographic glass negative half, ca. 1880. Photograph courtesy of Wisconsin Historical Society, Image ID: 7273.

languages. Van Schaick's photograph, although certainly posed, seems documentary for its indifference to disorder and in its recording of the rich details of daily life that do not necessarily cohere to cultural expectations or to the rules of pictorial composition.

By way of contrast, Bennett's stress on the picturesque is an important characteristic of his outdoor photographs, whether of landscapes or the people who inhabit them. By calling attention to the "picturesque," I am referring to an aesthetic category that emphasizes the picture-like quality of his photographs and is suggestive of a scene that is "pretty as a picture." There are, of course, many variances to this sensibility, but in Indian photographs such as Bennett's, much like Edward S. Curtis's, several shared elements exist. Most significantly, "there was almost always an effect of completeness and composure, a tendency towards the preferred view," writes Mick Gidley of Curtis's picturesque photographs, "the prospect suitably framed" (figure 49). Bennett may have departed from his famous contemporary by eschewing Curtis's "pictorialist" style, with its soft-focus, hazy appearance in favor of a "straight" photography of sharp-focus realism. But what they shared was a tendency to create images that looked balanced and composed, that depicted a scene that would look agreeable in a picture. Reflecting on the importance of the "picturesque" aesthetic to Native American photography, Theresa Harlan has noted that

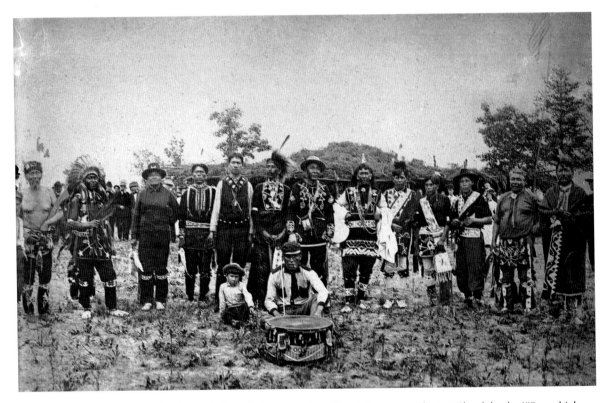

FIGURE 46. Charles Van Schaick. "Early Twentieth-Century Ho-Chunk Powwow." The Ho-Chunk leader Winneshiek is seated in front with Dream Drum at this Jackson County powwow. Modern print from copy negative, ca. 1908. Photograph courtesy of Wisconsin Historical Society, Image ID: 3693.

FIGURE 47. Charles Van Schaick. Black River Falls street scene with Ho-Chunk women. Modern print from copy negative, ca. 1900. Photograph courtesy of Wisconsin Historical Society, Image ID: 41985.

such pictures "made the forced assimilation of Indigenous people palatable, righteous, and even commemorative."[37]

With this in mind, compare Van Schaick's outdoor photographs with another by Bennett, entitled "Squaw [sic] Tanning a Deerskin." (figure 50). In this picture, one of the four women from the "Indian tent" (and possibly menstrual lodge) photograph stands next to a deerskin canvas, stretched tightly between horizontal poles and centered perfectly between two traditional wigwams. Wearing fine traditional clothes but with eyes averted from the camera, the young woman presses a tool against the white canvas, leaving a shadow-accented indentation at the photograph's very center. The photograph, taken with Bennett's favorite stereographic camera, pictures a perfectly composed scene uncluttered by extraneous details or by intrusions of modern, white society.

"Hidden Trace" Landscapes

Those pictured environments, even without a human presence, were extremely important; with the help of words, and some imaginative fantasy, they could call to mind hints of the Indian past. Realizing that a good portion of the Dells' allure hinged on what one tourism promoter/ riverboat pilot called its "primitive associations," Bennett worked diligently to photograph the "hidden trace of the native past." "All places in the Dells are suggestive of Indian life," noted J. E. Jones. "There are many traces of Indian occupation to be found along the river and back through the country, investing the locality with the charm necessary to all resorts—romantic tradition." Many of the dozens of period guidebooks shared Jones's sentiment. After comparing the Dells favorably to the sublime scenery of Yellowstone, James Maitland, for one, declared, "nor is this locality alone interesting because of its weird, impressive surroundings, for connected

FIGURE 48. Charles Van Schaick. Ho-Chunk families gathered outside of Werner's Drug Store on annuity payday. Modern print from copy negative, ca. 1900. Photograph courtesy of Wisconsin Historical Society, WHi (X3) 35420.

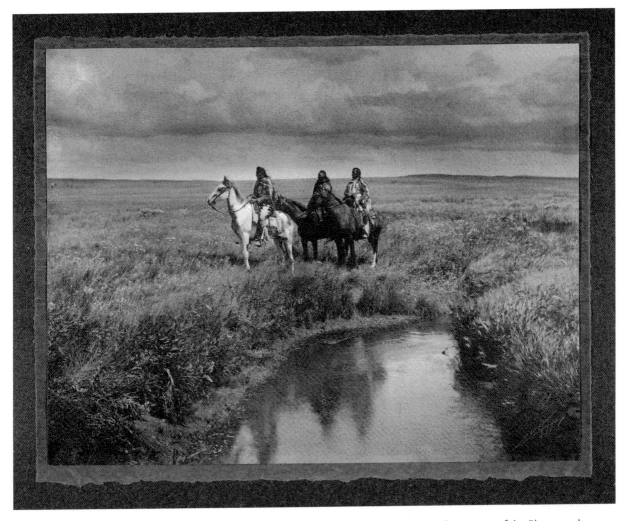

FIGURE 49. Edward S. Curtis. "The Three Chiefs." Gelatin silver print, n.d. Photograph courtesy of the Photography Collection, Miriam and Ira D. Wallach Division of Art, Prints, and Photographs, New York Public Library, Astor, Lenox and Tilden Foundations, ID 433203.

with it are reminiscences of Indian days. . . . Almost every spot along the banks of the river for miles hereabouts is identified with some legend of tragic intent."[38]

Thus, a third type of Indian photograph contained no people at all. Instead, these hidden-trace pictures sought to connect the Dells environment, with its many unique landscapes, to romantic stories that tourists would have heard on steamboats and read about in travel guides, including Bennett's. This is a key point, for nineteenth-century American audiences were accustomed to viewing photographs in relation to the written and spoken texts that accompanied them. Sometimes those texts were composed of detailed narratives that appeared in guidebooks; at other times, the principal text was simply the legend that accompanied the photograph. Susan

FIGURE 50. H. H. Bennett. "Squaw [*sic*] Tanning a Deerskin." Modern print from original stereographic glass negative half, ca. 1880. Photograph courtesy of Wisconsin Historical Society, Bennett Collection, Image ID: 7358.

Sontag puts it bluntly, and correctly, when she notes that a photograph's "meaning—and the viewer's response—depends on how the picture is identified or misidentified; that is, on words."[39] Although this held true for all types of photographs, it was especially so for those specifically designed to impart narratives of a place imbued by a storied and romantic past. Tourist fantasy and photographic realism conjoined in this uniquely Midwestern imaginative geography.

The past-tense quality of these hidden-trace narratives was taken for granted and was all-important. "Gay yachting and rowing parties now skim the mirror-like smoothness of lakes and lakelets," marveled one such writer, "which not many moons ago were only stirred by the prow of the Sioux or Winnebago birch-bark canoe."[40] Since the landscape itself remained mute to such tales, Bennett occasionally had to add visual clues to give it an historic Indian presence. In the early fall of 1892, Bennett wrote that he had purchased "a real Chippewa Indian birch canoe . . . from the northern part of the state, which I will use in some pictures that I will make at Boat Cave and perhaps other points." Bennett held true to his word as he positioned the Ojibwe-made canoe, throughout the Dells, as the centerpiece for dozens of well-composed photographs in stereographic, 8 × 10 inch views, and mammoth-plate panorama formats.[41]

One picture that conjures up fantasies of an imagined Indian past is his well-known "Lone Rock from Below with Canoe" (figure 51). A masterpiece of landscape photography, the view epitomizes the picturesque aesthetic: the dramatic striations of Lone Rock sit squarely in the photograph's center, with a near-perfect reflection in the still water. The canoe, neatly placed in the foreground and slightly off-center, seems to bring the reflection to shore; it balances the picture and provides its main visual interest. But the canoe represents much more, of course. Although local regional Ho-Chunk used dugouts as watercraft, not canoes from birch bark, as this material was scarce in central Wisconsin, the canoe symbolized Indian-ness to the picture's white viewers.[42]

Native Americans—at least those romanticized ones—were deemed curiosities of the past, noble ghosts who haunt the land. As for the contemporary presence of their descendants, well, that required some explanation. J. E. Jones, for one, felt compelled to apologize for the present-day Ho-Chunk people whom tourists might actually see in the Dells:

> While it may be true that the habits and appearance of the Indians who are now found in the country are not suggestive of any great degree of sentiment or romance, we should remember that they are in their most degenerate state. There was a time when the noble red man was 'lord of all he surveyed,' and though ignorant and unlettered, he was proud and spirited. There is just as much reason to suppose that the Indians of North America were at some time as capable of the sentiment and nobility given them by writers of history and fiction as were the earliest inhabitants of other sections.[43]

In this way, Jones and many other booster writers sought to connect the Dells with the long literary tradition that romanticized the safely dead Indian. Invoking both Longfellow and Cooper, but following the more formulaic conventions of dime novels, fellow guidebook authors conjured a place where tourists were encouraged to see the "spur and rocks, the many bends [and imagine] the terrible danger lurking in the numerous caves and grottos."[44]

Some hidden-trace narratives, such as Frank Wisner's *Romance of the Cliff,* suffered from the hackneyed formulae that infused much popular writing of the time. As part of a popular 1875 Wisconsin Dells guidebook, this lengthy "romance" relied on all the conventions that readers came to expect from the genre. These included everything from chivalric courtly love, the false promise of Indian-white marriage, and mistaken identity to a lover's leap, dramatic cliffs in the landscape, Indian melancholy, and white female captivity among "savages."[45] Centered on the fictional love affair between a French fur-trading explorer named Jean Baptiste DeRiviere and a stunningly beautiful "Indian maiden" named Lo-wel-li-ta, who turns out to be a white captive named Maggie Stanhope, the story takes place before Euro-American domination of the region. When DeRiviere, "familiarly known among his comrades as 'Handsome John,'" realizes

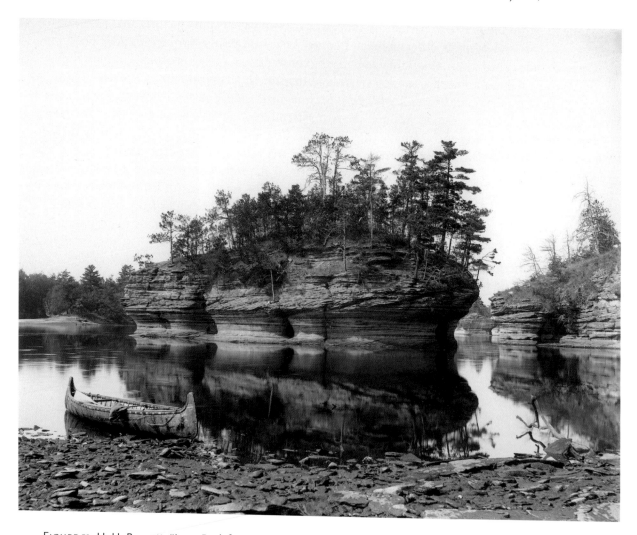

FIGURE 51. H. H. Bennett. "Lone Rock from Below with Canoe." Modern print from original 8 × 10 inch glass negative, 1897. Photograph courtesy of Wisconsin Historical Society, Image ID: 3543.

that the lovely maiden is "English, by Jove, and blue eyed!" he resolves to free her from her imprisonment. After much adventure, the two escape down the river through the Dells by canoe to the safe confines of the military fort.[46]

Hackneyed though it was, *Romance of the Cliff* endured well into the early twentieth century through multiple printings in dozens of Dells guidebooks, including Bennett's. Even today, long after Wisner's story has been forgotten and the river dammed to change its appearance irrevocably, traces of this early tourist fantasy remain in the Dells (figure 52). As literature, it was corny and trite; as history, it was worse. But that does not diminish the importance of such texts, which were devoured by nineteenth-century white readers hungry for romantic stories about Indians. It was no coincidence, as Werner Sollors has pointed out, that such "idealized imagery of Indians was produced at the height of the Indian removals."[47] Wisner himself, after all, was the newspaper editor who only two years earlier had called so forcefully for local Ho-Chunk eradication. Lest readers forget, he reminds them, in *Romance of the Cliff*, that the "degenerate posterity" of the story's characters still haunts the land.[48]

Tourist developers quickly realized that the "primitive associations" constructed by stories like *Romance of the Cliff* could be more profitably realized if connected directly to the riverscape,

FIGURE 52. Unknown photographer. "View from High Rock." H. H. Bennett Studio postcard, ca. 1970s. Author's collection.

especially in photographs (figure 53). In such a way, Romance Cliff and many other geological formations along the river—Indian Cavern, Cave of the Dark Waters, Indian Lovers' Rock, Squaw's Bed Chamber, Black Hawk's Roost, Black Hawk's Cave, and Black Hawk's Leap—became landmarks, named and storied sites for regional boosters (see map 1). As one of those boosters, H. H. Bennett created many of the most colorful names of these physical-geographical features, which soon became landmarks on the tourist itinerary and greatly enhanced their interest as subjects for his camera. Bennett's son, Ashley, put it directly when he noted that "many of his photographs necessitated his naming the places in the dells."[49]

In particular, these last two landmarks, Black Hawk's Cave and Black Hawk's Leap, achieved renown as the principal sites of a slightly different kind of hidden-trace narrative—the quasi-historical narrative that embellished portions of an actual past. The most important focused on Black Hawk, the Sauk chief who led the last major Native American military resistance in Wisconsin. After the massacre at Bad Axe River ended the 1832 conflict now known as the Black Hawk War, the embattled chief hid among the Ho-Chunk near present-day Tomah before finally surrendering at Fort Crawford several weeks later. According to Bennett and other local boosters, however, Black Hawk made *the Dells* his hideout and was captured there, but not before leaping the Wisconsin River at its narrowest point on horseback.[50]

The legend of Black Hawk's Dells hiding place and heroic equestrian leap, although discounted as fantasy by historians today, quickly became a narrative staple that Bennett fed to tourists who visited his studio and purchased his stereo views. When asked about "Indian legends" in the Dells region, Bennett typically replied that there were two stories worthy of elaboration: "One [*Romance of the Cliff*] is of a trader who was captured by the Indians and rescued by a squaw [*sic*] who proved to be a white girl. Another is that Black Hawk leaped across the narrow place in the Dells." Here, Bennett was not creating new stories, so much as retelling old ones that dated at least as early as the 1850s.[51] Two years after the bitter 1873 Ho-Chunk removal, the local newspaper invited readers to visit Black Hawk's Cave in the Dells and imagine seeing "the old red-skinned villain as we contemplate the deep and dark cavity in which he lay safely ensconced while his enemies were prowling through the underbrush in vain search after his scalp."[52]

There is evidence to suggest that at least some tourists incorporated such hidden-trace narratives into their own experiences of touring the Dells. One visitor from Madison claimed that "In Black Hawk's Cave, with its dark mouth, showing from the black rock you can easily imagine the Indian listening for the white man's tread on the heights above."[53] Similarly, Fanny Kennish Earl wrote of passing Black Hawk's Cave in a tour boat in 1895:

> We peer into its gloom, thrilling with the interest which a human life gives to this grotto beyond all others. After all, there is nothing in nature so rare, so picturesque, so beautiful, that the hope, the love, the hate, the despair of a human soul cannot deepen its tints or intensify the halo that surrounds it. One needs no imagination to picture the stalwart figure in Wisconsin's Indian warfare seeking in the familiar haunts of his tribe a refuge in the hour of his peril, where the determined foes of his race are hot upon his track.[54]

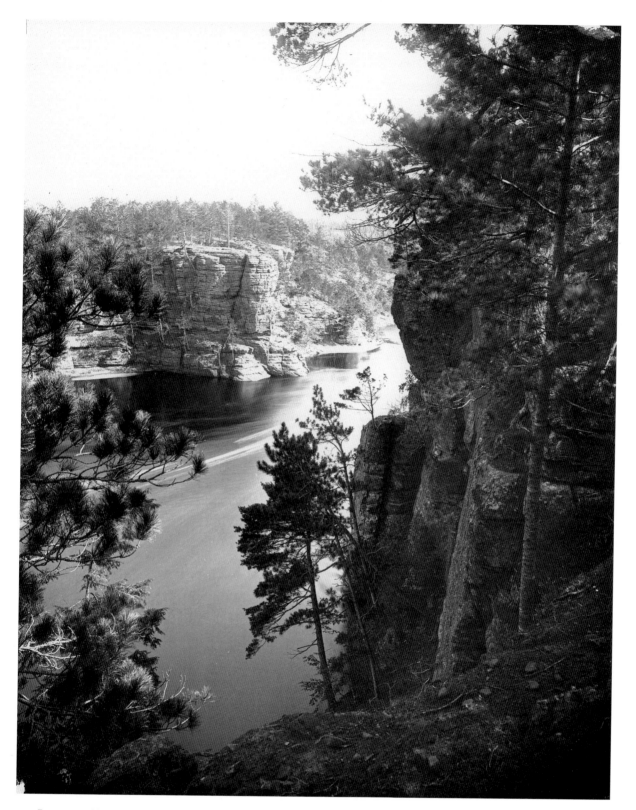

FIGURE 53. H. H. Bennett. "View of High Rock from Romance Cliff." Modern print from original 8 × 10 inch glass negative, ca. 1900. Photograph courtesy of Wisconsin Historical Society, Image ID: 7790.

Another tourist, Elizabeth B. Beebe of Chicago, gave in to the sentimental impulse and wrote a poem of farewell to the Dells, which included these nostalgic lines:

> To Romance Cliff a fond farewell,
> And High Rock, Gateway of the Dell,
> An Indian maiden, legends tell,
> Lept with her lover from the cliff.
> In fancy one can see the whiff
> of smoke from Indian's peace-pipe blown
> Ere Black Hawk took his leap alone.[55]

As seen through a stereoscope, Bennett's photographs successfully translate these stories into the illusion of three-dimensional reality. In "Black Hawk's Cave" (figure 54), the viewer is put in the position of Black Hawk himself allegedly hiding in the dark shadows and peering into the vibrant light of the river and opposite shore. "Overhanging Rock at Black Hawk's Leap," another popular stereograph, even more vividly evokes the hidden trace of the warrior's flight (figure 55). With its dramatic diagonal arc bisecting the photograph, Overhanging Rock presents an ideal platform for a fleeing equestrian.

<p align="center">෴</p>

H. H. Bennett consistently pictured Ho-Chunk people, or their "hidden traces," with an attention to precision and clarity of detail that he brought to all his view photography. His crisp and detailed photographs may have eschewed the soft-focus "pictorialist" style of Edward S. Curtis. Moreover, by striving to provide an accurate name in the Ho-Chunk language for his subjects, Bennett rarely indulged in Curtis's use of exotic titles to accentuate the representation of the "primitive." Overriding these different conventions, however, was a shared commitment to the picturesque approach to Native American photography. Seemingly frozen in time and bearing witness to traditional life, Bennett's studio portraits, outdoor scenes, and hidden-trace landscapes appear to confirm the essential otherness of his portrait subjects.

Despite the upheavals in American Indian life during this period, Bennett's photographs removed historical change from view and represented Ho-Chunk as elements of a fast-disappearing landscape. Nowhere in his oeuvre is there even a hint that the Ho-Chunk Nation had suffered a major catastrophe or that its people were experiencing profound hardship brought about by white expansion. Nor do we see Native peoples performing cultural acts beyond the narrowly defined roles choreographed by the photographer. By depicting Ho-Chunk outside the stream of history, as more aligned with pre-Columbian nature than Gilded Age culture, Bennett's photographs, no less than those of his contemporary Curtis, veiled the "almost endless series of damaging political and economic decisions made by human individuals and agencies."[56]

Underlying Bennett's and Curtis's shared picturesque aesthetic was an ideology—sometimes spoken, often simply understood—that Native Americans were a vanishing race. Even if Bennett rarely put the matter so baldly, others were quick to use his photographs to illustrate the apparent

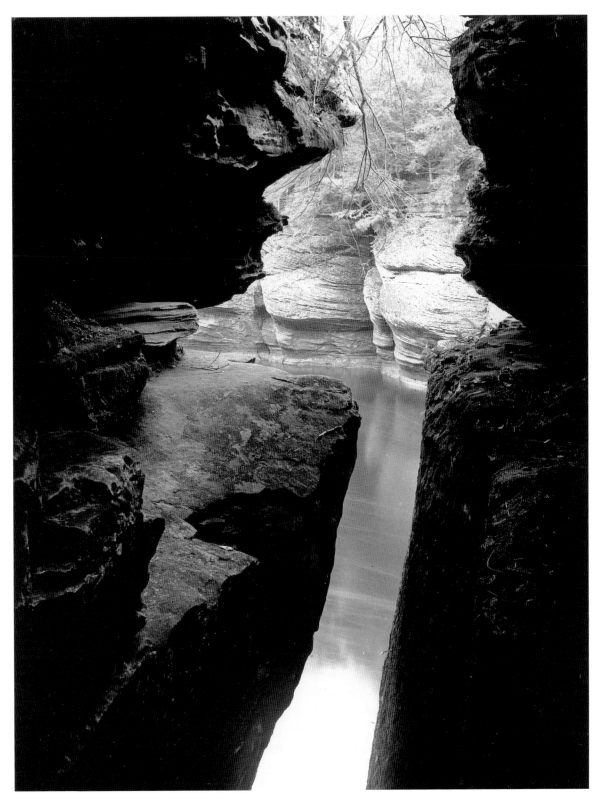

FIGURE 54. H. H. Bennett. "Black Hawk's Cave." Modern print from original stereographic glass negative half, date unknown, after 1883. Photograph courtesy of Wisconsin Historical Society, Image ID: 7268.

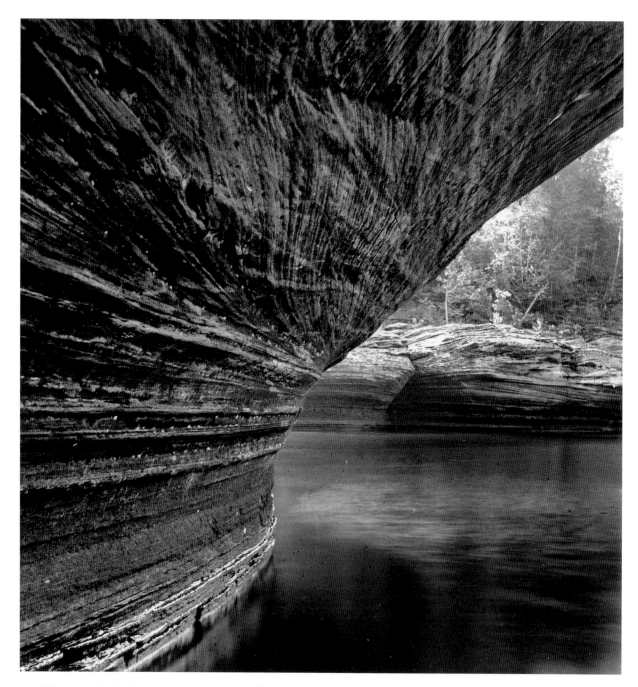

Figure 55. H. H. Bennett. "Overhanging Rock at Black Hawk's Leap." Modern print from original stereographic glass negative half, date unknown, before 1879. Photograph courtesy of Wisconsin Historical Society, Bennett Collection, Neg. 469.

inevitability of indigenous decline. In a 1904 article from the *Milwaukee Free Press* that focused on Ho-Chunk in the Dells and that reproduced four of Bennett's best-known photographs, the author closed with a chilling, but all-too-frequently-stated, view:

> The cold fact probably is that the Winnebagoes are a doomed people. General dissipation is doing much to decimate their ranks and inter-marriage will do the rest. As they now exist, they are interesting but pitiable. They present a problem greater, in some respects, than that of the Negro—especially for Wisconsin—and they will get but little consideration. The sun has gone down on the Winnebago. His day is absolutely done. Destiny!"[57]

Bennett may not have intended for his photographs that accompanied this article—those of He-noo-ke-ku (figure 33), playing moccasin (figure 42), a Ho-Chunk woman tanning a buckskin (figure 50), and Big Bear (figure 68)—to impart such an unsettling message. But once they left the confines of his Wisconsin Dells studio and circulated with other media, his photographs served as visual evidence of a vanishing race—and even as a justification for this increasingly powerful ideology. When Bennett did have the opportunity to gather some of his Ho-Chunk pictures to advertise his own "wanderings," his visual message was equally unambiguous: at the very center of Ho-Chunk life, he wanted readers to know, was a setting sun (figure 56).

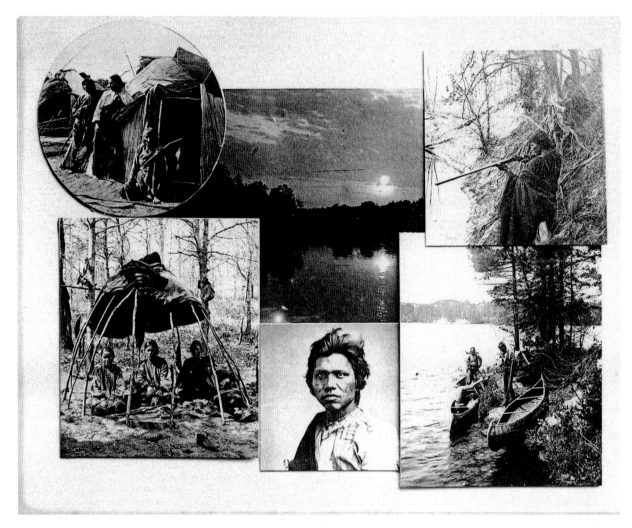

Figure 56. H. H. Bennett. "With the Winnebago's." Page from *Wanderings by a Wanderer* (n.p.: H. H. Bennett, ca. 1890). HHBP, Box 26, folder 1. Composite photograph courtesy of Wisconsin Historical Society, Image ID: 49572.

5

Photographic Practices as Profit-Driven Exchanges

OR ALL THEIR SIMILARITIES, an important difference existed between H. H. Bennett and the better-known and more ambitious Edward S. Curtis. The Wisconsin Dells photographer, like other professional studio photographers of his day, was far more preoccupied by the mundane concerns of obtaining contracts, filling orders, and completing assignments in a timely—and profitable—manner. Although Bennett also enjoyed the patronage of a wealthy entrepreneur to help finance his photographic art, he received considerably less support than Curtis.[1] The workaday demands of running a barely profitable business prevented him from straying too far from his studio, or from envisioning his photographs with the grandiosity of Curtis.

As a businessman, Bennett understood well the allure of Indian representations to a Euro-American stereo-viewing public, and he worked hard to create Ho-Chunk pictures that would have consumer appeal. He was certainly prodded by his "canvassers," traveling salesmen who marketed Bennett's photographic views in towns across the country, to increase his Indian output.[2] He sometimes wrote of his work "cultivating our Indians" and lamented the "slow process" necessary to "get their confidence and good will."[3] Bennett eventually became well acquainted with a number of local Ho-Chunk, encountering them in his Wisconsin Dells studio and at their nearby summer camps.

These transcultural encounters can be characterized as profit-driven exchanges between photographer and the people he considered photographic subjects. While I have argued that Bennett's photographs legitimized the devastating transformation of Ho-Chunk society by hiding those changes from view, it is not enough simply to decry these photographs solely as representations of domination. They are much more complex than that. In this chapter, I build on the work of Nigel Holman, who has explored the history of photography among the Zuni through what he calls a "photography-as-exchange model." Rather than focusing on photography exclusively as a technology of dominance, which he believes "ascribes an unrealistically passive role to Indians and other native peoples," Holman suggests investigating the continuous series of social and economic exchanges between photographer and photographed.[4] A similar

perspective has been recently put forth by Martha A. Sandweiss, who describes the nineteenth-century interaction between white photographer and Native American subject more typically as "a form of exchange" than of abject coercion.[5] Such a line of inquiry complicates our understanding of these important visual images—and of the negotiation, resistance, and survivance that lies at the heart of their creation.

WHITE/NATIVE NEGOTIATION IN PHOTOGRAPHY

Negotiation, in Bennett's case, usually involved monetary compensation. Because his photographs are posed, and often taken with an unwieldy wet-plate outfit requiring long exposure times, one can assume that he received permission to take his published photographs. The candid, stealth-like pictures that we have come to expect from photojournalists in the twentieth and twenty-first centuries were still years away during Bennett's time. And as we have seen, he chose not to photograph nonpicturesque street scenes or work scenes as Van Schaick did. Rather, the transcultural portraits that emerged from his camera were reflective of "a new kind of mutuality developed between the sitter and portraitist," Alan Trachtenberg notes. Such mutuality or collaboration "was based on the recognition, subversive though it was to the authority of the artist-operator, that power over the image lay finally in the will, the attention, the ability of the sitter to strike and hold a pose."[6]

At the heart of this interaction was money. The documentary record shows that Bennett paid Ho-Chunk to pose for the vast majority of his Indian pictures. Economic exchange was a fundamental component of the relationship between Bennett and Ho-Chunk people that lasted for roughly forty years; recognizing this fact is essential to reading the photographs themselves and to uncovering formerly buried moments of Native survivance.[7]

Bennett's cashbooks reveal that he "paid $2 for Indian pictures" in May of 1873, the date of his visit to the homestead of Wah-con-ja-z-gah (Yellow Thunder) (see figure 1).[8] What led to this early encounter is impossible to tell. But photographing the political leader shortly before the twin traumas of coerced removal and the leader's death might have earned Bennett contempt from the community, because his next Ho-Chunk photographs did not come for five more years. Once the threat of further removals subsided, Ho-Chunk leaders apparently made the decision that it was acceptable for Bennett to return for picture making. Between 1878 and 1881, the Dells' photographer made six trips to different Ho-Chunk homesteads, coming away with nearly a dozen photographic views. The timing of these pictures is significant, since most took place in 1880, immediately before the release of Bennett's first catalogue of stereographs.[9]

As a way to diversify his photographic offerings and to cultivate his reputation as one knowledgeable about Indian culture, Bennett's trips to Ho-Chunk villages took on great importance. On these occasions, he paid Ho-Chunk between 70 cents and, for several different photographs during one especially busy outing, $4.25 to pose for his camera; for the moccasin game stereograph (see figure 42), he paid the six men a total of $1.75. These were paltry sums, even for the period, especially since Bennett regularly paid assistants between $2 and $3 to accompany him on daylong photo excursions.[10]

Many Ho-Chunk today, based on what they have heard about the photographer over the years, believe that Bennett never adequately compensated the people in his photographs. More than one describes Bennett "as that white guy who got rich off of us." While my research indicates that Bennett did in fact pay his portrait subjects, it remains an open question whether it was "adequate." Such economic relationships certainly appear, from today's perspective, asymmetrical and manipulative, with Bennett profiting handsomely over the years from several days and a few dollars among the Ho-Chunk. Moreover, when compared to the severe impoverishment of Ho-Chunk at this time, Bennett undoubtedly appeared "rich."[11]

Beyond one-sided manipulation, however, these relationships suggest something else. They mark the beginning of profit-driven exchanges in which Ho-Chunk traded their time and their image as a commodity for badly needed resources. Of course, Ho-Chunk people had long been involved in economic exchange, especially during the early nineteenth century when Wisconsin's lead mining region first attracted white attention. By the turn of the twentieth century, the heavy materiality of lead had given way to the seemingly immateriality of the photographic image as a vital Ho-Chunk commodity.

Chach-sheb-nee-nick-ah (or Young Eagle) was one such Ho-Chunk who saw photography as an opportunity to profit financially, or at least to pay off debt. In June of 1904, Bennett took a fine portrait of this Ho-Chunk man in his studio (figure 57). Set before a painted backdrop, Chach-sheb-nee-nick-ah appears in "full fanciful dress" that includes one of Bennett's recently acquired Navajo blankets. Bennett described him as "one of our most intelligent men," and, indeed, Chach-sheb-nee-nick-ah probably was: posing for Bennett's stereo, 8 × 10 inch, and 18 × 22 inch cameras enabled him to pay off several loans from Bennett of $2.50 and $3.50 and paved the way for the photographer to purchase close to $5 worth of "unidentified objects" from him later that summer.[12] By this time, Bennett had become something of a trading post operator, acting as a pawnbroker for many local Ho-Chunk, a point to which I return in the next chapter.

For now, however, the central point is that Ho-Chunk community members such as Chach-sheb-nee-nick-ah did more than passively endure an encounter with the photographer. His nearly dozen visits to the Bennett studio before and after his June 1904 portrait sitting suggest that he must have exerted some active control over his representation. He and Bennett were certainly well acquainted and involved in a complex series of monetary exchanges, in which Bennett grumbled that he was on the losing end. Ho-Chunk such as Chach-sheb-nee-nick-ah were becoming more adept at bartering successfully with white entrepreneurs such as Bennett, who complained that the Ho-Chunk often traded on their own terms and posed how and when they wanted.

The Navajo blanket was the only studio prop provided, and although he was depicted as "fanciful" and "showy" and was certainly rendered harmless while clutching a tomahawk in the safe confines of Bennett's studio, Chach-sheb-nee-nick-ah quite possibly felt pride in this photograph.[13] Like Ha-zah-zoch-kah (Branching Horns) (shown in figure 34), he refused Bennett's repeated requests to be photographed in the Apache war bonnet. Certainly, his countenance suggests strength, not servility; survivance, not humiliation. Thus, embedded at the heart of such portraits was a tension between the power of the photographer to dictate the circumstances of the transcultural picture-making process and the agency of the portrait subjects to present themselves.

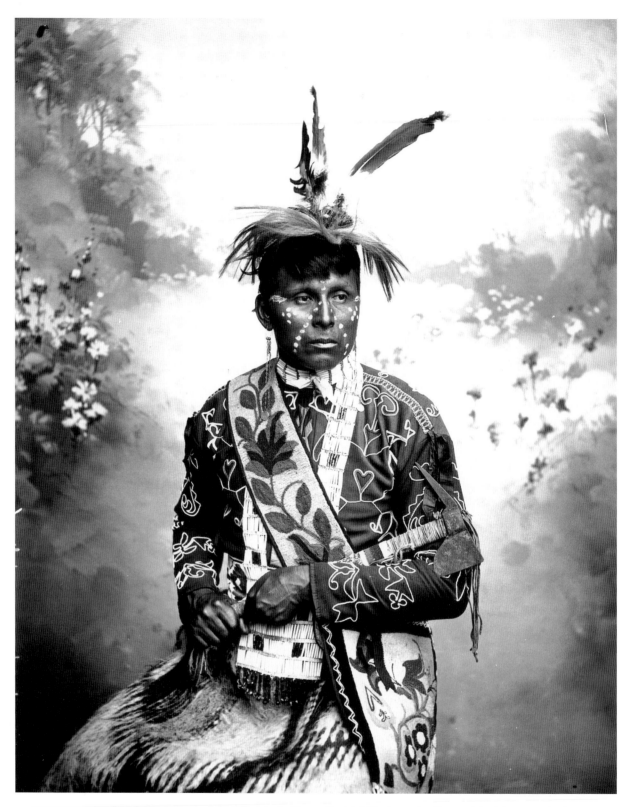

Figure 57. H. H. Bennett. "Chach-sheb-nee-nick-ah (Young Eagle)." Modern print from original 8 × 10 inch glass negative, 1904. Photograph courtesy of Wisconsin Historical Society, Image ID: 2285.

In some instances, photographic encounters were met with enthusiasm and an opportunity for Native subjects to profit (however modestly) from an hour's work; in others, the photographer's insistence that the subjects be pictured in certain ways were met with outright refusal.

HO-CHUNK RESISTANCES TO PHOTOGRAPHY

The elaborate studio photographs of Chach-sheb-nee-nick-ah and Ha-zah-zoch-kah came late in Bennett's career and marked a departure from both earlier portraits and in-situ poses. Their "showiness" in dress, face paint, and backdrop; their multiple camera exposures; and their copyrighted status all indicate Bennett's desire to reach a broader American audience with his Indian pictures. With the exception of these two young men, Native people seemed far less convinced by the advantages of appearing in Bennett's photographs, however. From early on, a number of Ho-Chunk prevented him from making many of the photographs that he—and probably they— knew would bring him money.

When Bennett recounted making his photograph of Wah-con-ja-z-gah (Yellow Thunder), he always told of his difficulty in obtaining permission. He wrote to one friend in 1883 that when he "insist[ed] on making a view of Indian camp, Indians appear[ed] armed with guns and bows and arrows insisting that they don't want [their] camp pictured."[14] His guidebook for that year includes a long biographical piece by a Milwaukee reporter that Bennett deemed, "in substance, correct."[15] In the highly stylized rhetoric of nineteenth-century boosterism, the reporter wrote that "when [Bennett] first attempted to picture an Indian village, the few women about rushed into the wigwams and closed the openings. One dashed through the woods and soon returned with a dozen men armed with bows and clubs. They set up a terrible whoop and made all sorts of hostile demonstrations. 'Indian no want you here,' one of them told him." Typically, Bennett dismissed Ho-Chunk "dread of photography" as superstition, for "no amount of talk could convince them that the mysterious operation of picture-taking was not responsible for death."[16]

Such belittling dismissals of Native peoples' unease with photography were meant to be humorous—look how naive these folks are: they think the camera will kill you. Further reflection, however, suggests that concerns of the potential harm of photography have validity. Certainly, the threat that photographs of the Disaffected Bands of Ho-Chunk—those who refused to remove to territories to the west—could be used for the purposes of surveillance and punishment were very real. Photography, John Tagg documents, has a long history of use by governmental regimes explicitly for the purposes of surveillance, identification, and correction; recalcitrant Indians were merely one more group to discipline. Certainly, Yellow Thunder himself was no stranger to surveillance and confinement. On more than one occasion, he was forcefully transported "by ball and chain" across the Mississippi River before he eventually escaped back to Wisconsin.[17]

More general, even, is the sense of loss when one group relinquishes control over its power of self-representation. Theresa Harlan has written perceptively about such encounters when she notes:

> During the intense period of photo-documentation many Native people tried to avoid the camera, as they feared the photograph would bring illness. Some Native people believed that with each photograph

their souls would weaken. This fear was looked upon as the illogical belief of a backward and simple people. Yet, I believe our grandmothers and grandfathers were right. The loss they sensed was very real and generations later is still felt by Native Americans today. Euro-American photographers contributed to and participated in the replacement of Native-conceived self imagery/identity with that of the Euro-American perceived and projected imagery of Native Americans.[18]

Put another way, Bennett's insistence on "viewing" Indians and selling the resultant photographs clashed with Ho-Chunk discomfort with being the subjects of the camera's lens, a clash that brought into conflict two very different worldviews. At times those conflicts were resolved, and some Ho-Chunk agreed to pose for Bennett's camera; at other times, probably more in fact, the Ho-Chunk held fast to their belief that photography represented an inappropriate intrusion in their lives.

Such beliefs frustrated Bennett, who found that "these Indians are a peculiar people to get along with."[19] Not only did canvassing salesmen ask for more "Indian photographs," but tourists were also demanding more things Indian. It must have pained Bennett, late in his life, to confess to one long-time customer from Chicago that he had no photographs

showing [Ho-Chunk] at their games, hunting or fishing, none of the squaws [sic] with papooses on their backs or carrying heavy burdens. Neither have I any pictures of the dances; this is because I could never persuade the head chiefs to allow pictures taken on those occasions. I speak their language a little and find some of them are superstitious about having their pictures taken and there are enough of that class in such dances as I have attended to rule my camera out.[20]

Although Ho-Chunk might have had little input into precisely how their images were packaged and sold to the American public, they exerted no small degree of control over what was photographed and when.

MAKING UP THE INDIAN

Ho-Chunk resistance to Indian photography and white demand for it occasionally led Bennett to fantastical solutions. In no less than a dozen instances, he plainly fabricated Indian photographic views. The most egregiously phony pictures depicted a local landmark along the Wisconsin River called "Cave of the Dark Waters" or, as guidebook writers fancifully dubbed it, "Place of the Nah-huh-nah."[21] After whitewashing the narrow inlet's walls in order to reflect light better, Bennett placed painted, cardboard cutout Indian figures into the landscape. The lifelike figures were sometimes inserted into a small canoe-like boat or stood alone holding aloft what resembles a sturgeon, which allegedly gave the cave its name (figure 58). Especially when seen through a stereoscope, the combination of cavernous walls, dark foreground and light background, and the reflected figure in the photograph's center produced a dramatic photograph—if a blatantly counterfeit picture of Native life.

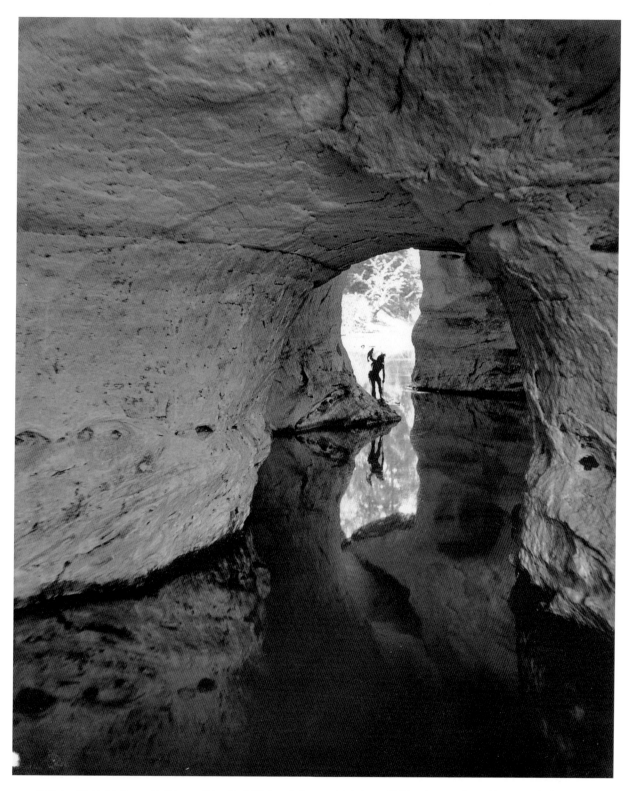

FIGURE 58. H. H. Bennett. "Cave of the Dark Waters." A stunningly beautiful landscape view with cutout Indian figure at its focal point. Modern print from original 5 × 8 inch stereographic glass negative half. Photograph courtesy of Wisconsin Historical Society, Image ID: 7266.

In another type of fabricated view, Bennett created a half-dozen photographs of two or three white men in his birch bark canoe enacting scenes from the imagined Ho-Chunk past. Draped, toga-like, in colorful blankets and topped with chicken-feather headdresses, the "play Indians" are shown paddling the canoe safely to shore, shooting bows and arrows, and bravely fishing in a dark cavern (figure 59). This photograph, and others like it, might be dismissed as silly moments of a good-humored artist, except for the fact that Bennett sold this photograph and other fabrications as "authentic." He reproduced it as a half-tone illustration of American Indian life in his book *The Wisconsin Dells* (1900), and a close facsimile as part of a photomontage entitled "With the Winnebagos" in his *Wanderings by a Wanderer* (1890). Finally, some made-up Indian photographs, such as of a wigwam, an Ojibwe canoe, and a white man with his back to the camera, were considered so valuable that Bennett took out copyright in 1903 (figure 60).[22]

<p style="text-align:center">༺༄ ༄༻</p>

At a time when white Americans everywhere were "playing Indian"—imitating selected elements of Native life to construct their individual and collective identities—such photographs blurred the distinction between the real and the fake, the colonizer and colonized—at least to their white viewers. Native American viewers, if they saw such photographs at all, would surely have been as offended as several contemporary Ho-Chunk to whom I have shown these and other fabricated pictures. Ho-Chunk viewers appreciated the artistry and technical skill that went into the creation of these images, but they also recognized, with Yi-Fu Tuan, that "as imagination reaches toward the excesses and incoherence of fantasy, it can also delude, enchain, and isolate."[23]

Compared with the Black River Falls photographer Charles Van Schaick, who successfully documented a wide range of Ho-Chunk ceremonies, social occasions, and activities of daily life, Bennett had to resort to creative fabrication. Differences in personality and temperament may have accounted for their varying access to Ho-Chunk pictures; some things we will never know, for Van Schaick, unlike Bennett, did not leave personal papers in the form of business records or correspondence.[24] What is known, however, is that the photographic practices of the two varied considerably. The Black River Falls photographer's inwardly focused practices of producing private pictures set him apart from the Dells photographer, whose externalizing practices aimed at an outside audience. The resulting public photographs from Bennett's camera tapped into the national demand for them. Certainly, both Bennett and Van Schaick were commercial photographers who expected to earn a living from their trade. But by restricting his commercial enterprise to satisfy the consumer demands of his patrons, both white and Native, Van Schaick earned the trust and good will of Wisconsin Ho-Chunk in ways that Bennett could not.

One can hardly avoid the conclusion that his difficulties in photographing Ho-Chunk stemmed, in no small part, because they saw Bennett as someone who sought to profit directly from selling their images. Ho-Chunk people, far from the passive subjects of the camera's objectifying gaze, maintained a significant degree of control over their own subjectivity—their survivance. As active participants in the transcultural photographic encounter, Ho-Chunk allowed the tourist promoter to photograph themselves but only when they wanted, where they wanted, and how they wanted. For everything else, Bennett was on his own.

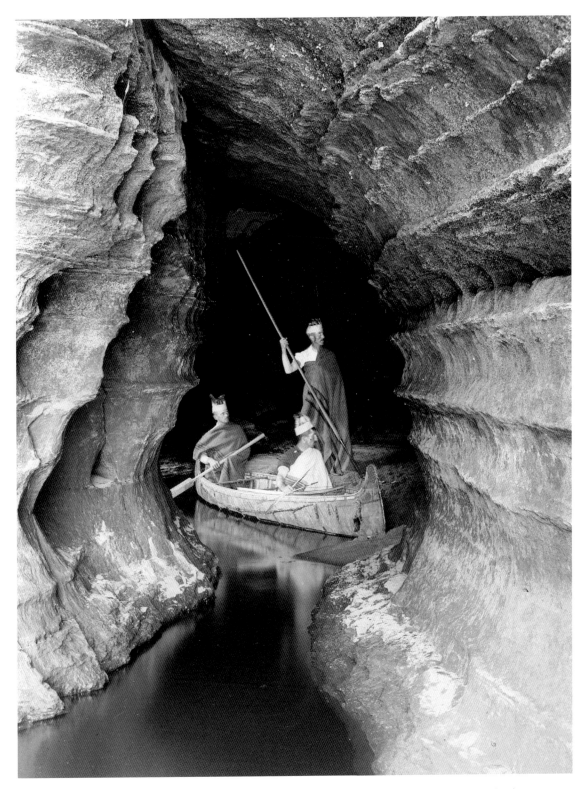

FIGURE 59. H. H. Bennett. "Boat Cave." Three white men "play Indian" in one of Bennett's favorite landscapes. Modern print from original stereographic glass negative half, date unknown. Photograph courtesy of Wisconsin Historical Society, Image ID: 7264.

FIGURE 60. H. H. Bennett. "Chapel Gorge." Modern print from original 5 × 8 inch stereographic glass negative half, 1903. Photograph courtesy of Wisconsin Historical Society, Image ID: 7325.

6

The Changing Political Economy of Indian Photography and Art

D URING THE LAST EIGHT YEARS OF HIS LIFE, H. H. Bennett became increasingly in-
volved with the area's Native inhabitants. The people he had known primarily as portrait
subjects now took on a quite different role in Bennett's life and studio; many Ho-Chunk
were also changed by an expanding engagement with a tourist industry that has come to define
the Wisconsin Dells. "I am only partly a Photographer now," Bennett wrote to a friend in St.
Paul, "selling souvenirs in the tourist season quite as much or more than pictures. Dealing with
the Winnebago Indians of the region, selling them beads, and buying their beadwork, bows and
arrows, and such of their old relics as they want to part with and I can sell." Wistfully, he con-
cluded: "But it's the same old gallery."[1] As his 1904 letter suggests, in a span of less than a
decade, the Bennett Studio had enlarged its activities dramatically, emerging less as a traditional
photographic workshop and picture gallery and more as a frontier trading post, a key economic
and cultural center positioned at the contact zone of Indian-white interaction. Whether or not
it remained "the same old gallery," by the beginning of the twentieth century, Bennett's studio
became a far more complex site of postcolonial encounter between two very different groups
of people, each of whom sought to promote its own, divergent interests with varying degrees of
success (figure 61).

THE CREATIVE DESTRUCTION OF CAPITALIST PRODUCTION AND THE DECLINE OF VIEW PHOTOGRAPHY

Bennett's turn away from producing original photography toward selling Indian artwork came
at a time of great economic pressure on him and all professional view photographers. It was not
a change that pleased him. In the summer of 1903 he complained to relatives of being "driven
nearly wild" with anxiety, and of not "getting time to sleep or eat." Earlier that spring, his busi-
ness presented such "a discouraging outlook" that, were he in better health, the sixty-year-old
Civil War veteran would return "to manual work."[2] Bennett had reason for concern: between

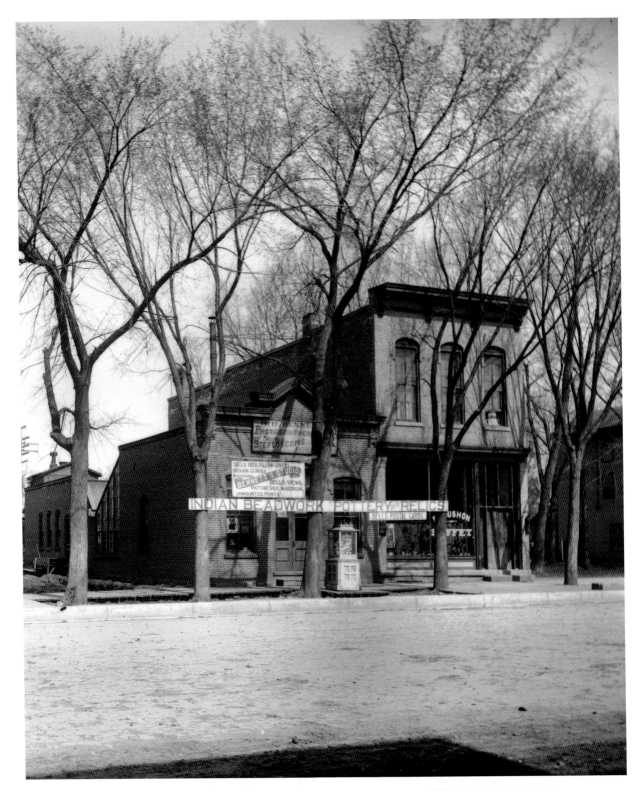

FIGURE 61. Unknown photographer, possibly either H. H. Bennett or Evaline Bennett. Street view of Bennett's studio. Modern print from 5 × 8 inch negative, ca. 1906. Photograph courtesy of Wisconsin Historical Society, Image ID: 8043.

1897 and 1905, sales of his photographs declined by 63 percent. His most profitable year for photography, 1881, brought him nearly $4,000, whereas he netted just over $600 twenty-five years later in 1906.[3]

Such a dramatic decline was not Bennett's alone. Throughout the nation, view photographers found their businesses increasingly under attack by a wide array of structural changes. A revolution in photographic production and distribution system—including the advent of dry plate negatives and flexible films, the appearance of readily available mass-market equipment and supplies at far lower prices, and the beginning of advertising and promotion campaigns emphasizing the ease and fun of personal photography—helped demystify the work of Bennett and other professional photographers. Many tourists, now equipped with their own easy-to-operate

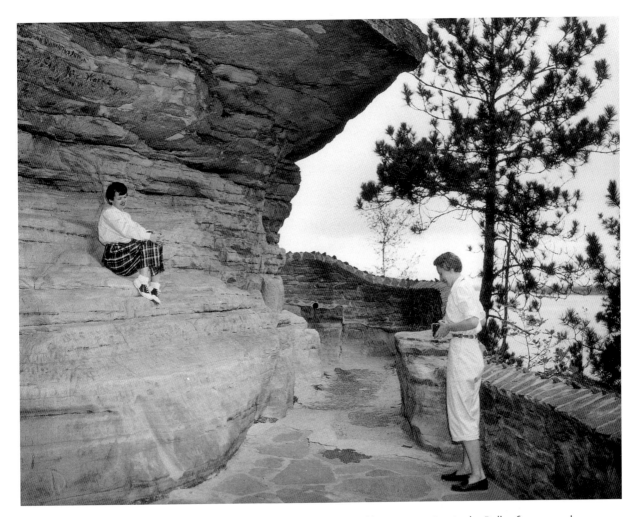

FIGURE 62. Oliver Reese. "Prudential Girls." These young women, like many tourists in the Dells after 1900, chose to make their own photographs and not rely on those produced by professionals like H. H. Bennett. 9 May 1957. Photograph courtesy of Wisconsin Historical Society, Image ID: 42222.

FIGURE 63. H. H. Bennett. Apollo Steamboat with tourists. Modern print from 5 × 8 inch negative, ca. 1900. Photograph courtesy of Wisconsin Historical Society, Bennett Collection, Neg. 3102.

cameras, preferred to produce their own photographs of the Dells landscapes, thus depleting Bennett's clientele and transforming the tradition of outdoor view photography on which his career rested (figure 62). Eventually, snapping vacation pictures on one's own, not purchasing photographs, became a rite of passage for most middle-class American tourists. The Dells photographer clearly recognized the changing business climate. To one former employee, he wrote: "If you ask me what's the matter, I should tell you that the amateur [photography] craze has killed the business for the professional. I don't blame the amateur, only it's unfortunate for those of us who don't know any other way to get bread and butter except with a camera."[4]

In Bennett's case, that was not all. Beginning in the 1880s, a lucrative portion of his trade rested on photographing the excursion boats that plied the Wisconsin River from their docks at the Dells. Bennett, or an assistant, would join the groups, ranging in size from several dozen to a couple of hundred people, and photograph the party at key stops along the river. He would then quickly return to the studio, develop and print "keep-sake photographs," and sell them when the group arrived back in town (figure 63). Such work provided a modest but steady income, earning Bennett nearly $700 in 1891 alone. Even this work dried up, too. The consolidation of the boat business by out-of-state investors denied Bennett access to the market on which he had

come to rely, and indeed had helped invent. His response to such cutthroat business practices was less sanguine than toward amateur photographers. Bennett's despondent wife and business partner wrote in 1902 that the photographer "is not out of the river much this year—is not picturing the boat at all. The relations with the [newly formed] Dells Co. are quite strained and things are very unpleasant this year."[5]

The result of these major technological, economic, and cultural trends was a fundamental restructuring of Bennett's business at a very late moment in his career. Caught in the maelstrom of capitalist transformation, Bennett reacted as best he could, by adapting to his new circumstances—and so, too, did local Ho-Chunk people. It is one thing to observe the "creative destruction" at the heart of modern capitalist production—the incessant breaking down of old patterns of industrial development, with the simultaneous creation of new economic opportunities—from a detached vantage point; it is another thing to live though it and suddenly discover the impossibility of making ends meet. Such intense economic pressure brought on both by changes in photographic practices and by a rationalization of the local tourism industry forced Bennett "to dig out business in other ways." It is here that he turned, once again, to his Ho-Chunk neighbors.[6]

HUSTLING NATIVE ART AND SOUVENIRS

Within a few years of being "driven nearly wild" with anxiety in 1903, Bennett felt better about his economic prospects. In an informative letter to a friend who once worked in the studio, he commented on the changes that had taken place:

> Here in the dark room about everything is just as you last saw it. But if you were to be around here for a few weeks you would likely wonder what has become of my photo view business, for now I am doing very little of it. If you were to look into the front room, you would see what I have been driven into. While a few views are shown, the walls are mostly covered with souvenir goods, burnt leather, burnt wood and all sorts of make believe Indian things. [These hang] beside quite a lot of real and very old Indian relics that I have got from my Winnebago friends. I would rather make and sell views, but the people buy them only in limited quantities so I try to keep what they will buy. With much hustling, we are doing more business in souvenirs the last two seasons than for many years past with photos alone.[7]

Bennett's 1906 letter to Will Holly indicates something of the complex series of social and economic interactions that transformed his business. Like the studios of many other early twentieth-century professional photographers, a vast array of Indian items—both "make believe" and "real and very old relics"—now adorned Bennett's gallery.[8] Bead belts, moccasins, and black ash splint basketry hand-crafted by local Ho-Chunk sat alongside pottery from the Tesuque and Santo Domingo Pueblos of New Mexico. Navajo blankets and Nez Perce war rattles were propped behind "a very large and gorgeous war bonnet of eagle feathers" from Mandan, North Dakota, and a "well decorated" peace pipe that included strings of Iroquois wampum. Next to this vibrant collage of artifacts from exceedingly diverse Native cultures was the "cheap stuff that an Indian

never saw until he saw it hanging in my place": the Indian pipes, tomahawks, decorated wood canoes, paddles, and sweet grass baskets produced by urban manufactures throughout the East Coast. Finally, there were bark picture frames, leather photo albums, china Indian figures, match holders, and "indestructible all-leather dolls"—each marked with the words "Wisconsin Dells" (figure 64).[9]

Thus, by 1906 and in response to the decline of his photographic business, H. H. Bennett had become thoroughly enmeshed in a complex web of commodities and capital that linked his photographic studio to points across the country. Those commodities included four distinct types of items: souvenirs based loosely on Indian motifs; mass-produced goods that bore only a superficial connection to Native American culture; Indian-made crafts and artifacts acquired through national distribution channels; and artwork purchased directly from local indigenous peoples. Maintaining such a complex business, Bennett wrote to his brother John in California, was an intensely time-consuming task, one that hardly allowed him "time to sleep or eat like a white man."[10]

It did not start out this way. Twenty-five years earlier, Bennett had begun dabbling in souvenirs that highlighted what he knew best: the scenic rock formations of the river. These lithographic albums featuring his best-known stereo views were soon supplanted by sofa pillow covers and spoons displaying the scenic wonders of the Dells. Such *souvenirs*, although modest in sales figures, were significant, as they set the precedent for contracting out work that, for the first time, he could not produce himself.

More important were the items that Bennett called *Indian Goods*: the mass-produced tchotchkes that he purchased from manufacturers as far away as New York, Philadelphia, and North Conway, New Hampshire. During the summer of 1900, Bennett placed his first modest orders with the Tanner Basket Company of New York for napkin rings, grass baskets, Indian pipes, and Indian dolls. Those orders increased nearly tenfold over the next six years and grew to include everything from miniature papooses to Indian pipe racks. Such "Indian goods"—disparaged by Bennett as the "stuff that people think they want to buy"—sold well, due, in part, to their low cost.[11] He paid handsomely for these low-cost items, however, especially the grass baskets. It was commonplace for Bennett to go deeply into debt as he occasionally put more than $4,000 into Indian goods—this at a time when the annual sales of photographs brought less than a quarter of that amount.

Bennett was not just purchasing Indian goods from these businesses; he was also selling the handcrafted items that he purchased from neighboring Ho-Chunk artisans and from traders across the country. In a few short years, his studio stocked a vast array of what he called *Indian Crafts*: locally produced artwork and historic pieces acquired through a network of national distributors. Some, like J. S. Candelario of Santa Fe and H. C. Youtz of Cerrillos, New Mexico, were large in scale, with a rationalized system for ordering specific pieces by catalogue. A larger number of distributors were located on reservations—Navajo, Northern Cheyenne, Santee Sioux, Lac du Flambeau—with direct access to the men and women who produced the artwork. Finally, there were individual and family contacts for Indian-made crafts. Bennett frequently called on his brothers and a son living in the West to supply him with "saleable handiwork." "I don't know

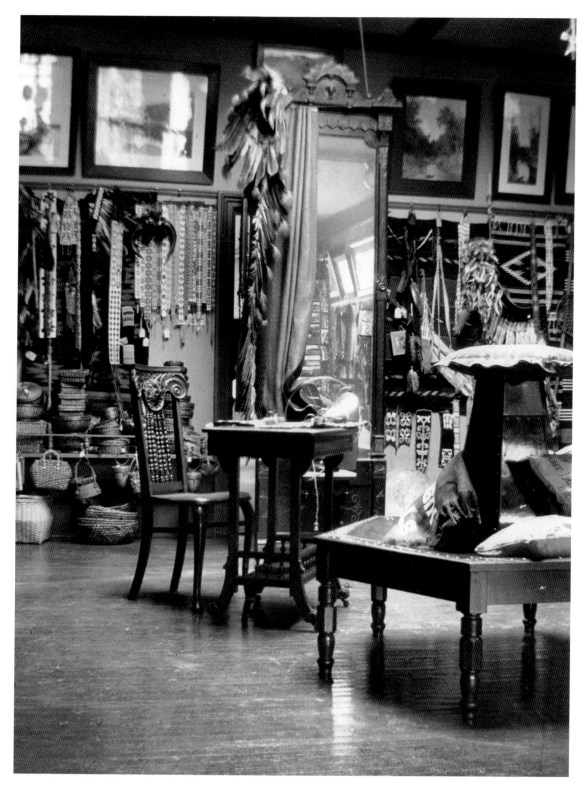

FIGURE 64. Unknown photographer, possibly Evaline M. Bennett. Bennett's studio interior. As this interior view indicates, by 1906 Bennett's studio relied more on the sales of Indian goods than photography. Modern print from original glass negative, ca. May 1912. Photograph courtesy of Wisconsin Historical Society, Image ID: 3998.

as there is an Indian within a hundred miles of where you are," Bennett wrote to his son on the Flathead Reservation in Hot Springs, Montana, "but if there was many thereabouts you might be able to pick up some of their articles that we can use in our trade here."[12] By 1907, he could boast of being able to sell "Indian crafts" from roughly a dozen separate groups, including: Navajo; Dakota from Mandan, North Dakota, and Pine Ridge, South Dakota; two Pueblo groups in New Mexico; Crow; Iroquois; Comanche; Caddo; Tesuque; Nez Perce; Cheyenne; Ojibwe; and Ho-Chunk.[13]

The salability of these Indian-made crafts depended, to a large extent, on a perceived sense of their authenticity, which, by definition, stood apart from modern, industrial capitalism. Unlike souvenirs and mass-produced "Indian goods," Indian-made craft objects acquired value precisely because they were "real," produced by the apparent "primitiveness" of Indian hand labor. At a time when increasing industrialization and corporate control were transforming every aspect of American society, the immediacy of handcrafted artwork must have seemed like a welcome antidote to such enormous changes for many middle-class Americans. Beginning with T. J. Jackson Lears's study of antimodernism at the turn of the twentieth century, historians have long observed that anxieties over that period's tumultuous social forces—mass immigration, industrialization, urbanization—helped trigger a search for authentic experiences in the realm of public culture and in the domestic sphere. Whether or not middle-class Americans found the experiences "authentic" is another question, but where they searched is clear: in the "exotic" displays of allegedly primitive cultures at the great World's Fairs, like Chicago's of 1893, and in pre-industrial and "primitive" hand-crafted goods of Native Americans.[14]

Certainly, an alleged "primitiveness" gave hand-made Indian artwork its cachet. Reflecting on the cultural value of Indian crafts at this time, Leah Dilworth writes "in contrast to industrial work, which was rigidly structured by boss and the clock, was mechanized, urban, repetitive, mindless, proletarian, centralized, and unskilled, artisanal labor was characterized as . . . 'by hand,' rural, traditional, classless, satisfying, local, and skilled." Moreover, it's also clear that such demand was actively created by interests that might benefit from their sale. Western tourist promoters, Indian dealers and traders, curio store owners, and interior design professionals profitably tapped into budding white desires for a sense of the authentic and shrewdly helped stimulate a demand for those very Indian-made products. The broad scale of this advertising work suggests that "primitivism was not the pet project of a small group of avant-garde artists, intellectuals, or authors," but that it reached deep into the American middle classes. Cultural value translated into market value, driving up the prices of such "primitive" artwork. And where prices appeared too high, those with more limited income could always purchase simulated items that contained at least the aura of authenticity, if not its actuality. Within the context of the early twentieth-century United States, no group better exemplified the perceived stability, tight social relations, and supposed primitivism of craft societies better than Native Americans—culturally valuable attributes apparently found in the artwork they produced.[15]

Bennett himself was surprised at the remarkable demand for Indian crafts and wrote quite frequently, and with astonishment, about what he called "the Indian fad." It might be true that the "class of people who come here do not, as a rule, buy very expensive articles," and many

seemed quite content to purchase the "make believe Indian things" assembled at factories in New York. But enough desired "genuine Indian articles" that, at times, he could hardly keep well stocked. In letters to his suppliers, he repeatedly insisted that he only wanted "*real* Indian work and good in design."[16] Unlike factory-produced goods, Bennett wrote to one Arkansas customer, "no two [Ho-Chunk-made crafts] are alike." Despite the extra time that such work takes, Ho-Chunk artisans "seem to be averse to duplicating any piece of their beadwork"[17] (figure 65).

As part of his effort to market the authenticity of Indian crafts, Bennett insisted that suppliers furnish information about the purpose and origin of each article. As Bennett wrote to one supplier from Mandan, North Dakota, his "business depends largely on keeping our visitors interested and any information we can give as to what Indian wore or used the articles or stories

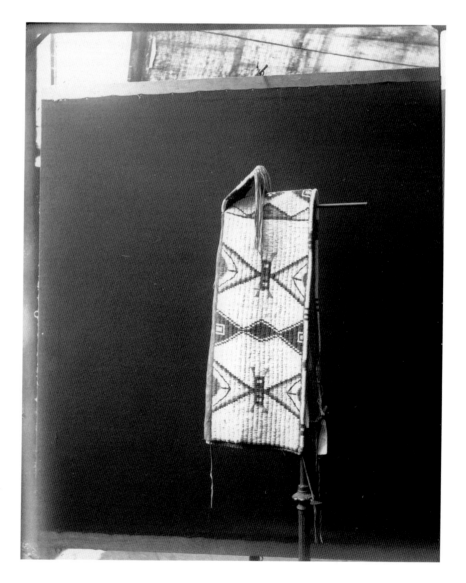

FIGURE 65. H. H. Bennett. Ho-Chunk beadwork, probably papoose case, with porcupine quills. Modern print from original stereographic glass negative half, ca. 1906. Photograph courtesy of Wisconsin Historical Society, Image ID: 8122.

connected with the things is of much value to us." Most notably, he wanted information about the maker of each item. "Names and particulars," he found, "even if they don't come from any Indian of note, have much to do with the selling." Upon the sale of twelve items to the director of the Union Depot, in Chicago, Bennett assured the purchaser that "the name on each tag is really the name of the squaw [sic] of whom I bought the belt or job and who said they made the article. I mention this because in my last season's retail trade I found it of much advantage." Similarly, he thanked the headmaster of the Indian Day School in Manderson, South Dakota, for "the pains you have taken to put the names of the Indians on each article and the information in your letter, all of which adds to the interest and attractiveness of the articles and so makes them more saleable."[18]

On one hand, Bennett's practice of verifying the authenticity of an Indian-made object followed the practice of such well-known collector-dealers as George Wharton James and Grace Nicholson. James, in particular, was an outspoken proponent of authentic Native art and its uplifting effects on white society. In his 1908 book *What the White Race May Learn from the Indian*, he pleaded for

> the white race to incorporate into its civilization the good things of the Indian civilization; to forsake the injurious things of pseudo-civilization, artificial, and over-refined life, and to return to the simple, healthful, and natural life which the Indians largely lived before and after they came under domination.[19]

Such uplift was not possible through the mass-produced Indians goods coming from a New York factory, but through authentic artwork coming from the hands of "real" Indian peoples. Where Bennett departed from James and his contemporaries in the West was in his insistence that authentic items carry the names of the artists who made them. Grace Nicholson, for one, may have wished to learn more about the people from whom she acquired so many Navajo goods, but she rarely, if ever, named them when selling to white patrons. In this way, Bennett's practice of attaching individual names to art products mirrored his practice of naming the people he photographed.[20]

Unlike the anonymous, unskilled factory work that increasingly produced much of the nation's consumption goods, Indian crafts came from the skilled hands and creative imaginations of a single—and, in Bennett's case, a named—individual. In an age of mass production, they were comforting objects to middle-class collector-connoisseurs and "Indian hobbyists" intent on filling their homes with Native artifacts and eliding concerns about an increasingly fragmented urban society. Produced by a wide range of Native artisans, Indian crafts were nevertheless marketed and sold through the highly organized and rational distribution systems of modern capitalism. That system, thoroughly hidden from view, brought together dozens of suppliers and purchasers at Bennett's photographic studio. The result was a complex web of economic interactions born from the creative destruction of Bennett's previous way of life (map 3). For a product whose worth depended, in part, on a perception that it stood apart from modern capitalism, this was no small feat.[21]

A Photographic Studio Becomes a Trading Post

As important as Navajo rugs, Santo Domingo pottery, Apache war bonnets, and Dakota moccasins were to Bennett's business, the most significant items came from the people he knew best and about whom he could tell the most vivid stories. Ho-Chunk artisans sold their first handcrafted object to Bennett in 1883, when he paid $1 for "an Indian bow."[22] He acquired such items slowly and haphazardly for the next twenty years until he noticed that an ever-greater number of tourists began asking for Indian crafts. The timing could hardly have been better for the photographer, whose business had been flagging for nearly a decade. "You see the Indian seems to be a fad just now and their handiwork is quite saleable," he wrote to one brother in 1903. "I am keeping a small stock of seed beads and selling to the Indians and have got them coming my way."[23] A long history of trading, bartering, and negotiation marked the photographic encounter between Bennett and many local Ho-Chunk. It must have seemed logical, then, for each to look to the other when confronted with the newly opening market for Native American products.

Indeed, by spring and through the summer of 1903, hardly a day passed without a Ho-Chunk artisan coming to Bennett's studio. The exact nature of their exchange varied. In many cases,

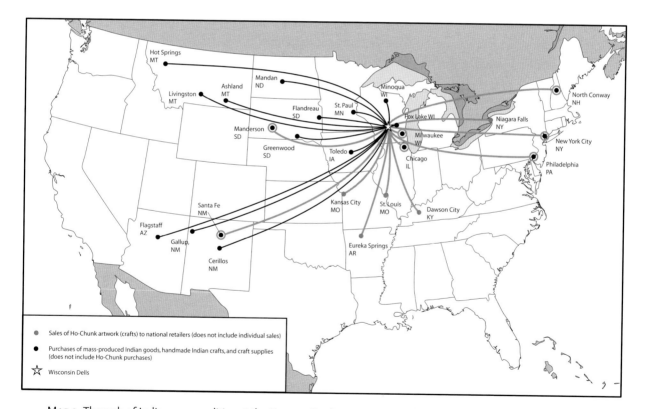

Map 3. The web of Indian commodities at the Bennett Studio, Wisconsin Dells, 1903–1906. Source: Calculated by author from Bennett letters to various correspondents from H. H. Bennett Collection, Microfilm Reels 4–6, Wisconsin Historical Society.

Bennett supplied the beads necessary to produce the fine Ho-Chunk artwork that acquired such high demand. Then, when artisans, mostly women, completed the beadwork they would sell the products to Bennett, who, in turn, retailed them to tourists or wholesaled them to dealers across the country. In other cases, the photographer bartered for one-of-a-kind Ho-Chunk objects such as a bear claw necklace, a war club, an otter-skin medicine charm, and a deer call. Finally, and quite frequently, Bennett made small cash loans ranging from 15 cents to $2.50, keeping items like knives, blankets, beaded shirts, shoes and pants, and bracelets as security.[24] Toward the end of his life he reflected, with a sense of superiority so characteristic of its day, that he hoped that he had "been of some benefit to the Indians of this region and given them some points; but [I] cannot find that I have got them but little trained in the white man's methods."[25]

"White man's methods" meant, for Bennett, economic terms that he found favorable. But, in a contact zone like turn-of-the-twentieth-century Wisconsin, negotiation between these two parties mattered a great deal. By adopting each of these business practices, Bennett was acting in ways similar to Indian traders in the West. As Erika Bsumek demonstrates in her study of Navajo traders, several specific forms of exchange were characteristic of the day and necessary for traders to establish a reputation for fairness and a consistent trading relationship. The first was "lending out," or providing artisans with artistic materials such as beads or wool to ensure that they would return with a finished product. Second was "bartering," itself an outgrowth of gift exchanges, which was defined by "personal interaction, the pursuit of mutual self-interest, and the manipulation of cultural mores."[26] Bartering frequently involved lengthy social rituals and, as one Navajo trader put it bluntly, "patience was needed when dickering for a rug."[27] Third was pawnbroking, the most controversial of all trading practices, but one that held several meanings in a society that was cash poor and where work opportunities were limited. Most importantly, the pawn allowed Native Americans to get the goods and cash they needed during especially lean times. As coercive as it could potentially be—and at one point the federal government sought to eradicate pawnbroking—the practice established long-term bonds based on honor and trust between the two groups.[28]

Although each of these economic relationships was mutually beneficial—Ho-Chunk received badly needed cash, and Bennett gained the artifacts that he sold to keep his business operating—they were always, at their core, unequal. Bennett purchased when and what he wanted, and at prices often favorable to him. Sometimes he returned beadwork, as he did to Choo-nah-hoo-kah (James Standing Water), stating flatly, *Don't send any bead work to me for I can't buy it. White folks don't buy it any more and I have got more than I want.* In letters like this, Bennett sometimes signed his name "Wah-goo-noo-nie-shee-dah-dah-schoon-sckoon," which he translated as "Old Man Got No Money." At other times, his frustration was palpable. He bitterly complained that he was unable to get enough items from Ho-Chunk artisans because they could not be "depended on to furnish any given quantity."[29]

Such inconsistencies in supply and demand—a logic of market capitalism that ran counter to different systems of exchange—must have led many Ho-Chunk to share the same frustrations with Bennett as he did with them. When Bennett grumbled that Ho-Chunk were "stubborn" and "so negligent in the fulfillment of promises that I am getting tired of them," he conjured an

image of primitive people who did not play by the rules of so-called civilized society.[30] What he did not see was a trading partner at once knowledgeable and shrewd, a group of skilled artisans struggling to make an inherently unfair system work in their favor.

In this way, Bennett departed from the business practices of his fellow Indian traders in the West, and he suffered for it. Experienced Navajo traders such as Lorenzo Hubbell routinely bought more items than they apparently needed, in spite of the reasonable prediction that overstocked items would not be easy to sell. Such "overstocking" of goods, a fourth distinct business practice at trading posts, might have carried financial risk for Indian traders but, as Bsumek reports, it was essential in earning the long-term trust of Navajos. By contrast, Bennett's "white man's methods" prevented him from establishing an unambiguous reputation for fairness with his Ho-Chunk neighbors.[31]

When frustrated with Bennett and his refusal to purchase their artwork, Ho-Chunk artisans began to sell their beadwork "directly to tourists and often for less price" than they sold to him.[32] Such economic behavior might appear "irrational," but in the long run, by cutting out the middleman—traders such as Bennett—Ho-Chunk artisans have been able to gain greater economic self-sufficiency and cultural sovereignty. Susie Redhorn, a Ho-Chunk woman whom Bennett regarded as one of the region's most skilled artists, frequently supplied the Dells photographer with her much-valued beadwork. In March 1905, however, she received a curt letter from Bennett, stating that he was "returning the beadwork; there is no sale now for bead belts so I am not buying any more." Although her connection to the Bennett studio persisted, she began selling artwork directly to Dells tourists, making a greater profit and garnering a substantial reputation over the years as one of the region's premier artists (figure 66).[33]

At other times, Ho-Chunk artisans exhibited the sort of assertive economic behavior that, for anyone else, would have been considered rational and astute. Bennett was not the only businessman in town who purchased and sold Ho-Chunk artwork, something that local artisans recognized early on. As if they had read early twentieth-century college textbooks extolling the virtues of laissez-faire capitalism and the power of price competition, economically adroit Ho-Chunk artisans repeatedly played Bennett off other local dealers, forcing up their prices for beadwork. Recognizing the demand for their work allowed Ho-Chunk artisans to compete for the best prices available. In response to savvy Ho-Chunk business practices, Bennett bemoaned his chief competitor's unwillingness to collude with him and set an advantageous price. "McNess makes a fool of the trade by paying them more sometimes than I will for their work which he has to do to get any of it," Bennett complained to his brother. Mostly, however, he blamed Ho-Chunk artisans, who were not content merely to trade on his terms. He lamented to the superintendent of the Indian school on the Pine Ridge Reservation that Ho-Chunk artisans had "learned of the craze for beadwork and are keen for all they can get out of it."[34]

Bennett might have held the balance of power in such relationships (he could always order the products he needed from national distributors), but Ho-Chunk artisans were not without agency. By choosing with whom to trade, by driving hard bargains, and by using the production of artifacts to sustain a culture of geographic mobility, Ho-Chunk artisans successfully made an exploitative process work in their favor. On one hand, Ho-Chunk people were subjected to

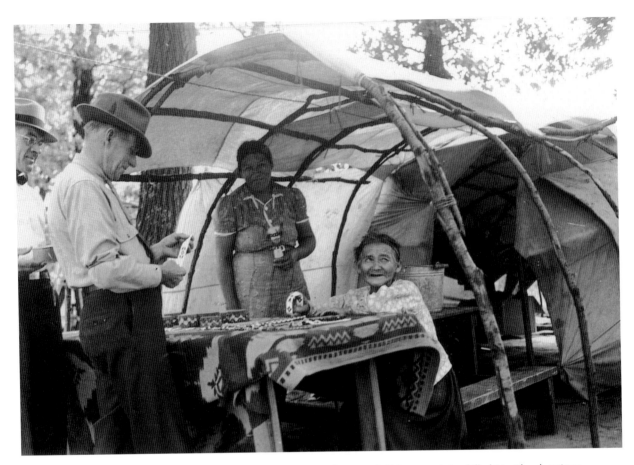

FIGURE 66. Unknown photographer. "Suzie [*sic*] Redhorn Selling Beads." An especially skilled Ho-Chunk artisan, Susie Redhorn sells beadwork directly to tourists at her Dells Park stand. Modern print from copy negative, 1941. Photograph courtesy of Wisconsin Historical Society, Image ID: 36848.

unjust economic circumstances that devalued their skills and their culture, and that made making a living extraordinarily difficult; on the other hand, and seen from a local perspective, Ho-Chunk understood important elements of the marketplace and, as a matter of survivance, worked it as best they could. Although Bennett failed in his bid to have them "trained in the white man's methods," Ho-Chunk artisans used those very methods to their advantage.

LEARNING TO SPEAK HO-CHUNK

An indication of the growing economic interdependence between Bennett and many Wisconsin Dells area Native Americans comes from the photographer's sustained attempt to learn the Ho-Chunk language during the last several years of his life. Even before then, and shortly after their first encounter, Bennett had "made an effort to get a knowledge of the Winnebago language.

But the fight for bread and butter did not allow [him to] accomplish" a thorough understanding. Those earliest attempts to speak Ho-Chunk, dating from the 1870s and 1880s, were limited to learning a few names of individuals and objects that he photographed. Reflecting on these efforts to a friend in Chicago, Bennett believed that his difficulties in learning the language stemmed from his instructors' "good-natured assertion that when [he] said a word or phrase 'all right,'" often the next person he spoke with would not understand him in the least. He therefore "came to feel that such of those people as [he] had the good will of were too easy as instructors to be efficient as such."[35]

Although his Ho-Chunk language teachers remained no less friendly, by 1902 they worked ever more intensively with the photographer—and he learned a great deal. Not surprisingly, the people whom he "had the good will of" tended to be those who appeared in his photographs and supplied him with artwork. With pride, he relayed to Julia Lapham of Milwaukee that local artisans also supplied him with a number of Ho-Chunk names: "The name they call me mostly is Choo-kah-gah, meaning Grand father . . . or sometimes they call me O-gee-wah-gah-kah, in my case meaning the man that takes pictures." Finally, there was the moniker that he occasionally used for himself: "Wha-goo-noo-nick (old man) Shu-dah-dah (money) Shoon-scoon (got none or all gone) this is when I don't wish to lend them money or buy what they have to sell."[36]

Learning the various proper names of the people with whom he had most direct contact became one of Bennett's most important projects; it also proved to be one of the most difficult. As Paul Radin pointed out, individual Ho-Chunk names were based on a plethora of interrelated factors, including clan affiliation, personal achievement, social functions, physiological characteristics, and so on.[37] Bennett, it seems from all available evidence, never understood this sophisticated Ho-Chunk naming system. But to his credit, he endeavored to learn not just an Anglicized name—as, for example, Standing Bear—but the traditional Ho-Chunk name as well, Hoonch-nah-zhee-gah. Traditional Ho-Chunk names thus received primacy, as, for example, when Bennett noted, "Cha-heme-me-nonk-ga-wee-gah is known as Emma Pettibone," or "Hah-nah-nah-schoon-e-gah is known as John Canoe." He often included notes on certain individuals, indicating, for instance, that "Ha-schooh-skah is known as Susie Redhorn, who makes good bead work" and that "Albert Thunder can read and write quite well. Says he has traveled with Buffalo Bill's and other shows." Albert Thunder proved to be an important informant who helped Bennett spell many of the words that he found especially troubling. Almost as frequent were words that described family relationships and which were often used as names: father, mother, oldest girl, fourth boy, and grandfather.

As with most people learning a second language, Bennett devoted considerable energy learning the words for common objects that might be shared between the two cultures. Ho-Chunk words for "clouds," "water," "tobacco," and "potato" were several such nouns. Similarly, simple phrases that might be useful included "writing with ink," "stove has no fire," and "smell good." Although Bennett was not entirely accurate in these transcriptions, especially in his translations of personal names, contemporary Ho-Chunk speakers recognize the sounds that he must have heard and tried to write out phonetically.[38]

One finds the greatest attention and specificity in the realm that Bennett knew best: economic transactions. The photographer undertook exhaustive translations of a wide array of words useful in such exchanges, such as "money," "one dollar," "birch canoe," "beads," "woman's bead belt," "reed mat," "war club of wood," "moccasins," "blanket," "bows and arrows," "baskets," "rattle," and so on. These nouns were supplemented by phrases useful for business relationships, ranging from "not much money," "how much," and "too cheap" to "hard work," "fine, feel good," and "go away."

Notably absent in such exchanges, however, were phrases of friendship that one might expect between two equal parties, like "how's your family" or "come in and have a seat."[39] Contemporary Ho-Chunk conversant in the language point out that Bennett achieved a modest but one-dimensional level of fluency. That he became adept at transcribing words for salable objects and for business greetings, while stumbling at complex personal names or social contexts, should not come as a surprise.[40] After all, the photographer's reasons for learning the language hinged on what would be useful for profit-driven exchanges. In these efforts, Bennett was not alone. As Ruth Underhill found during her anthropological work on the Navajo Reservation, the "trader's life" and livelihood depended on his "ability to please the Navajos"; most of the successful traders learned at least something of the Navajo language. And like Bennett, if they found language barriers to be insurmountable, the most proven response was to offer "a friendly smile."[41]

THE INTERPLAY OF ECONOMIC AND SOCIAL EXCHANGE

Economic motivations may have compelled H. H. Bennett to learn words from the Ho-Chunk language, but as with many transcultural encounters, there was more to it than that. Indeed, economic and social strands of the relationship between these very different people entwined, making it difficult to separate overtly financial motivations from more personal incentives. When asked by the Gimbel Brothers' department store in Milwaukee to "secure the services of a squaw [sic] to do bead work in the store," Bennett wanted assurance that "some one would be expected to be responsible for their proper and fair treatment while there." Patronizing though such words might have been, Bennett recognized that "these people speak American but imperfectly and have never been in a city," thus necessitating such assistance.[42]

Not infrequently, he spoke of these and other "Winnebago friends" with affection, and there is some evidence that Bennett considered them as such. In order to cheer up his homesick son Ashley, who was living in Minneapolis at the time, Bennett sent a bunch of springtime arbutus, given to him by his "Ho-chung-er-rah, Wing chigerah friends." Listing the gift bearers by name—Ha-noosh-noosh coo-noo gah, Khee-khee-gah, Hoonch skah-gah, and Mock-es-sah-ka-wee gah, the wife of Hoonch-nah-zhee-gah—Bennett hoped that "these things please you and help to bring memories of the past." Earlier, when Ashley had been living in Montana, Bennett once wrote that "Big Bear (Hoonch-Schad-e-gah) has been visiting today, he asked about you and wished to be remembered." Unfortunately, no record exists of what Hoonch-Schad-e-gah said to Bennett, or of what any of his other "Ho-chung-er-rah, Wing chigerah friends" told him. However, by closely reading several of the documents—including photographs—that Bennett

left detailing this relationship, the picture of a complex encounter of social and economic inter-
action emerges.[43]

Recall that, at this time, Ho-Chunk artisans visited the Bennett studio regularly—indeed, on
a daily basis during especially busy periods. Throughout his long career, Bennett may not have
been successful in learning a great deal about Ho-Chunk religious beliefs or of the intimate
details of Native life, but on rare occasions some Ho-Chunk taught the aging photographer a
number of words for principal deities, caregivers, and spiritual places. Diary entries and letters
near the end of his life indicate that several Ho-Chunk men and women visiting Bennett's stu-
dio described a few elements of their spiritual practices and sacred beliefs.

One such man was Thomas Ho-pin-kah, with whom the Bennetts shared "a full one hour
[of] genuinely good visit and chat." The grandson of the Ho-Chunk leader Spoon Decorah, whom
Bennett described as "one of the most intelligent and respected of the Winnebago tribe," Ho-pin-
kah was well traveled. The twenty-five-year-old Ho-Chunk man had attended Virginia's Hamp-
ton Institute and Indian boarding schools in Tomah, Wisconsin, and Carlisle, Pennsylvania,
where he was a member of the famed Carlisle Indian School Band. Bennett viewed him with
admiration, noting that Ho-pin-kah spoke "three languages, has written a book for publication
of the Indian legends and traditions . . . and betokens a degree of cultivation far beyond any other
Indian I have known." This last attribute was apparently compromised, in Bennett's opinion, by
the fact that the young man still "clings to many of the traditions of his people." Not one to miss
an opportunity, however, Bennett persuaded Ho-pin-kah to describe some of those traditions,
which he recorded with care.[44]

Bennett studiously documented these conversations, but remained skeptical that he was
learning Ho-Chunk culture in any deep and meaningful way. In response to one correspondent
from Milwaukee, Bennett wrote:

> I cannot help the feeling that . . . the little I have from these people of their legends and traditions
> is so mixed with fancies that are far from history that I cannot feel our Bureau of Ethnology would
> think them worthy of consideration.[45]

Bennett was wise to treat the stories he was hearing with uncertainty, perhaps even more than
he realized. Anthropologists across the United States were busy interviewing Native Americans
at this time, searching for stories of traditional culture. None was more busy in the Great Lakes
region than Paul Radin, whose influential *Crashing Thunder: The Autobiography of an American
Indian* presented the life story of a Ho-Chunk man named Sam Blowsnake. Although Radin
insisted that "everything in this manuscript comes directly from [Sam Blowsnake] as was told in
the original and in the first person," thus making the book an "absolutely and bewilderingly hon-
est account of his life," subsequent research has found that Blowsnake, in fact, had "lied all the
time." Or, perhaps more accurately, Blowsnake regularly blurred the boundaries between fact
and fiction, between interpretation and truth, with contradictory stories that make it impossible
to read *Crashing Thunder* as Radin had hoped—as an objective account of an authentic and rep-
resentative Indian.[46]

Bennett possessed none of the certainty of Radin, whose important ethnographic study *The Winnebago Tribe* was published as an annual report of the Bureau of Ethnology. And Radin, for his part, chose photographers other than Bennett to illustrate *The Winnebago Tribe*. One might surmise that Bennett's photographs were too staged and "showy" for the scientific-minded Radin. But of the two, Bennett seems to have more accurately grasped his own limitations and the true nature of his exchange with Ho-Chunk people.

Cigars, Turkey Feathers, and Fast Cars: Big Bear's Portraits of Survivance

Another Ho-Chunk man whom Bennett knew well was Hoonch-Schad-e-gah, or Big Bear. They became acquainted shortly after the young photographer returned to Wisconsin after the Civil War and remained what Bennett characterized as "friends" for the next four decades. Letters indicate that Hoonch-Schad-e-gah occasionally joined Bennett along the river for photographic excursions and perhaps served as the interpreter who helped the photographer gain admission to Ho-Chunk camps. He also knew Bennett's family, brought them flowers and handpicked berries (as he did when he wished a homesick Ashley well), and from time to time spoke to them about his culture. During his many visits to the Bennett Studio, Hoonch-Schad-e-gah performed medicinal ceremonies, instructed them in the use of tobacco for healing and food preparation, gave them artwork intended specifically as gifts, sold his hand-crafted bows and arrows, and told Bennett a modest amount about his people's spiritual beliefs. As friendly as he was to Bennett, Hoonch-Schad-e-gah was nevertheless careful not to reveal too many important details of his cultural system or spiritual beliefs. Nowhere in Bennett's detailed notes does he even mention the specific clans that defined Ho-Chunk social organization; nor does he discuss the complex array of rituals, practices, and concepts that formed the basis of Ho-Chunk religious beliefs.[47]

Hoonch-Schad-e-gah was more than a pleasant conversationalist for the photographer, however; he was also the person who appears most frequently in Bennett's Ho-Chunk portraits. Pictured no less than seven times in both studio and on-site locations, Hoonch-Schad-e-gah presents something of an enigma. None of the picturesque elements that define Bennett's approach can be found in these photographs of Hoonch-Schad-e-gah: they might be posed, but none are of the sort that might look pleasing in a picture frame; they might conjure images of "the Indian," but that Indian is behaving in a rather unconventional manner. Things are a little odd in Bennett's Hoonch-Schad-e-gah transcultural pictures.

Take the stereograph of Big Bear in Diamond Grotto (figure 67). The "grotto," a small cavern near the entrance to the often-visited Witches' Gulch, was not one of Bennett's most photographed landforms; when he did picture it, he inevitably placed a humorous object of interest at its center—a dog, a cardboard cutout picture of a young girl, a "hermit" with flowing white hair and beard, or, in this case, his Ho-Chunk friend. Hoonch-Schad-e-gah sat for four different negatives here, amid the "grotto's" graffiti-covered walls, each photograph appearing slightly different but all with Hoonch-Schad-e-gah holding the same awkward pose. Wearing the everyday clothes of a late-nineteenth-century Ho-Chunk man, Hoonch-Schad-e-gah signifies his

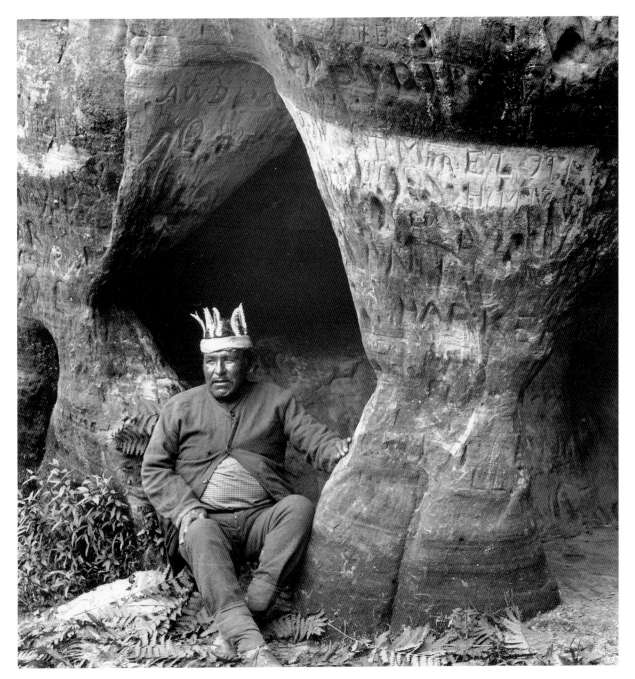

FIGURE 67. H. H. Bennett. "Big Bear in Diamond Grotto." Modern print from original stereographic glass negative half, date unknown. Photograph courtesy of Wisconsin Historical Society, Image ID: 7289.

Indianness with a rather non-traditional headdress of turkey feathers, which would seem to mock stereotypes of generic Indian war bonnets.

Hoonch-Schad-e-gah's clothing is no more fanciful in his series of studio portraits (figure 68). Eschewing Bennett's invitation to adorn himself in some of the photographer's recently acquired articles from western Indian craft suppliers, Hoonch-Schad-e-gah strikes a pose at once threatening and playful. The threat of the Indian holding a bow and arrow is neutralized, and parodied even, by the casual way Hoonch-Schad-e-gah positions himself, grasping his weapon with one hand as he rests casually on his knee, his face in mock grimace. If not exactly "jolly" or "happy go lucky," in the words of one newspaper article that described him, Hoonch-Schad-e-gah was adept at the role of post-Indian warrior of survivance, as Gerald Vizenor puts it. As an active repudiation of tragedy and victimry, survivance is found not in the "fugitive poses" of stoic Indians playing the part of a "vanishing race" but in Native peoples' creative responses to remarkably difficult circumstances. Sometimes, as in Hoonch-Schad-e-gah's example, those responses are tinged with humor. In other cases, Ho-Chunk learned to pose in silence as an act of survivance.[48]

Vizenor describes the strenuous difficulties of survivance, which connotes more than endurance or mere response to calamity, but implies active and creative measures of survival. Photography offered one possible route to survivance even if it also foreclosed it. Hoonch-Schad-e-gah, according to his obituary in a local white newspaper, was a respected leader of the Ho-Chunk Nation, who helped mediate controversies between various tribal factions.[49] Fluent in both the English and Ho-Chunk languages, Hoonch-Schad-e-gah bridged white and Indian worlds; he played on Indian stereotypes, mocking white misunderstandings and teasing viewing audiences. Sometimes, his pictures would seem to slip between confirmation and opposition of white expectations.

Another such photograph, dating just before his death in 1904, shows Hoonch-Schad-e-gah without the props of bow and arrow or turkey headdress (figure 69). Nevertheless, his Indianness is apparent by his skin color just as the whiteness of the automobile's four occupants is confirmed by theirs. Much more than pigment sets apart the central figures of this photograph, however, who are defined most clearly by their relative position to automobile technology. Embracing the new technology are four white men, including the car's driver, H. H. Bennett's son, Ashley, and to his left the well-dressed George Crandall, a prominent businessman and Bennett's son-in-law. Hoonch-Schad-e-gah, conversely, stands at arm's length distance from the automobile. With one hand holding a blanket and walking stick and the other resting against the car's headlight, he seems to be pushing against the tide of progress. The 8 × 10 inch photograph, unlike other Hoonch-Schad-e-gah images, was not meant to be sold to tourists, but rather was intended as a keepsake for the photograph's subjects, including Bennett's Ho-Chunk friend.

It is also a photograph riddled with ambiguity and mixed messages. With a razor-sharp clarity characteristic of Walker Evans's photographs thirty years later, it features a posted sign informing viewers that "NO PERSONS ARE ALLOWED TO RIDE OR DRIVE OVER THIS BRIDGE FASTER THAN A WALK." What are we to make of this sign, centered perfectly above the car? Is Hoonch-Schad-e-gah there to remind the car's occupants of this new rule? It is true

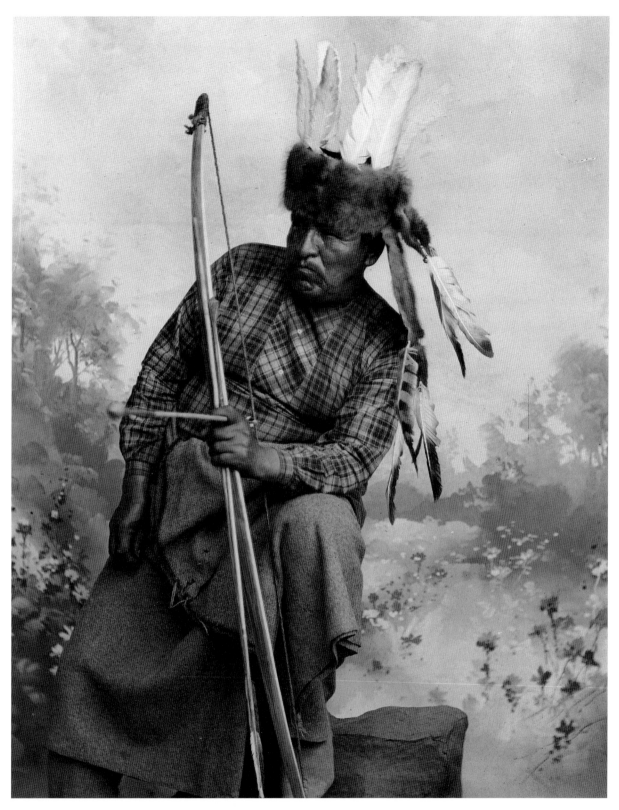

Figure 68. H. H. Bennett. "Big Bear." Modern print from original stereographic glass negative half, date unknown. Photograph courtesy of Wisconsin Historical Society, Image ID: 7565.

that Hoonch-Schad-e-gah is positioned beyond the automobile's immediate sphere, but his bearing and clothing suggest nothing of the stereotypical images of Indians outside the realm of technology and modernity that eventually came to dominate the tourist world (figure 70). In contrast to such clearly coded images, Bennett's photograph stands out for its uncertainty and lack of fixed meaning. "Things get weird," Philip Deloria notes, "when the symbolic systems built on cars and Indians intersect." Reflecting on photographs similar to Bennett's picture of Hoonch-Schad-e-gah, Deloria points out the irony-filled history of automobiles in Native American cultures: "On the one hand, there is a palpable disconnection between the high-tech automotive world and the primitivism that so often clings to the figure of the Indian. At the same time, however, those very distinctions are constantly being squashed back together."[50] If there is a joke embedded in this photograph, both the white driver and Native man, each chewing on a half-smoked cigar, are in on it.

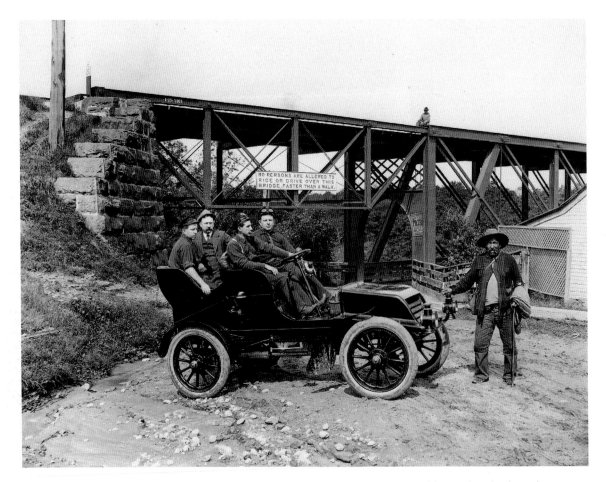

FIGURE 69. H. H. Bennett. Big Bear and automobile, with H. H. Bennett's son, Ashley, at the wheel. Modern print from original 8 × 10 inch glass negative, ca. 1905. Photograph courtesy of Wisconsin Historical Society, Image ID: 4748.

FIGURE 70. Cover, *Rand McNally Official Auto Trails Map for Illinois District 1*, ca. 1920s.
Courtesy of Rand McNally Archives, Newberry Library, Chicago.

As subversive as Hoonch-Schad-e-gah's photographs might have been, ultimately, their use and circulation remained out of his control. How was he to know that, in a Milwaukee newspaper article featuring his portrait with bow and arrow, his legitimate claims to tribal leadership would be sarcastically derided as "an up-to-date representative of true royalty"? How would he have found out that this same article would scoff at his suggestion that he "was one of the 'real' Indians of the section and that many of the younger men were only 'make believes,'" thereby belittling very real and bitterly contentious debates within the Ho-Chunk community about significant matters of assimilation and cultural survival?[51]

Despite such troubling questions, Hoonch-Schad-e-gah, Thomas Ho-pin-kah, and other Ho-Chunk who became frequent visitors to the photographer's studio surely felt a degree of trust and good will toward Bennett that would have been difficult to muster for many whites in town. Hoonch-Schad-e-gah's survivance must be measured within its immediate context, which even as late as the 1960s was one of caste-like poverty for many Ho-Chunk and sometimes hostile race relations. One barometer of local sentiment was the city newspaper, which regularly ran vicious articles condemning the people who refused to leave the increasingly important resort area. In one typical article of 1905, the year of Hoonch-Schad-e-gah's death, the author emphasized the moral distance between contemporary Ho-Chunk and historic Indians:

> Along the first part of the last century, until 1837, the Winnebagos owned all of the land between the Wisconsin and the Mississippi. They were a clean, courageous, energetic people, powerful among the tribes of early Wisconsin." No more: "The 'noble red man' is certainly passing away through a scum of shiftless, pitiful degeneracy.[52]

In comparison, the aging photographer who enjoyed "a genuinely good visit and chat" with Ho-Chunk such as Ho-pin-hah and Hoonch-Schad-e-gah must have seemed different—perhaps even a friend.

<center>∽∾ ∾∽</center>

In return, at a time of serious economic jeopardy, H. H. Bennett turned to Native Americans, who essentially saved his business. The precipitous decline in his studio's total sales reversed its downward spiral around 1900 when Ho-Chunk artisans began supplying the photographer with handcrafted beadwork and black ash baskets. These items, when supplemented by Indian-made crafts purchased from national distributors and mass-produced Indian goods, more than offset the dramatic and continuing fall in receipts from photographs, thus restoring profitability to the Bennett Studio (chart 1).

To achieve this modest success, Bennett worked hard to get the best prices that he could from both consumers and suppliers—as any businessman would. Unfortunately, that meant effectively suppressing the income of the people on whom he had come to rely. Ho-Chunk artisans had become increasingly skillful at negotiating better prices for their work, but they were at a profound disadvantage that Bennett could plainly see. Just as he recognized capitalism's creative destruction of his photographic practice, so too did it become apparent that Ho-Chunk artisans,

however proficient and imaginative, were no match for an increasingly rationalized system of mass-produced Indian goods. To one friend in New York, he wrote in 1907 that "the lot that are near here now seem anxious to do something, or at least part of them do. So I am buying all I dare of what they make. But that is far from keeping them busy, and they can't compete with white man's prices on goods that are made in a factory."[53]

Breaking with his unstated policy of not overstocking Ho-Chunk crafts came a little too late for both Bennett and Ho-Chunk artisans. Linked as they were by the common experience of coping with outmoded systems of production—Bennett with changing photographic production and distribution systems, and a reorganized tourist economy; and Ho-Chunk with their centuries-old practices of food production, geographic mobility, and cosmology under attack from every side—it might be asked: why didn't the Dells photographer do more to assist the plight of his Ho-Chunk neighbors? There was, after all, an almost unconscious kinship between Bennett and the Ho-Chunk people in the Wisconsin contact zone as they each struggled with social and economic forces beyond their immediate control. But the redemption was one-sided: Ho-Chunk people played a key role in salvaging his business, but Bennett never publicly defended the area's indigenous inhabitants by writing a letter to the editor, by putting up posters, by lobbying state and national politicians, or by presenting a counterargument to those that regularly appeared in state and local newspapers.

And yet these are precisely the sorts of political activities that Bennett did pursue during the final years of his life, only not on behalf of the Ho-Chunk. Rather, he parlayed his considerable stature in local cultural and economic affairs into the cause of nature preservation as he fought a well publicized, but ultimately unsuccessful, battle to prevent the damming of the Wisconsin

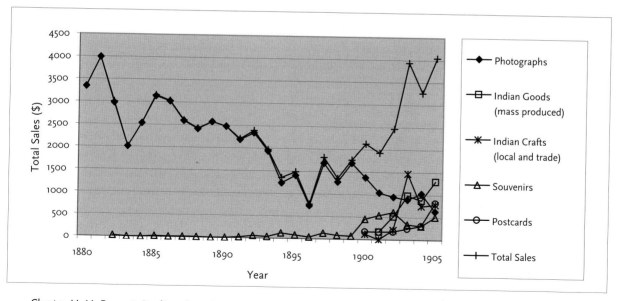

Chart 1. H. H. Bennett Studio sales, 1880–1905. *Source:* Sales figures calculated by author from data in Cashbooks, 1880–1905, Box 35, H. H. Bennett Papers, Wisconsin Historical Society.

River at the Dells. Following a line of reasoning that was applied to the great National Parks of the West, the political causes of nature preservation and Native peoples' sovereignty were considered incompatible. For Bennett, the priority was clear: "one of Wisconsin's beauty spots should be preserved for the people and not sacrificed to the greed of commercialism, in the interests of power promotion." In this 1906 letter to J. H. Davidson, a Republican congressman from Oshkosh, Wisconsin, Bennett laid out a passionate case for "the preservation of beauty" in the Dells, a case that he took to political leaders across the state and country, including U.S. Senator Robert M. La Follette, a staunch ally, and Major William Voorhees Judson, the chief engineer of the U.S. War Department, who wasn't. In pro-dam Kilbourn City, Bennett's vigorous environmental campaign earned him local scorn—during one lobbying trip to Milwaukee, his wife wrote him that local Kilbourn residents had begun to refer to him as "a public enemy"—demonstrating his occasional willingness to take an unpopular course of action.[54]

For their part, Ho-Chunk people made survivance their first order of business. By the 1890s, it had become clear to many that their image—in the form of performances in Wild West shows, as the subject of photographs, and by means of their hand-crafted art objects—had acquired not only cultural value in white society, but market value as well. Wisely, Ho-Chunk men and women such as Hoonch-Schad-e-gah, Chach-sheb-nee-nick-ah, and Susie Redhorn recognized this market value and utilized it in creative ways. The resulting photographic, social, and economic encounters between the Dells' earliest tourism promoter and its indigenous people were highly complex and suggestive of the contradictions inherent in postcolonial relationships more generally. Certainly, these encounters attest to white ambivalence about Indian modernity, but there is something more. By rejecting wage labor (walking away from cranberry harvesting at key moments), by controlling image production (refusing to wear an inappropriate Apache headdress), and by strategizing the means of mass/hand craft production (selling artwork directly to tourists or to other dealers in town), local Ho-Chunk fit into a narrative thread of survivance. Each of these actions—and the stories undoubtedly told about them—suggests presence, self-reflexivity, and agency. A camera might have been a tool of domination, but it could also be turned into a technology of survivance.

As powerful as such actions were in providing a real sense of agency to Wisconsin's Ho-Chunk, it must be remembered that survivance occurs within a context of oppression and struggle. Return, then, to Bennett's studio near the end of his life. His decision, in 1907, finally to overstock Ho-Chunk craft objects did, indeed, come a little too late. What he did not realize was that, one year earlier, the twenty-five-year stipulation concerning Ho-Chunk homesteads expired and, for the first time, their lands were listed on county tax rolls. This unfortunate fact became known to most Ho-Chunk landowners only in 1906, and, when they failed to pay taxes that year, a land company quickly bought up most of their better, suddenly "available" land. Although tax-free status was restored four years later to the remaining homesteads, by then many Wisconsin Ho-Chunk had lost their most precious resource.[55] It's no wonder that so many seemed "anxious to do something."

Epilogue

Picturing Ho-Chunk Today

THE INDIGENOUS TRAGEDY OF A PEOPLE SURVIVING GENOCIDE, orphaned, displaced, and largely deculturated in their own homeland," Lucy Lippard writes, "is *the* tragedy of this country, affecting everyone far more than most of us realize."[1] Photography not only recorded that tragedy but also participated in its performance. By casting American Indians in narrowly defined roles that assumed, and seemed to demonstrate, their inferiority, non-Native photographers such as H. H. Bennett created picturesque visual images that reinforced white cultural assumptions. Those assumptions were based on the erroneous, but pervasive, belief that the old-time Indians—the real Indians—were vanishing.

This could hardly have been otherwise for, as Willow Roberts Powers notes, "photographs taken across cultures make a very uneasy boundary crossing: on each side lie issues of meaning, of different philosophies of knowledge, of infringement of sacred areas, not to mention the sticks-and-stones of bad manners, unequal power relations, and plain, unadorned ignorance."[2] As a product of his age, Bennett shared the dominant culture's conviction that his Native neighbors in the nineteenth-century Wisconsin contact zone were destined to assimilate into white society—to vanish as a people. His studio portraits and in-situ photographs of Ho-Chunk men and women depict "good specimens of Indians as they used to dress," far removed from the struggles, joys, tensions, and beauty of everyday life. A sense of timelessness shrouds his photographs, reinforcing a national wave of Gilded Age sentimentality about "the vanishing race," and cloaking the tragedy of America's imperialist past.

When Rainbow Big Blackhawk looks at Bennett's Ho-Chunk photographs today, he sees what so many non-Natives also see: "the stoic Indian." "But we're so much more than that," he adds, wondering, "where is the humor and wit that, to me, characterize my people?" Like other Ho-Chunk people whom I've asked to look at Bennett's photographs, Big Blackhawk seems unconvinced that they show anything special. The various meanings that these photographs apparently held for Bennett's non-Native viewers—of romance, fantasy, mystery, nostalgia, and guilt—are met with skepticism by Ho-Chunk today, whose interest in them tends to stem more from possible familial connections and the circumstances surrounding their production.[3]

Those circumstances, or photographic encounters, were fundamental components of a power dynamic that enabled tourist promoters such as Bennett to make the replacement of a budding resort area's indigenous inhabitants with pleasure-seeking tourists seem natural and inevitable. That dynamic was never stable, however, and demonstrates a complex series of transcultural exchanges between photographer and photographed that, on occasion, resulted in these important pictures. Sometimes, Native Americans agreed to pose for his camera, while at other times they refused his requests to photograph both ceremonies and individuals in ways that they deemed inappropriate. Photography and, later, the sale of handicraft items became an important form of economic exchange that had significant social implications. That Bennett held the balance of power did not mean that Ho-Chunk passively endured an encounter with the photographer: in important ways, community members controlled the circumstances surrounding their representation (in both photography and artwork) and used it as a means to profit, however modestly.

But that is not all; H. H. Bennett's Ho-Chunk photographs show something else, too. Although manipulated and "constructed," these images nonetheless testify to the endurance, survival, and creativity of indigenous peoples in the American Midwest. Once considered a group on the edge of extinction, Ho-Chunk of the early twenty-first century are a vibrant and thriving community with more than 6,100 enrolled members who hold title to more than 2,000 acres of land scattered across the southern half of Wisconsin. Four profitable gaming operations have generated income and a level of economic self-sufficiency unimaginable one hundred years ago. Making a connection between the past of Bennett's era and the present is important for such Ho-Chunk as Montgomery Green, a retired naval officer who laments growing up without the ceremonies that were an important part of his father's generation. These photographs, he says, give a sense of "traditional life, even if they don't reflect the reality of most people in those days."[4]

Other Ho-Chunk agree that Bennett's photographs bear witness to Native American survivance during unimaginably difficult circumstances. When Chloris Lowe Jr. looks at Bennett's portrait of Chach-sheb-nee-nick-ah (Young Eagle) (see figure 57), he sees someone with composure and pride. "There is a look of defiance in this photograph," Lowe says, "this young man knows what he is doing."[5] Echoing Gerald Vizenor's belief that the crucial stories of Natives in photographs are in their eyes and hands, Lowe maintains that the public face that Chach-sheb-nee-nick-ah imparts to the camera is one of active presence. He rejects the casually stated opinion that the photographic encounter was one of pure victimization: "here is a person who was there [in Bennett's studio] for a reason, he certainly had his own ambitions for this photograph." Chloris Lowe Jr. is not alone in seeing Native survivance in such Indian pictures. His father, Chloris Lowe Sr., views Bennett with a mixture of contempt and gratitude—contempt for the photographer's perceived exploitation of his ancestors, and gratitude for leaving behind a legacy of significant pictures. Indeed, so important is Bennett's photograph of Chach-sheb-nee-nick-ah to the elder Lowe that he lovingly painted a 20 × 30 inch portrait of the Ho-Chunk man that now hangs in the family's formal dining room (figure 71).[6]

Reflecting on Bennett's Ho-Chunk photographs, Chloris Lowe Jr., twice the elected leader of the Ho-Chunk Nation, finds that the camera has long been an important instrument in his personal life and that of his culture. As a young boy growing up in the 1950s, he would frequently

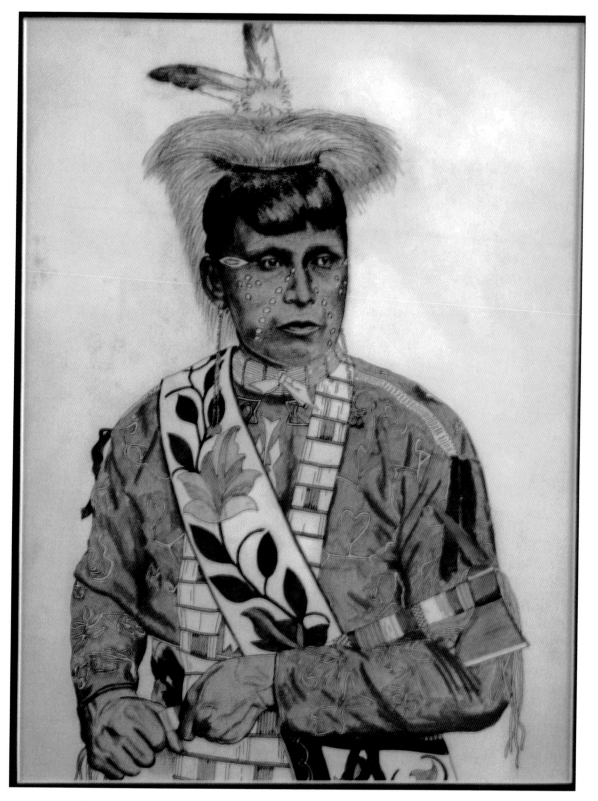

FIGURE 71. Chloris Lowe Sr. *Chach-sheb-nee-nick-ah (Young Eagle)*. 20 × 30 inch watercolor painting, 1993. Photograph by author, reprinted courtesy of Chloris Lowe Sr.

visit his grandparents, who sold beadwork and baskets to tourists at the Dells Park Trading Post (also called "Indian Camp"), located across the river from downtown:

> The tourists would come to the camp and pay to look at us. Imagine that! We always got a kick out of that and thought it was real funny. My grandmother, who was very social and enjoyed meeting new people, would laugh at what she thought were the funny tourists, who treated us like curiosities. In many ways, my grandmother was really a little capitalist, who was very good at working with people and driving hard bargains.

Lowe's father also recalled those experiences. Retired now after more than forty years of work as a long-haul truck driver, the senior Lowe has focused his long-time interest in Ho-Chunk heritage into a successful second career. He is actively involved in the Ho-Chunk Nation's Hocąk Wazija Haci language division, working to preserve his native language and teach it to young people and creating art that reimagines the transcultural encounters in the Dells.

One such artwork is a vibrant watercolor that graces the walls of the Hocąk Wazija Haci language division, near Mauston, Wisconsin (figure 72). The painting depicts his family's summer encampment north of the Dells, where they would sell an array of hand-made baskets and other

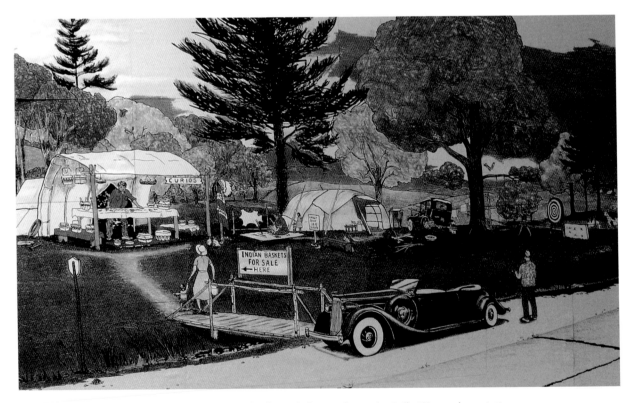

FIGURE 72. Chloris Lowe Sr. *1930s-era Ho-Chunk Roadside Stand near the Dells.* Watercolor painting, 1994. Photograph by author, reprinted courtesy of Chloris Lowe Sr.

"curios." In the picture, a Ho-Chunk man awaits visiting tourists in hopes of making a sale, while a woman weaves a new basket and children play in the warm summer sunshine. Automobiles make a highly visible appearance, with the suggestive contrast between the gleaming tourist car and the "ndn" car, badly in need of repair but an excellent place for a child to play. Characteristically, a white tourist prepares to photograph the scene. As Lowe's son explains, this was entirely characteristic:

> Not only would they sell their artwork, but they would allow tourists to take pictures of themselves wearing blankets and feathers, and get paid for it. Along with seasonal agricultural work, hunting, trapping, and fishing this was an important way for them to maintain economic self-sufficiency—and they did.

Taking this lesson to heart, Lowe began working, when he was fifteen years old, as a performer at the Stand Rock Indian Ceremonial and then, three years later, as a riverboat guide in the Lower Dells. Although the pay on the river was only minimum wage, during the next four summers he earned a considerable sum that more than paid for his college education. What made the difference and helped launch his career was photography. With the assistance of the boat line's white owner, Peter Helland, Lowe had color postcards made of himself on the boat, which he then gave to the more than one thousand tourists who plied the river daily. Although he did not charge for the photographs, the vast majority requested that he sign the postcards; in return, he received tips ranging from 25 cents to a dollar. Over the course of the next four years, Lowe reckons that nearly fifty thousand photographs of himself were distributed to tourists from around the state, region, and world (figure 73). Reflecting generally on the importance of photography, but with clear implications for Chloris Lowe Jr.'s story, the Comanche writer Paul Chaat Smith believes that "the camera . . . was more than another tool we could adopt to our own ends. It helped make us what we are today."[7]

PHOTOGRAPHIC SOVEREIGNTY IN THE ART OF TOM JONES

Today, more than 130 years after Bennett's first photographic encounter with Native people in the Wisconsin Dells, Ho-Chunk like Chloris Lowe Jr. are using photography distinctly for their own purposes. They are also increasingly turning the camera lens back on their own culture, making photographs of their families, friends, and vacations, filling their homes with the private snapshots of ordinary life. And why should this be otherwise? Photography, especially with the emergence of relatively inexpensive digital cameras and printing, is growing in nation-wide popularity. Whether created from one's own camera, or that of a professional, photographs provide an essential technology for remembrance. They help us recall loved ones who might be near at hand, or miles away, as well as important community events such as the annual Memorial Day Powwow (figures 74 and 75).[8]

Tom Jones remembers that as he was growing up he saw members of the Ho-Chunk nation "shooting snapshots of their families like any other family in America," but there was a difference.

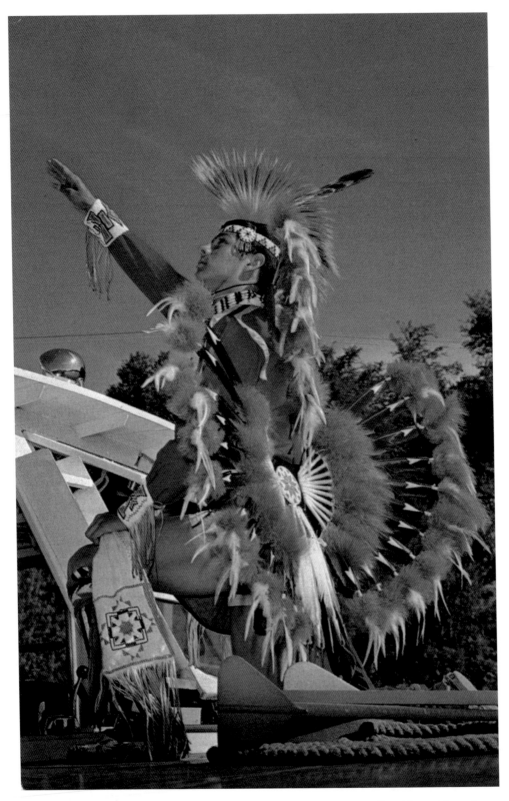

Figure 73. John A. Trumbull. "White Eagle." Chloris Lowe Jr. as Riverview Boat Line guide. 1965. Color postcard courtesy of Chloris Lowe Jr.

"Culturally, a Ho Chunk knows when you can photograph and when it is inappropriate," Jones recalls, noting that Native people are thus more likely to steer clear of the abuses or intrusions of past white photographers. He noticed how important photographs really were in many people's lives, both in private homes as well as in more public settings such as the Memorial Day Pow-wow. There, nearly ten years ago, he observed a circle of seventy-some white-painted flagpoles surrounding the powwow arena that flew the service flags of Ho-Chunk veterans. But the veterans' memorial poles exhibited more than just American flags presented to families of deceased veterans by U.S. Armed Forces, as important as those symbols of national pride and honorable

FIGURE 74. Tom Jones. "Nina Cleveland." 1999. Photograph courtesy of Tom Jones.

service were; quite often, the flagpoles also displayed photographs of the veterans themselves. The photographs, along with selections of medals and often tobacco offerings, were tied to the flagpoles, making the entire structure a cherished memento, carefully tended by a family honoring their departed relatives.[9]

Jones began photographing the veterans' memorial poles, like the one of the decorated World War II veteran Edward Littlejohn Sr., out of his interest in the importance and use of photography in contemporary Ho-Chunk culture (figure 76). Jones's photograph, like the cultural practice that it documents, connects past and present, individuals and a larger community. Placed on the pole by his son, Eliot Littlejohn, himself an Air Force veteran of the Vietnam War, the framed picture commands our immediate attention, but so too does the tobacco basket below. Behind the sharply focused portrait, Jones includes scenes from the powwow grounds, including a booth for United National Indian Tribal Youth (UNITY), reminding viewers that the memorial is part of a dynamic celebration of families and collective memory.

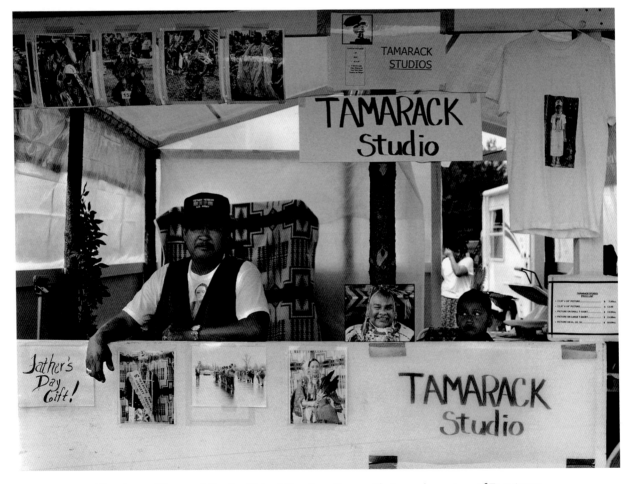

FIGURE 75. Tom Jones. "Tamarack Studio, Cleland Goodbear." 2001. Photograph courtesy of Tom Jones.

Tom Jones's picture of the Littlejohn memorial pole is part of a series of photographs documenting this new tradition among the families of Ho-Chunk veterans today. It is also part of a much larger, and ever-growing, body of work that records "the contemporary life of my tribe, the Ho Chunk Nation of Wisconsin." As he writes in his artist statement for this work, "by doing so, I hope to give both my tribe and the outside world a perspective from someone who comes from within the Ho Chunk community." This perspective is important for Jones, as he explains:

> Traditionally, photographs of Native Americans have been taken by outsiders. We have generally been represented with beads and feathers, widely known though the extraordinary photographic portrayals of Edward Curtis. While this is an aspect of our life, it is not the whole. Like many Native Americans, the Ho Chunk People still adhere to traditional ways in spite of adapting to the white culture that surrounds them.[10]

Jones is not disparaging of Curtis's—or Bennett's—Native American photographs; they are, indeed, "extraordinary." But his is a rather different project, one in which Jones's membership in the Ho-Chunk community creates new opportunities for photographic expression, as well as greater responsibilities.

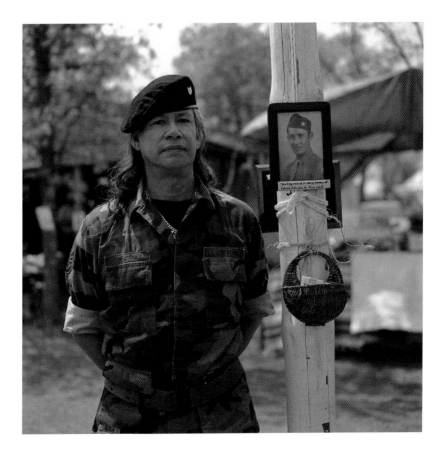

FIGURE 76. Tom Jones. "Eliot & Edward Littlejohn Sr., Memorial Pole." 2003. Photograph courtesy of Tom Jones.

The descendant of a respected Ho-Chunk family—his mother, Jo Ann Funmaker Jones, served as president of the Ho-Chunk Nation from 1991 to 1995—Tom Jones grew up in Florida and spent his summers in Wisconsin. When his family moved back to Wisconsin during his high school years, Jones would often travel from Madison to the Ho-Chunk tribal center in Black River Falls, where he became much more familiar with the community. After earning a B.A. in art from the University of Wisconsin–Madison, he worked mainly in painting for the next decade. Although he had always been interested in photography—his father, Tom Jones Sr., worked as a commercial photographer and always had cameras around the home—Jones only began serious art photography upon his return to a graduate art program. At Columbia College in Chicago, where he earned his Masters of Fine Arts degree, Jones concentrated on photography, with the hope of expanding his artistic output. Counting the masters of documentary photography and the modernist emphasis on abstraction as among his most important influences, Jones endeavors to create photographs that are both aesthetically compelling and rich in archival detail. The principal focus of this work, since the late 1990s, has centered on the Ho-Chunk Nation.

Jones is not alone among Native American artists who have turned to photography, but the group is small. Certainly, Native Americans have been taking photographs for more than a century, since at least 1882 when the famous Hunkpapa Sioux leader Sitting Bull captured a photographer on film.[11] Beyond this earliest instance, professional photographs have long been made by Native Americans: beginning in the end of the nineteenth century, photographers such as Jennie Ross Cobb (Cherokee), Richard Throssel (Metis/Cree), Horace Poolaw (Kiowa), Jean Fredericks (Hopi), and Lee Marmon (Laguna Pueblo) have created a rich collection of pictures that chronicle everyday life and family portraits among a wide range of people.[12]

Still, as Jones is the first to recognize, the number of Native photographers, especially among those considered "artists," has remained limited, although there are more than is commonly recognized. Jones explains that this is partly due to Native skepticism of the camera brought on by an earlier generation's past abuses, some of whom were occasionally "disrespectful and bad mannered people." More important, even, are economic considerations. "This art is very expensive and the access to camera and darkroom equipment difficult" to come by, Jones makes clear.

> Even today in order to be accepted in the art world you must also have a college degree and in most cases a Master of Fine Arts before anyone will look at your work—again economics. What the general public does not understand is that the people from my mother's generation and before were sent away to Indian boarding schools. Here they were taught to darn socks and read bible passages. They were taught trades such as masons, barbers, shoemakers, etc. So, photography would not even be an option in their mind. During the summers they would return home to their families and would do migrant work. They were trying to survive for basic necessities, so economically having a camera was not even an option. Personally, I have seen very few photographs of my mother as a child.[13]

What has changed is access to greater cultural and economic resources that has accompanied political sovereignty, filling Ho-Chunk homes with family snapshots and sending some of its members, such as Tom Jones, to art school. The result is a perspective that might be called

"photographic sovereignty." In a contemporary version of survivance, Native photographers reclaim ownership over how their cultures are depicted by creating visual images that are firmly rooted in indigenous realities. "No longer is the camera held by an outsider looking in, the camera is held with brown hands opening familiar worlds," writes Hulleah J. Tsinhnahjinnie. "We document ourselves with a humanising eye, we create new visions with ease, and we can turn the camera and show how we see you."[14]

The photographs by Tom Jones noticeably evoke the "humanising eye" that Tsinhnahjinnie describes. With humor, a keen sense of irony, and admiration for the people he photographs, Jones pictures Native peoples in a wide range of settings: in their homes, at the powwow grounds, and in their Wisconsin homeland. Occasionally they are shown in ceremonial dress, sometimes they wear ordinary clothes of modern America. Often, as in his photograph of Waylon Welch, a young Mohican boy, his portrait subjects comfortably bridge both worlds, even reclaiming offensive stereotypes from mainstream America (figure 77).

Among the themes most evident in his work is that most human and culturally specific of subjects, the family. Grandparents, children, aunts and uncles, and mothers and fathers are pictured with a warmth and intimacy so often missing in earlier photography. One interesting example depicts "Albert Cleveland with Gabrielle and Olivia Rave," three people of different

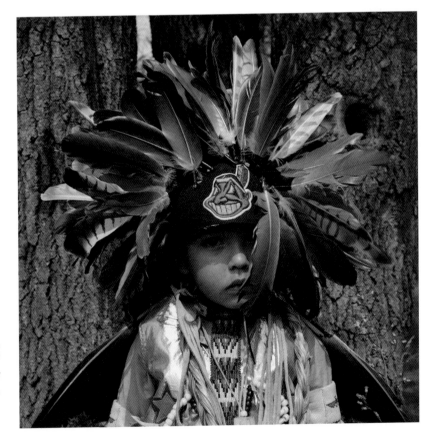

FIGURE 77. Tom Jones. "Waylon Welch, Mohican." 2004. Photograph courtesy of Tom Jones.

generations, each of whom presents a different face to the camera (figure 78). The young man, sitting comfortably in a lawn chair, smiles as he looks to his right. Behind him stand two smartly dressed girls, evidently sisters, with slightly more serious expressions; one girl looks directly at the sitting man, while her sister focuses directly at the camera lens. The portrait's title gives away little about whom we are seeing except, perhaps, that this is not a father with his daughters. Without more explicit captioning, white viewers might simply see two young girls standing behind a seated man. But, as Tom Jones notes, Ho-Chunk viewers recognize this photograph immediately as a picture of an uncle and his two nieces. "The girls' deference—standing with those serious looks on their faces—is indicative of the special relationship of uncles and their nieces and nephews in Ho-Chunk society," Jones explains.

Even more visually complex is "Choka Watching Oprah," one of Jones's most widely circulated and best-known photographs (figure 79). Part of his series of Ho-Chunk elders, "Wank Sheek Ka Day," the photograph resists simple interpretation. Choka, the word for "grandfather" in the Ho-Chunk language, is Jones's own grandfather, Jim Funmaker, and is pictured reclining in the comfort of his own home. As he lifts his sunglasses to watch the television at the end of the room, Choka sees that transcultural elder of American popular culture, Oprah Winfrey. Surrounding Choka and Oprah are the furnishings of the Ho-Chunk elder's private life: an

FIGURE 78. Tom Jones. "Albert Cleveland with Gabrielle and Olivia Rave." 1999. Photograph courtesy of Tom Jones.

enormous tapestry of a grizzly bear, set amid a mountainous landscape, and which also appears to be looking in Oprah's direction; an even larger blanket behind Jim Funmaker with repeating stereotypical images of Indian warriors, moccasins, pottery, drum, and painted buffalo hide; and a dozen framed photographs of family members.

The entire scene is busy, crowded, and perhaps could be read as a critique of the kitschy "Indian" blankets sold to fuel an ongoing "Indian fad." Certainly, the blanket commands our attention as it covers not only Mr. Funmaker's wall but the majority of the photograph as well. But, as art critic Melanie Herzog has written about this photograph, such an interpretation would surely miss the point, for

> this blanket is, for Mr. Funmaker, worthy of display in his living room. As does the bear tapestry, this blanket problematizes an easy reading of Jones's photograph, for its presence demands that viewers also consider the ways that such objects can carry positive and empowering meaning for Native consumers.[15]

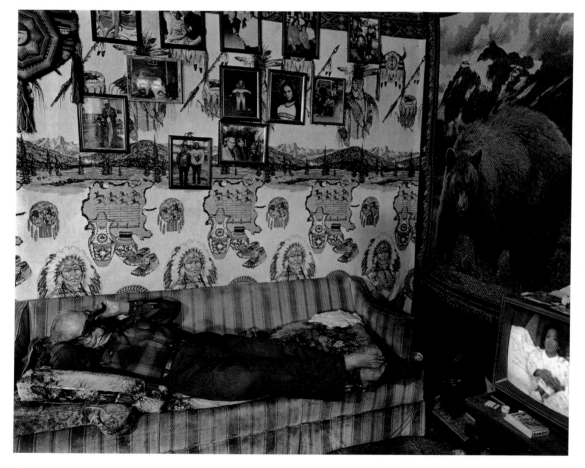

FIGURE 79. Tom Jones. "Choka Watching Oprah." 1998. Photograph courtesy of Tom Jones.

The photograph is filled with paradoxical, affectionate humor, and a great deal of visual information; Ho-Chunk viewers would most certainly understand that Jim Funmaker was a member of the Bear Clan. "Choka Watching Oprah" does more than provide visual data, however, as it also challenges non-Indian viewers to confront their own stereotypes of Native culture.

Irony is a primary filter through which Tom Jones's humanizing eye views its subjects. Whether photographing a young woman in elaborate, full-dress regalia holding an oversize plastic water gun, an old 1980s-era "Indian car" offered in a powwow raffle contest, or his grandfather standing next to a life-size woodcarving out of the Old West and titled "Cowboy and Indian," Jones infuses many of his pictures with a playful irony. Jones's aesthetic of ironic juxtaposition disrupts the binary that separates "pure" or "traditional culture" from "modern" or "contemporary" life—such divisions blur in his photographs the way they do in everyday life.

Take the example of the so-called "Indian" or "ndn" car. Dented, with steaming radiator, and held together with a bumper sticker proclaiming "Indian Power," the "ndn" car is a humorous critique of white expectations of Native automobility. Phil Deloria points to the music of Anishinaabe singer Keith Secola and Spokane writer Sherman Alexie as provocative sources of this humor. To these artists, I would add Tom Jones. Susette LaMere, a Ho-Chunk woman who long worked for the tribe's cultural resources division, agrees. She finds in Tom Jones's aesthetic an important political point: "his pictures break the chain of misunderstanding. He helps people see how all the stereotypes are wrong."[16]

Drawing from his interest in photography and the historic representation of Native peoples, Jones has also begun reexamining early pictures and infusing them with an active Ho-Chunk presence. Jones describes how years ago he "began collecting photographic postcards from the turn of the last century. In one of my searches I came across an image of a beautiful Native American woman with a child strapped to her back. Underneath the image was the caption: *The White Man's Burden*. This image has stayed with me." With this postcard as inspiration, Jones created a series of digital images that give voice and life to once static photographs. He scoured the Internet and neighborhood antique stores for old postcards; then, with computer manipulation, he changed their appearance with superimposed images and provocative captioning. Using the American patriotic song "America" ("My Country 'Tis of Thee") as the thread within the series, Jones employs a line from two of the four standard verses for each of the sixteen individual pieces:

My country, 'tis of thee,
Sweet land of liberty,
Of thee I sing.
Land where my fathers died,
Land of the Pilgrims' pride,
From every mountain side
Let freedom ring.

Our father's God to Thee
Author of liberty,

To Thee we sing.

Long may our land be bright

With freedom's holy light

Protect us by Thy might

Great God, our King![17]

The resulting series, "Dear America," lays bare the paradox at the heart of American civilization: liberty and freedom—arguably the country's most cherished values—came at the expense of the continent's original inhabitants. In one digital image that Jones titles "Our Father's God to Thee," a postcard shows a distant view of the Bethany Indian Mission School, in Wittenberg, Wisconsin, one of the state's numerous boarding schools designed to Christianize and "Americanize" Ho-Chunk and other Native children (figure 80). With several dozen Native children standing and sitting below a balcony with their white teachers, the postcard seems entirely factual in its subject matter. What gives it "punctum," what makes the photograph "sting" contemporary

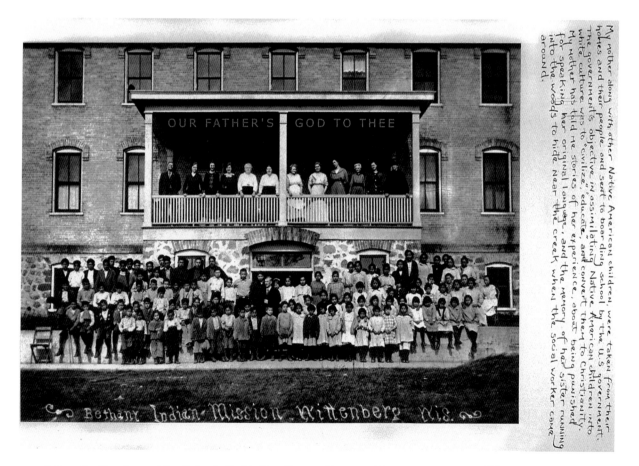

FIGURE 80. Tom Jones. "Our Father's God to Thee." 2002. Photographic montage courtesy of Tom Jones.

viewers, as Roland Barthes puts it, is the potent combination of title and caption that Jones has added.[18] To the block-lettered title, "Our Father's God to Thee," he includes a handwritten note to readers of the length that one might typically find on the back of a picture postcard. The specific note, however, is unexpected:

> My mother, along with other Native American children, were taken from their homes and their people and sent to boarding school by the U.S. government. The government's objective in assimilating Native American children into white culture was to "civilize," "educate," and convert them to Christianity. My mother has told me stories of her experience, about being punished for speaking her original language, and the memory of her niece running into the woods to hide near the creek when the social worker came around.

Such sobering words give the photograph its punctum—the image bruises, stings, and is poignant. The photographic image, like all those in the series, works to subvert our expectations of postcards like this, which typically contain brief, quotidian messages relating to the weather, travel conditions, and date of expected return.

მ ბ

Tom Jones is among a group of contemporary Native artists whose reexamination of historic photographs makes us question our own assumptions of visual images of Native Americans, including those of photographers such as H. H. Bennett. The irony and humor that pervade Jones's photographs seem removed from the picturesque aesthetic that guided an earlier generation of transcultural photographers. It is difficult to imagine a photograph like Jones's "No Cameras," for instance—a picture that pokes fun at the very real issue of obtaining permission to photograph Native Americans—emerging from Bennett's camera (figure 81).

However distant they may be in time, cultural background, personal temperament, and motivation, H. H. Bennett and Tom Jones share something important: an abiding interest in picturing Ho-Chunk (figure 82). Their pictures are different, to be sure. But each, in his own way, records the survivance of people who have been in Wisconsin for a long time. This has not been lost on members of the Ho-Chunk Nation, of course. Tom Jones has seen his photographs displayed at funeral wakes and on the Memorial Day powwow poles—the very poles that he has been documenting for nearly a decade.

And, today, in a remarkable turn of events, Ho-Chunk are not only purchasing land along the Wisconsin River that was taken from them during the nineteenth century, but they are also using Bennett's photographs for teaching young people about their past and for advertising their hugely successful gaming enterprises (see figures 83, 84a, and 84b). The Wisconsin Dells photographer, were he alive today, would probably be surprised that descendants of the people he photographed nearly 130 years ago are still around; Wah-con-ja-z-gah (Yellow Thunder), undoubtedly, would not be.

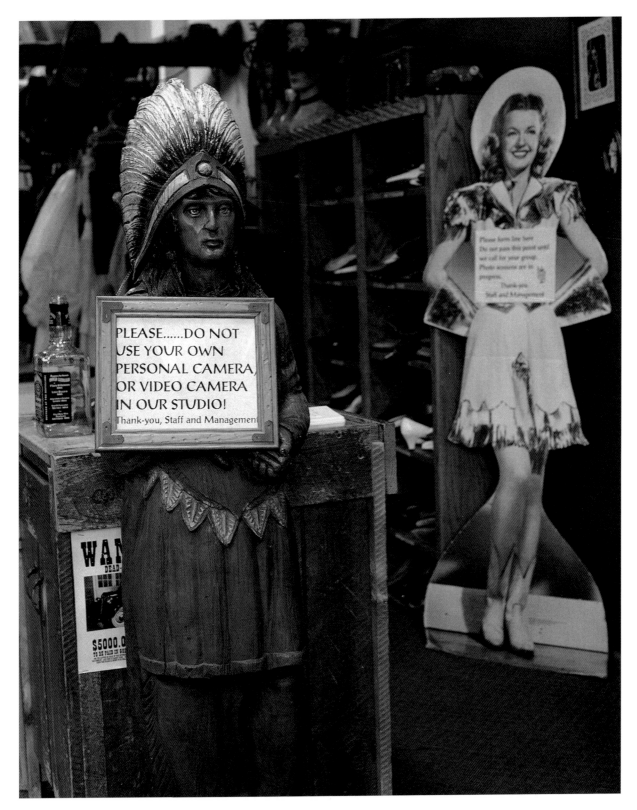

FIGURE 81. Tom Jones. "No Cameras." 2007. Photograph courtesy of Tom Jones.

FIGURE 82. Tom Jones. Madison, Wisconsin, 2006. Photograph by author.

FIGURE 83. Ad from the 2001 Official Wisconsin Highway Map. Published by the Association of Wisconsin Tourism Attractions, Madison, Wisconsin. Reprinted courtesy of the Ho-Chunk Nation.

FIGURE 84a and b. 2002 calendar. Published by the Ho-Chunk Nation, Black River Falls, Wisconsin. Reprinted courtesy of the Ho-Chunk Nation.

Notes

PROLOGUE

1. The Cody reference is from the *Wisconsin Mirror* (undated: ca. 1882), in the H. H. Bennett Miscellaneous Articles Scrapbook, from Reel 7, H. H. Bennett Papers, Wisconsin Historical Society (hereafter, HHBP). Here and throughout, I preserve the original spelling for Ho-Chunk names that Bennett used in his published and unpublished writings. This is problematic because Bennett, according to Nancy Lurie, had "a tin ear" for the Ho-Chunk language; he frequently misinterpreted what he heard. However, Lurie and contemporary Ho-Chunk who are fluent in the language can often make out what he was trying to say. Thus, Bennett's translation of Yellow Thunder, *Wah-con-ja-z*, is phonetically similar to a modern Ho-Chunk translation, *Wakaja Zi*. I thank Preston Thompson of the Ho-Chunk Traditional Court and Hocąk Wazija Haci Language Division for sharing his insights into Bennett's efforts to learn the Ho-Chunk language, about which I have more to say in chapter 6. Lurie, letter to the author, 18 August 2002.

There are, of course, numerous terms to refer to the original inhabitants of North America, including American Indian, Native American, Indigenous, Indian, and Native, as well as the specific names for tribal affiliation, such as Ho-Chunk. Because there is no one agreed-upon way to refer to Native people, I vary the usage throughout the text, keeping in mind that most have their own, personal preference. Similarly, wherever possible, I try to be tribally specific, making clear the important differences between the continent's many Native peoples.

2. Miss Carmel, "A Woman's Way of Seeing Things," *Rockford Morning Star*, 27 August 1899. Reel 7, scrapbook, HHBP.

3. *Melbourne (Australia) Age*, 21 October 1893; reprinted in *Milwaukee Sunday Telegraph*, 12 December 1893, Bennett Scrapbook, Reel 7, HHBP. The article's author, one of twenty-nine international members of the World's Fair Foreign Commissioners and newspaper correspondents, visited the Dells while on assignment at the 1893 Chicago World's Columbian Exposition. He notes that "the local photographer was on board, and I kept close to his side, for I found he had been one of the earliest settlers in the district, when Indians actually did roam along these river banks, and possessed an inexhaustible fund of anecdote and information." Bennett's photographic encounter with Wah-con-ja-z-gah is also described in his 1883 photographic catalogue, *Wanderings Among the Wonders and Beauties of Western Scenery*, 1883, Box 25, Folder 18, HHBP. The catalogue includes an article written by a journalist named Kaine that first appeared in the *Milwaukee Sentinel* on 28 January 1883.

4. I would like to thank Willard Lonetree and Susette LaMere of the Ho-Chunk Nation for bringing this important, and consistently neglected, observation to my attention. Interview with the author, 11 January 2002, Wisconsin Dells, WI.

CHAPTER 1. CONTACT ZONES

1. Jolene Rickard, "The Occupation of Indigenous Space as 'Photograph,'" in *Native Nations: Journeys in American Photography,* ed. Jane Alison (London: Barbican Art Gallery, 1998), 57–71, quote on page 57.

2. Robert F. Berkhofer Jr., *The White Man's Indian: Images of the American Indian from Columbus to the Present* (New York: Vintage Books, 1978).

3. See, for example: Patty Loew, *Native People of Wisconsin* (Madison: Wisconsin Historical Society Press, 2003), iii, 61, 63; Zoltan Grossman, "The Ho-Chunk and Dakota Nations," in *Wisconsin's Past and Present: A Historical Atlas,* ed. Wisconsin Cartographers Guild (Madison: University of Wisconsin Press, 1998), 10; Robert E. Bieder, *Native American Communities in Wisconsin, 1600–1960: A Study of Tradition and Change* (Madison: University of Wisconsin Press, 1995), 112; Nancy Oestreich Lurie, "Winnebago," in *Handbook of North American Indians,* ed. Bruce Trigger (Washington, DC: Smithsonian Institution Press, 1978), 702.

4. Rick Hill, "High-Speed Film Captures the Vanishing American, in Living Color," *American Indian Culture and Research Journal* 20, no. 3 (1996): 114, 117. See also Richard W. Hill, "Developed Identities: Seeing the Stereotypes and Beyond," in *Spirit Capture: Photographs from the National Museum of the American Indian,* ed. Tim Johnson (Washington, DC: Smithsonian Institution Press, 1998), 139–60.

5. Walter Benjamin, "The Work of Art in the Age of Mechanical Reproduction," in *Illuminations,* ed. Hannah Arendt, trans. Harry Zohn (New York: Harcourt Brace Jovanovich, 1968 [1936]), 226; Hulleah J. Tsinhnahjinnie, "Compensating Imbalances," *Exposure* 29, no. 1 (1993): 29–30.

6. Susan Sontag, *On Photography* (New York: Farrar, Straus and Giroux, 1977), 64. Vine Deloria Jr., introduction to *The Vanishing Race and Other Illusions: Photographs of Indians by Edward S. Curtis,* by Christopher M. Lyman (Washington, DC: Smithsonian Institution Press, 1982). The model of photography as a tool of domination is employed most vigorously in James C. Faris, *Navajo and Photography: A Critical History of the Representation of an American People* (Albuquerque: University of New Mexico Press, 1996). For a useful overview of another group's use of photography at roughly the same time to accomplish similar goals, see James R. Ryan, *Picturing Empire: Photography and the Visualization of the British Empire* (Chicago: University of Chicago Press, 1997).

7. For a sophisticated discussion of photography as artistic and political representation, see Mick Gidley, *Edward S. Curtis and the North American Indian, Incorporated* (Cambridge: Cambridge University Press, 1998). Three recent volumes making a strong case that non-Natives frequently used photography as "a weapon of colonization" to project white, colonial viewpoints onto Native American culture are Alison, *Native Nations;* Johnson, *Spirit Capture;* and Lucy R. Lippard, ed., *Partial Recall: Photographs of Native North Americans* (New York: New Press, 1992).

8. P[atrick] Donan, *The Tourists' Wonderland: Containing a Brief Description of the Chicago, Milwaukee, and St. Paul Railway Together with Interesting General Descriptive Matter Pertaining to the Country Traversed by This Line and Its Connections* (Chicago: R. R. Donnelley and Sons, 1884), 7.

9. Benjamin, "Work of Art," 226. Jennifer Green-Lewis makes a similar point when she writes that "instead of focusing on disparate images, 'interrogating' old photographs for the information we suspect they harbor, or treating them as unmediating windows on a nineteenth-century world, instead of revisiting only those versions of it which are regularly displayed, we must explore photography as a cultural practice, trace its significance in social as much as aesthetic terms." Green-Lewis, *Framing the Victorians: Photography and the Culture of Realism* (Ithaca, NY: Cornell University Press, 1996), 19.

10. Mary Louise Pratt, *Imperial Eyes: Travel Writing and Transculturation* (New York: Routledge, 1992), 4–8. I thank Walter Metz for first bringing this important connection between postcolonial theory and Native American photography to my attention at the Visual Cultures symposium in Berlin, Germany, April 2005.

11. Ibid., 6. Several recent and important books on Native American photography that make use of a similar theoretical model are Laura Wexler, "Käsebier's Indians," in *Tender Violence: Domestic Visions in an Age of U.S. Imperialism* (Chapel Hill: University of North Carolina Press, 2000), 177–208; Frank H. Goodyear, *Red Cloud: Photographs of a Lakota Chief* (Lincoln: University of Nebraska Press, 2003), 3–7; and Carol J. Williams, *Framing the West: Race, Gender, and the Photographic Frontier in the Pacific Northwest* (Oxford: Oxford University Press, 2003), 27–29.

12. In addition to Pratt, *Imperial Eyes*, I have found two recent books to be especially helpful: Robert J. C. Young, *Postcolonialism: An Historical Introduction* (Malden, MA: Blackwell, 2001); and Bill Ashcroft, Gareth Griffiths, and Helen Tiffin, *The Empire Writes Back: Theory and Practice in Post-Colonial Literatures* (New York: Routledge, 2002). More directly relevant to photographic representational practices and colonialism are Ryan, *Picturing Empire;* and Eleanor M. Hight and Gary D. Sampson, *Colonialist Photography: Imag(in)ing Race and Place* (London: Routledge, 2002).

13. Alan Trachtenberg, *Reading American Photographs: Images as History, Mathew Brady to Walker Evans* (New York: Hill and Wang, 1989), 29. See also Williams, *Framing the West.*

14. Nigel Holman, "Photography as Social and Economic Exchange: Understanding the Challenges Posed by Photography of Zuni Religious Ceremonies," *American Indian Culture and Research Journal* 20, no. 3 (1996): 94. See also Victoria Wyatt, "Interpreting the Balance of Power: A Case Study of Photographer and Subject in Images of Native Americans," *Exposure* 28, no. 3 (1992): 23–33.

15. Goodyear, *Red Cloud,* 16.

16. Paul Chaat Smith, "Every Picture Tells a Story," in *Partial Recall: Photographs of Native North Americans,* ed. Lucy R. Lippard (New York: New Press, 1992), 94–99, quote on page 97. Gerald Vizenor, *Fugitive Poses: Native American Scenes of Absence and Presence* (Lincoln: University of Nebraska Press, 1998). The critical role of technology in Native survivance is provocatively addressed in Philip J. Deloria, *Indians in Unexpected Places* (Lawrence: University Press of Kansas, 2004), 136–82.

17. Vizenor, *Fugitive Poses,* 15. See also Gerald Vizenor, *Manifest Manners: Postindian Warriors of Survivance* (Hanover, NH: Wesleyan University Press, 1994).

18. Author's field notes from the National Museum of the American Indian, 5 November 2005. The panel's text is attributed to Paul Chaat Smith. Useful overviews of the NMAI, with discussions of how the museum deploys the concept of survivance, may be found in Amanda J. Cobb, "The National Museum of the American Indian as Cultural Sovereignty," *American Quarterly* 57, no. 2 (June 2005): 485–506; and the articles in the special issue of *American Indian Quarterly* 29, nos. 3/4 (Summer/Fall 2005). In one especially fine essay, Ho-Chunk scholar Amy Lonetree calls indigenous survivance "the central message of the museum." Lonetree, "Missed Opportunities: Reflections on the NMAI," 642.

19. These extremely valuable materials are now part of the H. H. Bennett Collection at the Wisconsin Historical Society.

20. Devon Mihesuah, introduction to *Natives and Academics: Researching and Writing about American Indians,* ed. Devon Mihesuah (Lincoln: University of Nebraska Press, 1998), 2.

21. Michael Katakis further emphasizes the need for people in the photographs, and their descendants, to provide an interpretive lens: "This is a piece of the puzzle that has been missing for so long, and it must be very important piece, because for decades their voices have been purposely excluded." Katakis, "The Illusion of the Image," in *Excavating Voices: Listening to Photographs of Native Americans,* ed. Michael Katakis (Philadelphia: University of Pennsylvania Museum, 1998), 1–5. For useful, methodological statements on the issues confronted in this research, see Ira Jacknis, "Preface to Special Issue on the Photography of Native

Americans," *American Indian Culture and Research Journal* 20, no. 3 (1996): 1–14; and Willow Roberts Powers, "Images across Boundaries: History, Use, and Ethics of Photographs of American Indians," *American Indian Culture and Research Journal* 20, no. 3 (1996): 129–36.

22. Shawn Michelle Smith, *Photography on the Color Line: W. E. B. Du Bois, Race, and Visual Culture* (Durham, NC: Duke University Press, 2004), 3.

23. Rickard, "Occupation of Indigenous Space," 57–71.

24. Lucy R. Lippard, introduction to *Partial Recall*, 13–45.

25. *2006 Travel and Attraction Guide to the Wisconsin Dells, the Waterpark Capital of the World* (Wisconsin Dells: Visitors and Convention Bureau, 2006), 4.

26. Lance Tallmadge quoted in *Thunder in the Dells*, a Wisconsin Public Television documentary co-produced by Dave Erickson and Lance Tallmadge (Spring Green, WI: Ootek Productions, 1992).

27. Albert Yellow Thunder quoted in Don Saunders, "When the Moon Is a Silver Canoe: Legends of the Wisconsin Dells" (Wisconsin Dells: Don Saunders, 1947), 4, Wisconsin Historical Society Pamphlet Collection, Pam 56–207. A short biography of Albert Yellow Thunder may be found in Michael Goc, *Others before You: The History of Wisconsin Dells Country* (Friendship, WI: New Past Press, 1995), 328.

28. J. G. Norwood, "Owen's Geological Reconnaissance of the Chippewa Land District," Senate Ex. Doc. 57, 30th Cong., 1st sess. (Washington, DC: GPO, 1848), 108.

29. I. A. Lapham to Ann M. Lapham, 7 June 1847; 7 May 1848; I. A. Lapham, "Lecture to the Unitarian Church, Milwaukee, 4 February 1848; and I. A. Lapham, "Geological Note of a Tour to the Dells," 22 October–1 November 1849, both from the Increase A. Lapham Papers, Box 2, 1844–1849, Wisconsin Historical Society, Madison. I. A. Lapham, *Wisconsin: Its Geography and Topography, History, Geology and Mineralogy*, 2nd ed. (Milwaukee: I. A. Hopkins, 1846).

30. Lawrence Martin, *The Physical Geography of Wisconsin* (Madison: University of Wisconsin Press, 1965), 345; Robert H. Dott Jr. and John W. Attig, *Roadside Geology of Wisconsin* (Missoula, MT: Mountain Press, 2004); 208–9; Saunders, "When the Moon Is a Silver Canoe," 2.

31. Dott and Attig, *Roadside Geology of Wisconsin*, 187–211. Also useful are several historical summaries of the region's geology; see Rollin D. Salisbury and Wallace W. Atwood, *The Geography of the Region about Devil's Lake and the Dells of the Wisconsin* (Madison: Wisconsin Geological and Natural History Survey, 1900); C. R. Van Hise, "The Origin of the Dells of the Wisconsin," *Transactions of the Wisconsin Academy of Sciences, Arts, and Letters* 10 (July 1895): 556–60.

32. Traditional Ho-Chunk seasonal migrations and patterns of agricultural production and hunting are documented in Paul Radin, *The Winnebago Tribe* (Lincoln: University of Nebraska Press, 1984), 61–69. See also Charles Callendar, "Great Lakes Riverine Sociopolitical Organization," in Trigger, *Handbook of North American Indians*, 610–21. The tendency of Europeans and Euro-Americans to equate Native American seasonal mobility with haphazard wandering is a common theme in much scholarly work on Indian history. For one now-classic statement of a very different context, but with relevant connections, see William Cronon, *Changes in the Land* (New York: Hill and Wang, 1983).

33. Yellow Thunder quoted in Saunders, "When the Moon Is a Silver Canoe," 2–3.

34. *Wisconsin Mirror*, 28 June 1873; Steven Hoelscher, "'A Pretty Strange Place': Nineteenth-Century Scenic Tourism in the Dells," in *Wisconsin Land and Life*, ed. Robert C. Ostergren and Thomas R. Vale (Madison: University of Wisconsin Press, 1997), 424–49.

35. Hoelscher, "'Pretty Strange Place,'" 444. As one local newspaper that championed the dam put it, "the class of visitors will [no longer] be confined to mere sight-seers, but will include people who are looking for diversion and recreation." *Kilbourn Illustrated Weekly Events*, 7 September 1906. The damming of the Wisconsin River at the Dells in 1907–9 is an important story that I outline in chapter 6.

36. Anon., *Uncle Sam's Journey* (Chicago: Chicago, Milwaukee, and St. Paul Railway, 1887), 3.

37. Paul Lear, "The Dells of the Wisconsin River," *Wildwood's Magazine* (1889–1890): 159.

38. The following paragraphs are based on several principal sources, including Patty Loew, *Indian Nations of Wisconsin: Histories of Endurance and Renewal* (Madison: Wisconsin Historical Society Press, 2001), 40–42; Lurie, "Winnebago," 690–707; Radin, *Winnebago Tribe;* and Bieder, *Native American Communities in Wisconsin,* 37–43.

39. Loew, *Indian Nations,* 40–41.

40. Ibid., 53.

41. Lurie, "Winnebago," 702–3; and Helen Miner Miller and Nancy Oestreich Lurie, *Report on the Winnebago Project: Contribution of Community Development to the Prevention of Dependency* (Washington, DC: U.S. Social Security Administration, 1963).

42. Grant Arndt, "No Middle Ground: Ho-Chunk Powwows and the Production of Social Space in Native Wisconsin" (unpublished Ph.D. diss., University of Chicago, 2004), 195–254.

43. Grant Arndt, "Ho-Chunk 'Indian Powwows' of the Early Twentieth Century," in *Powwow,* ed. Clyde Ellis, Luke Eric Lassiter, and Gary H. Dunham (Lincoln: University of Nebraska Press, 2005), 46–67.

44. Betty Cass, "Indian Tribal Dances Weave Old Spell at Wisconsin River," *(Madison) Wisconsin State Journal,* 6 August 1922; and anon., "Three Hundred Winnebago Indians Off to Kilbourn to Participate in Pageant Planned for Tourists," *La Crosse Tribune Leader,* 15 June 1930; Chief Za-Za-Mo-Ne-Ka (He Who Walks Alone), "The Indian Ceremonial Dances at the Dells, Descriptive Program" (Wisconsin Historical Society Pamphlet Collection, 57–2060, exact date unknown, ca. late 1920s). The Stand Rock Ceremonial is nicely detailed in Arndt, "Ho-Chunk 'Indian Powwows' of the Early Twentieth Century." Arndt is careful to note the complexity of the performance and its devolution over the years from a "space of encounter" between different groups into a "commercial enterprise." He also notes later practices of intolerable and exploitative labor conditions on the part of the operators of the Stand Rock Indian Ceremonial that led, in 1959, to lawsuits and charges of "involuntary servitude." See Elliott Maraniss, "Dells Indians Sue; Charge 'Servitude,'" *(Madison) Capital Times,* 23 April 1959. I would like to thank Susette LaMere for bringing this history, and the above newspaper article, to my attention.

45. Duaine Counsell, "Parson's Indian Trading Post," *Wisconsin Academy Review,* March 1982, 34–35.

46. Barbara Kirshenblatt-Gimblett, *Destination Culture: Tourism, Museums, Heritage* (Berkeley: University of California Press, 1998), 45. On the "thriving business in the sale of hand-made Indian baskets and other wares," see anon., "Three Hundred Winnebago Indians Off to Kilbourn."

47. Anon., "The Dells of the Wisconsin River: Indians, History" (H. H. Bennett Studio Publication, 1954), HHBP, Box 25, Folder 11. The full history of the Stand Rock Ceremonial and its meaning for its Ho-Chunk performers has yet to be written, although Grant Arndt has made a good start. His research has found that the ceremonial was a complex site of cultural encounter, one that enabled a certain degree of Ho-Chunk autonomy, but that also presented an opportunity for white exploitation. See Arndt, "Ho-Chunk 'Indian Powwows,'" 62–63.

48. By "imaginative geography," I am referring to the images of the world and its diverse people that help a group define its identity. Originally derived from the influential scholarship of Edward Said, imaginative geographies blur the distinctions between the "real" world and the "fictional world." That is, they are real not because imaginative geographies accurately depict the world as it is but because they have reflected and reinforced people's imagination of the world in tangible and concrete ways. Edward S. Said, *Orientalism,* 2nd ed. (New York: Vintage Books, 1994). See also Derek Gregory, "Imaginative Geographies," *Progress in Human Geography* 19, no. 4 (1995): 447–85; Joan M. Schwartz and James R. Ryan, "Introduction: Photography and the Geographical Imagination," in *Picturing Place: Photography and the Geographic Imagination,* ed. Joan M. Schwartz and James R. Ryan (London: I. B. Tauris, 2003); and Steven Hoelscher, "Imaginative Geographies," in *Encyclopedia of Human Geography,* ed. Barney Warf (Thousand Oaks, CA: Sage, 2006), 244–46.

49. P[atrick] Donan, *The Dells of the Wisconsin, Fully Illustrated* (Chicago: Rollins, presented by the Chicago, Milwaukee, and St. Paul Railroad, 1879), 6–8; WHS Pamphlet Collection, Pam 57–2005. For

background on early tourism to places such as Niagara Falls, see John F. Sears, *Sacred Places: American Tourist Attractions in the Nineteenth Century* (New York: Oxford University Press, 1989).

50. Terrance L. Marvel, "Between Art and Commerce: H. H. Bennett and the Development of Tourism," in *H. H. Bennett: A Sense of Place*, ed. Tom Bamberger and Terrance L. Marvel (Milwaukee: Milwaukee Art Museum, 1992), 25.

51. Martha Sandweiss, ed., *Photography in Nineteenth-Century America* (Fort Worth, TX: Amon Carter Museum, 1991); and Bamberger and Marvel, *H. H. Bennett*. The two essays from this catalogue, "A Sense of Place" by Tom Bamberger and "Between Art and Commerce" by Terrance Marvel, are useful introductions to Bennett and his work. John Szarkowski, the influential historian of photography and long-time director of the Department of Photography at the Museum of Modern Art, deserves credit for introducing Bennett into the canon of American photographic history. A native of Wisconsin, Szarkowski had long known of Bennett's work in the Dells and included three of his photographs in MOMA's important 1963 exhibit on American landscape photography. John Szarkowski, *The Photographer and the American Landscape* (New York: Museum of Modern Art, 1963). See also Szarkowski, *American Landscapes: Photographs from the Collection of the Museum of Modern Art* (New York: Museum of Modern Art, 1981); and Szarkowski, *Looking at Photographs: 100 Pictures from the Collections of the Museum of Modern Art* (New York: Museum of Modern Art, 1973).

52. For biographical information on H. H. Bennett, see Sara Rath, *Pioneer Photographer: Wisconsin's H. H. Bennett* (Madison: Tamarack Press, 1979); Bamberger, "Sense of Place," 5–11; Frank H. Goodyear, "Directing the City to the Country: Henry H. Bennett in the Wisconsin Dells," *History of Photography* 24, no. 2 (2000): 163–68; Sandweiss, *Photography in Nineteenth-Century America*, 319; Jim Temmer, "A Compelling Vision: H. H. Bennett and the Wisconsin Dells," *Wisconsin Magazine of History* 85, no. 4 (Summer 2002): 12–19; and Hoelscher, "Photographic Construction of Tourist Space."

53. H. H. Bennett, "Family History," 2 January 1897, HHBP, Box 43, folder 2. One begins to get a sense of the difficulties the young Henry Bennett faced during these years in a letter to Hosea W. Rood, of Washburn, Wisconsin. After describing the journey to Kilbourn City, Bennett notes that his father returned to Vermont the following year to gather the remaining family, leaving Henry alone for a good portion of the year: "Meanwhile, there came the financial panic of 1857 through which I passed without letting them (my folks) know what hard scratching their 14 year old boy was having." Bennett to Rood, 7 October 1892, Reel 1, HHBP. For a useful overview of the migrations of which the Bennett family was a part, see John C. Hudson, "North American Origins of Middlewestern Frontier Populations," *Annals of the Association of American Geographers* 78 (1988): 395–413.

54. The early history of Kilbourn City is recounted in Goc, *Others before You*.

55. George Bennett to Henry H. Bennett, Brattleboro, Vermont, 5 February 1864, Box 1, Folder 8; George Bennett to Mother and Father, Brattleboro, Vermont, 2 June 1867, Box 1, Folder 9 HHBP.

56. H. H. Bennett to Charlie Bennett, 5 July 1883, Box 2, Folder 10, HHBP. Apart from a year (1867) working in Tomah, Wisconsin (a larger town forty-six miles north of Kilbourn City) and month-long contract work for railroads, Bennett spent the remainder of his life in the Wisconsin Dells region.

57. A. C. Bennett, "A Wisconsin Pioneer in Photography," *Wisconsin Magazine of History* 22, no. 3 (March 1939): 268.

58. H. H. Bennett, diary entries, 20 January, 8 February, and 25 February 1866, Box 5, Folder 3; receipts and expenses file, 1867 Box 5, Folder 4, HHBP; emphasis in original. Economic stress was an ever-present part of Bennett's adult life, a point frequently found in his extensive correspondence. In one letter to his brother-in-law, Bennett lamented that in recent years "I have been running backward until I am discouraged. Sometimes I think perhaps I should try something else but then I feel I am too old to take up any other work. The feeling often comes to me that I am not cut out right to prosper. I am sure no one has worked harder or tried more heartily than I have but everything goes wrong or most everything." Bennett to James McVey, 3 November 1888, Box 4, Folder 1, HHBP.

59. George Houghton to family, Kilbourn City, 26 July 1857, Box 1, Folder 1, HHBP.

60. Bennett diary, 23 April 1866, Box 5, Folder 3, HHBP.

61. Diary entry, 25 May 1866, Box 5, Folder 3, HHBP.

CHAPTER 2. "VIEWING" INDIANS AND LANDSCAPE IN NINETEENTH-CENTURY WISCONSIN

1. "Bill Presented to the Chamber of Deputies, France, 15 June 1839," in *Photography in Print,* ed. Vicki Goldberg (Albuquerque: University of New Mexico Press, 1988), 31–35, quote on page 35. See also Helmut Gernsheim, *A Concise History of Photography* (New York: Dover, 1986), 8–12.

2. Martha A. Sandweiss, *Print the Legend: Photography and the American West* (New Haven, CT: Yale University Press, 2002), 208–12. More typical dating of the "first Indian photograph" rests on 1845, with the London portraits of Kahkewaquonaby, also known as the Reverend Peter Jones and the son of an Ojibway Indian woman and a Welsh father. Paula Richardson Fleming and Judith Luskey, *The North American Indians in Early Photographs* (New York: Barnes and Noble Books, 1992 [1986]), 14–16.

3. Fleming and Luskey, *North American Indians in Early Photographs.*

4. Ibid. See also William H. Goetzmann, *The First Americans: Photographs from the Library of Congress* (Washington, DC: Starwood, 1991); and Alfred L. Bush and Lee Clark Mitchell, *The Photograph and the American Indian* (Princeton, NJ: Princeton University Press, 1994).

5. Alan Trachtenberg, *The Incorporation of America: Culture and Society in the Gilded Age* (New York: Hill and Wang, 1982), 37. See also Alan Trachtenberg, *Shades of Hiawatha: Staging Indians, Making Americans, 1880–1930* (New York: Hill and Wang, 2004); Natasha Bonilla Martinez and Rose Wyaco, "Camera Shots: Photographers, Expeditions, and Collections," in Johnson, *Spirit Capture,* 78; and Berkhofer, *White Man's Indian.*

6. Weston J. Naef and James N. Wood, *Era of Exploration: The Rise of Landscape Photography in the American West, 1860–1885* (Boston: New York Graphic Society, 1975), 12.

7. Barbara Novak, *Nature and Culture: American Landscape Painting, 1825–1875* (New York: Oxford University Press, 1995), 3.

8. John F. Sears, *Sacred Places: American Tourist Attractions in the Nineteenth Century* (New York: Oxford University Press, 1989). Sears notes how, in his description of visiting Niagara in the early nineteenth century, Nathanial Hawthorne casts the entire experience in religious terms. "The beholder," Hawthorne writes, "must stand beside [Niagara] in the simplicity of his heart, suffering the mighty scene to work its own impression." Quote on page 16. Emma Shaw quote from *Gems of the Northwest: A Brief Description of Prominent Places of Interest along the Chicago, Milwaukee, and St. Paul Railway* (Chicago: Rand McNally, 1885), 35. The Columbus, Wisconsin, traveler's account was reprinted in the *Wisconsin Mirror,* 21 July 1876.

9. Edward L. Wilson, "Our Picture," *Philadelphia Photographer* 1 (September 1864): 1. Quoted in Peter Bacon Hales, "American Views and the Romance of Modernization," in *Photography in Nineteenth-Century America,* ed. Martha A. Sandweiss (Fort Worth, TX: Amon Carter Museum, 1991), 205–57, quote on pages 208–9.

10. Stephen Daniels, *Fields of Vision: Landscape Imagery and National Identity in England and the United States* (Cambridge, UK: Polity Press, 1993). For an important analysis of the relationship between landscape representation and nation building for an earlier period, see Angela Miller, *The Empire of the Eye: Landscape Representation and American Cultural Politics, 1825–1875* (Ithaca, NY: Cornell University Press, 1993).

11. Hales, "American Views and the Romance of Modernization."

12. In addition to Hales's important essay, I have found several other sources more generally on visual culture to be especially helpful. These include Miles Orvell, "Viewing the Landscape," in *American Photography* (New York: Oxford University Press, 2003), 39–60; Roland Barthes, *Camera Lucida: Reflections on Photography,* trans. Richard Howard (New York: Hill and Wang, 1981); Vicki Goldberg, *The Power of Photography:*

How Photographs Changed Our Lives (New York: Abbeville, 1993); W. J. T. Mitchell, *Picture Theory: Essays on Verbal and Visual Representation* (Chicago: University of Chicago Press, 1994); Marita Sturken and Lisa Cartwright, *Practices of Looking: An Introduction to Visual Culture* (Oxford: Oxford University Press, 2001); and Trachtenberg, *Reading American Photographs.*

13. The Ansel Adams quote is from a 1940 exhibition that he helped organize and that displayed the work of O'Sullivan, Jackson, and Watkins. Quoted in Sandweiss, *Print the Legend,* 184. Sandweiss cautions that survey photographs "were never meant to stand as independent works of art," and that to interpret meaning based on artistic intent all too often simply "mirrors the interests of latter-day critics," such as Adams. In this argument, she echoes an important article by Rosalind Krauss, "Photography's Discursive Spaces: Landscape/View," *Art Journal* (Winter 1982): 311–19.

14. For a useful overview of the much-discussed Jackson photographs, see Howard Bossen, "A Tall Tale Retold: The Influence of the Photographs of William Henry Jackson on the Passage of the Yellowstone Park Act of 1872," *Studies in Visual Communication* 8, no. 1 (1982): 98–109. See also Peter Bacon Hales, *William Henry Jackson and the Transformation of the American Landscape* (Philadelphia: Temple University Press, 1988), 106–11.

15. *The History of Columbia County, Wisconsin—Illustrated* (Chicago: Western Historical Company, 1880), 468.

16. In this way, photography is a language that, as Yi-Fu Tuan has argued, can make place. Yi-Fu Tuan, "Language and the Making of Place: A Narrative-Descriptive Approach," *Annals of the Association of American Geographers* 81, no. 4 (1991): 684–96.

17. To one correspondent, Bennett wrote that "My civil life has been full of hard work, but I was fortunate in selecting a work soon after I came out of the army that has been one of pleasure and in which I have been more successful in making a name and reputation than in accumulating sheckels." Bennett to Hosea W. Rood, 7 October 1892, Reel 1, HHBP.

18. James Maitland, *The Golden Northwest* (Chicago: Rollins, 1879), 29.

19. *Wisconsin Mirror,* 7 April 1872; Donan, *Dells of the Wisconsin,* 7; H. H. Bennett to J. E. Porter, 1 January 1887, Box 9, Folder 5; Financial Records and Ledgers, Box 15, Folders 1–3, HHBP.

20. J. J. Brown, *The Tourist's Guide to and through the Dells of the Wisconsin River and Vicinity, Kilbourn City* (Kilbourn City, WI, 1875), 3–5; A. C. Bennett, "Wisconsin Pioneer in Photography," 274.

21. Nat Wetzel, *The Dells of the Wisconsin: America's Most Beautiful Summer Home* (Kilbourn City, WI, 1903); and Jean Reese, "Boat Trips through the Dells," unpublished manuscript, n.d., in author's possession, 18.

22. The nineteenth-century Dells tourist industry is treated in Steven Hoelscher, "A Pretty Strange Place: Nineteenth-Century Scenic Tourism in the Dells," in *Wisconsin Land and Life,* ed. Robert C. Ostergren and Thomas R. Vale (Madison: University of Wisconsin Press, 1997), 424–49.

23. *Wisconsin Mirror,* 1876; Wisconsin Central Railroad, *Pen and Camera* (Milwaukee: Louis Eckstein, 1890). Such a connection between landscape photographers and railroad-driven resort development is well documented for the Far West. Carleton Watkins, Alfred A. Hart, Charles Roscoe Savage, F. Jay Haynes, and Andrew Joseph Russell are only the best known among the western landscapists whose work helped promote railroad expansion. Frank Henry Goodyear, "Constructing a National Landscape: Photography and Tourism in Nineteenth-Century America" (Ph.D. diss., University of Texas at Austin, 1998); Hales, *William Henry Jackson;* Anne Farrar Hyde, *An American Vision: Far Western Landscape and National Culture, 1820–1920* (New York: New York University Press, 1990), 80–96; Edward Nolan, *Northern Pacific Views: The Railroad Photography of F. Jay Haynes, 1876–1905* (Helena: Montana Historical Society, 1983); and Peter Palmquist, *Carleton E. Watkins, Photographer of the American West* (Albuquerque: University of New Mexico Press, 1983).

24. Bennett's letters indicate that he answered thousands upon thousands of queries regarding hotels and boat tours (for merely one example, see Bennett to M. Kittie, 5 June 1883, Box 9, Folder 2, HHBP). On

occasion and for special visitors, he would guide parties along the river. Marvel, "Between Art and Commerce," 17.

25. Szarkowski, *Photographer and the American Landscape*, 4; Szarkowski, *American Landscapes*, 10.

26. Martinez and Wyaco, "Camera Shots," 78. It is difficult to provide exact dates for many of Bennett's photographs because he never labeled his negatives beyond simple titles. However, by matching a variety of sources—Bennett's stereo catalogues, letters, and business records with local newspapers—it's possible to determine some dates. The earliest discussion that I have found of Bennett's Ho-Chunk photographs comes from the local newspaper, the *Wisconsin Mirror*, which reported on 24 May 1873 that Bennett had made photographs of Wah-con-ja-z-gah's camp (see figure 1).

27. Lippard, introduction to *Partial Recall*, 26. Nigel Russell, "Process and Pictures: The Beginnings of Photography and of Photographing American Indians," in Johnson, *Spirit Capture*, 113–34.

28. Martin A. Berger, "Landscape Photography and the White Gaze," in *Sight Unseen: Whiteness and American Visual Culture* (Berkeley: University of California Press, 2005), 43–79; Albert Boime, *The Magisterial Gaze: Manifest Destiny and American Landscape Painting, c. 1830–1865* (Washington, DC: Smithsonian Institution Press, 1991); and Hales, "American Views," 236.

29. H. H. Bennett to George Brown, 7 September 1883, HHBP, Box 3, Folder 5.

Chapter 3. Ho-Chunk Removals, Returns, and Survivance

1. Helen Hunt Jackson, "The Winnebagoes," in *A Century of Dishonor: A Sketch of the United States Government's Dealings with Some of the Indian Tribes* (New York: Harper and Brothers, 1881; Norman: University of Oklahoma Press, 1995), 218–56.

2. Sonya Atalay, "No Sense of Struggle: Creating a Context for Survivance at the NMAI," *American Indian Quarterly* 30, no. 3/4 (Summer and Fall 2006): 609.

3. Richard White, *The Middle Ground: Indians, Empires, and Republics in the Great Lakes Region, 1650–1815* (Cambridge: Cambridge University Press, 1991). Quote is from Lurie, "Winnebago," 696–97.

4. Bieder, *Native American Communities in Wisconsin*, 124.

5. Frederick Marryat, "An English Officer's Description of Wisconsin in 1837," *Wisconsin Historical Collections* 14 (1898): 137–54, quote on 138–39; emphasis in original. Henry Merrell, a postmaster at Fort Winnebago at the time of the 1837 treaty, gives a detailed account in "Pioneer Life in Wisconsin," *Wisconsin Historical Collections* 7 (1876): 366–404, esp. 393–94. Useful overviews of the treaty may be found in Lurie, "Winnebago," 699; and Bieder, *Native American Communities in Wisconsin*, 131–32.

6. Henry Merrell was one of the early whites of the region to deem the 1837 treaty "fraudulent." Noting that the treaty "very naturally engendered the most embittered feelings and recollections" by Ho-Chunk, he asked rhetorically, "is it any wonder that we have Indian wars when they are so treated?" Despite the tinge of ethnocentrism that infects his writing, Merrell stands out as prescient: "it is wrong to deceive, cheat or mislead them, as they are as sharp to see through such management as civilized men, if not more so, for they have more time to think over transactions of this kind." Merrell, "Pioneer Life in Wisconsin," 394.

7. By the mid-nineteenth century, the U.S. government recognized two separate nations—the Nebraska and the Wisconsin Ho-Chunk. Today, people from both groups often visit each other and intermarry. However, because a tribal member can be enrolled in only one recognized nation, children of these marriages must be enrolled in either Wisconsin or Nebraska. Nancy Oestreich Lurie, *Wisconsin Indians*, 2nd ed. (Madison: Wisconsin Historical Society Press, 2002), 13.

8. To date, no comprehensive history of the Wisconsin Ho-Chunk removals has been written. For this discussion, I have relied on a number of primary sources, mostly in the form of the meticulously detailed *Reports of the Commissioner of Indian Affairs* and from white recollections immediately after or shortly after the event, including John H. Fonda, "Early Wisconsin," *Report and Collections of the State Historical Society*

of Wisconsin 5 (1868): 277–82; Elisha W. Keyes, "Early Days in Jefferson County," *Collections of the State Historical Society of Wisconsin* 11 (1888): 430–31; John T. De La Ronde, "Personal Narrative," *Report and Collections of the State Historical Society of Wisconsin* 7 (1876): 345–65; and Moses Paquette, "The Wisconsin Winnebagoes; An Interview by the Editor [Reuben Gold Thwaites]," *Collections of the State Historical Society of Wisconsin* 12 (1892): 399–433. Such treatment is further confirmed by J. Stucki, a missionary in Wisconsin during the mid-nineteenth century, in *Die Winnebago Indianer: Ihre Religion, Sitten und Gebräuche* (Cleveland: Central, 1897), 2–3. Three important interviews with Ho-Chunk leaders of the time supplement the white recollections: Spoon Decorah, "Narrative of Spoon Decorah; in an Interview with the Editor [Reuben Gold Thwaites]," *Collections of the State Historical Society of Wisconsin* 13 (1895): 448–62; Walking Cloud, "Narrative of Walking Cloud; in an Interview with the Editor [Reuben Gold Thwaites]," *Collections of the State Historical Society of Wisconsin* 13 (1895): 463–67; and Little Hill, "The Uprooted Winnebago," in *Native American Testimony*, ed. Peter Nabokov (New York: Penguin Books, 1999 [1865]), 161–64. Secondary sources include Louise Phelps Kellogg, "The Removal of the Winnebago," *Transactions of the Wisconsin Academy of Sciences, Arts, and Letters* 21 (1924): 23–29; Lawrence Onsager, "The Removal of the Winnebago Indians from Wisconsin in 1873–74" (unpublished M.A. thesis, Loma Linda University, 1985); Grossman, "Ho-Chunk and Dakota Nations," 8–9; Arndt, "No Middle Ground," 142–64; Loew, *Indian Nations of Wisconsin*, 47; Bieder, *Native American Communities*, 132, 170–72; and especially the important work of Nancy Oestreich Lurie: "The Winnebago Indians: A Study in Cultural Change" (unpublished Ph.D. diss., Northwestern University, 1952), 124–35, 167–70; "Winnebago"; and *Wisconsin Indians*, 20–22.

9. These numbers were calculated by Nancy Lurie from the Annual Reports of the Commissioner of Indian Affairs for 1862 to 1865. Lurie, "Winnebago," 700.

10. Keyes, "Early Days," 430–31; and De La Ronde, "Personal Narrative," 363.

11. Henry M. Rice to Rueben Gold Thwaites, 14 October 1887. Reprinted, in part, in Paquette, "Wisconsin Winnebagoes," 407.

12. Francis Paul Prucha, "United States Indian Policies, 1815–1860," in *History of Indian-White Relations*, vol. 4, *Handbook of North American Indians*, ed. Wilcomb E. Washburn (Washington, DC: Smithsonian Institution Press, 1988), 40–50.

13. Decorah, "Narrative of Spoon Decorah," 459. The literature on U.S. policy of Indian removal in the early to mid-nineteenth century is vast, but several especially relevant items stand out: Francis Paul Prucha, *The Great Father: The United States Government and the American Indians*, vol. 1 (Lincoln: University of Nebraska Press, 1984); and Ronald N. Satz, *American Indian Policy in the Jacksonian Era* (Lincoln: University of Nebraska Press, 1975).

14. Satz, *American Indian Policy*, 459.

15. D. W. Meinig, *The Shaping of America: A Geographical Perspective on 500 Years of History*, vol. 2, *Continental America, 1800–1867* (New Haven, CT: Yale University Press, 1993), 170–96. Patricia Limerick, *The Legacy of Conquest: The Unbroken Past of the American West* (New York: Norton, 1987).

16. Onsager, "Removal of the Winnebago Indians," 222–24, 229.

17. Andrew Jackson Turner, quoted in the *(Portage) Wisconsin State Register*, 19 July 1873.

18. John T. Kingston, "Early Western Days," *Wisconsin Historical Collections* 7 (1908 [1876]): 304. [Secretary of the Interior] *Report of the Commissioner of Indian Affairs*, 43rd Cong., 1st sess., H. Ex. Doc. 1 (Washington, DC: G.P.O., 1874), pt. 5, serial 1639, pp. 28–29. For general background, see Onsager, "Removal of the Winnebago."

19. Wisner, "Sympathy," *Wisconsin Mirror*, 23 August 1873.

20. Rebecca Solnit, *River of Shadows: Eadweard Muybridge and the Technological Wild West* (New York: Viking, 2003), 103.

21. According to the 1872 Report, Ho-Chunk were "accused of causing considerable annoyance to the farmers in some localities, and on account of complaints having been made in this respect, Congress has

appropriated funds to remove them." Accomplishing their removal would require "additional and severe legislation on the part of Congress, as the Indians are attached to the country and express great repugnance to their contemplated removal from it." [Department of the Interior] *Annual Report of the Commissioner of Indian Affairs to the Secretary for the Year 1872* (Washington, DC: G.P.O., 1872), 21–22. Data on the number of Wisconsin Ho-Chunk who were removed to Nebraska and who quickly returned to Wisconsin are from [Secretary of the Interior] *Annual Report of the Commissioner of Indian Affairs to the Secretary in the Year 1875* (Washington, D.C.: G.P.O., 1874), 100. One eyewitness recounted how "in a good many camps, the troops would find only women and children, the men being off on hunting expeditions. In such cases, the women and children were put into sleighs and carried off; the men, upon their return, finding their wigwams deserted and their families gone, would perforce follow and join them." Paquette, "Wisconsin Winnebagoes," 413.

22. U.S. Senate, *Winnebago Indians of Wisconsin*, 46th Cong., 3rd sess., chapter 23, 21 Statute 315, 18 January 1881, pp. 187–89: "An act for the relief of the Winnebago Indians in Wisconsin, and to aid them to obtain subsistence by agricultural pursuits, and to promote their civilization." See also Lurie, "Winnebago," 702–3; and Bieder, *Native American Communities in Wisconsin*, 170–71.

CHAPTER 4. VISUAL DIMENSIONS OF BENNETT'S HO-CHUNK PHOTOGRAPHS

1. H. H. Bennett, "Wanderings among the Wonders and Beauties of Western Scenery." Bennett to Charles A. J. Marsh, Minneapolis, MN, 4 October 1894, Reel 1, HHBP.

2. H. H. Bennett to M. L. Purcell, Flandreau, S.D., 17 May 1903, Reel 4, HHBP.

3. For a national-scope reading of this view, see Brian W. Dippie, *The Vanishing American: White Attitudes and U.S. Indian Policy* (Middletown, CT: Wesleyan University Press, 1982); Dippie, "Photographic Allegories and Indian Destiny," in *Images of the Indian: Portrayals of Native Peoples*, ed. Joe Sawchuk (Brandon, MB, Canada: Bearpaw, 1999), 49–81; Mick Gidley, ed., *Edward S. Curtis and the North American Project in the Field* (Lincoln: University of Nebraska Press, 2003); Gidley, *Edward S. Curtis and the North American Indian, Incorporated*; and Lyman, *Vanishing Race*. For my understanding of the cultural determinants that produce photographs, what I am calling a photograph's visual dimensions, I am indebted to Miles Orvell, "Where Is Photography?" *Photo Review* 19 (Fall 1996): 13–15.

4. T. W. Ingersoll's photographs are described in Edward W. Earle, "The Stereograph in America: Pictorial Antecedents and Cultural Perspectives," in *Points of View: The Stereograph in America—A Cultural History*, ed. Edward W. Earle (Rochester, NY: Visual Studies Workshop Press, 1979), 9–23.

5. Russell, "Process and Pictures," 123–24. See also Richard N. Masteller, "Western Views in Eastern Parlors: The Contribution of the Stereograph Photographer to the Conquest of the West," *Prospects* 6 (1981): 55–71.

6. Although he rarely worked in portraiture after his turn to landscape views, Bennett's wives, first Frankie and then Evaline, carried on the portrait trade. It is difficult to know whom among the Bennett family actually took the photograph of He-noo-ke-ku—Bennett certainly claimed it in his "Among the Winnebago" series—but it is quite possible that Frankie took this handsome portrait. H. H. Bennett to Arthur H. McArthur, 8 September 1886, Box 4, Folder 1–5, HHBP. See also Rath, *Pioneer Photographer*, 28.

7. In her pose and expression, He-noo-ke-ku is following conventions of Victorian-era portraiture. Audrey Linkman, *The Victorians: Photographic Portraits* (London: Tauris Books, 1993).

8. I would like to thank Nancy Lurie for helping me identify much of the material culture in this and in other of Bennett's Ho-Chunk photographs. Lurie, interview with the author, 1 July 2002, Milwaukee.

9. Leah Dilworth, *Imagining Indians in the Southwest: Persistent Visions of a Primitive Past* (Washington, DC: Smithsonian Institution Press, 1996), 131; and Erika M. Bsumek, *Indian-Made: The Production and Consumption of the Navajo, 1880–1940* (Lawrence: University Press of Kansas, forthcoming).

10. H. H. Bennett to Ashley Bennett, Hot Springs, MT, 16 January 1904, Reel 4, HHBP.

11. Comments of Thomas Hopinkah during meeting at Bennett Studio Museum, Wisconsin Dells, WI, 11 January 2002. One man who visited Bennett often and who traveled with Buffalo Bill and other Wild West shows was Albert Thunder. As I detail below, it was probably this experience that led to Albert Thunder's fluency in English, for he helped Bennett translate many Ho-Chunk words into English: "Exercises in Ho-Chunk-ah-rah Wong-cig-ah-rah," Box 8, Folder 9, HHBP. For a useful study of Ho-Chunk cultural performances of this period that employed "show Indians," see Arndt, "Ho-Chunk 'Indian Powwows,'" 46–67.

12. "Copyrights granted to H. H. Bennett," Box 15, Folder 6, HHBP. This was an unusual move for Bennett, as he submitted only twenty-seven copyright applications during his forty-year career. For two excellent discussions of "show Indians" and their important roles in Wild West performances, see L. G. Moses, *Wild West Shows and the Images of American Indians, 1883–1993* (Albuquerque: University of New Mexico Press, 1996); and Joy S. Kasson, *Buffalo Bill's Wild West: Celebrity, Memory, and Popular History* (New York: Hill and Wang, 2000), 161–220. See also Arndt, "Ho-Chunk 'Indian Powwows.'"

13. For background on the making of the Plains Indian image, see Mark Engel, "Seeing with the Stereotypic Eye: The Visual Image of the Plains Indian," in Sawchuk, *Images of the Indian*, 82–110.

14. Erickson and Tallmadge, *Thunder in the Dells*.

15. Vizenor, *Fugitive Poses*, 157; emphasis and lowercase spelling in original.

16. While every town of note had at least one commercial photographer, not every town was as fortunate as Black River Falls to have someone as competent as Charles Van Schaick. Among the small, but growing, literature on such small town commercial photographers, a useful point of comparison may be found in James R. Shortridge, *Our Town on the Plains: J. J. Pennell's Photographs of Junction City, Kansas, 1893–1922* (Lawrence: University Press of Kansas, 2000).

17. Van Schaick is best known as the "careful, competent photographer" in Michael Lesy's highly original, and controversial, *Wisconsin Death Trip* (New York: Pantheon, 1973). With its extraordinarily bleak vision of American frontier life and heavy-handed manipulation of photographic images and mismatching text, the book owes more to the sensibility of Dadaist collage than careful historical research. Reviewers might have panned *Wisconsin Death Trip*, but the book also became something of a cult classic that captured a moment of disenchantment during the Watergate and immediate post-Vietnam era; it even served as the inspiration for a 1999 British Broadcasting Corporation film of the same title. However, as a work of photographic scholarship, *Wisconsin Death Trip* is deeply flawed. As Sontag memorably described Lesy's book, despite its pretense of academic scholarship (it earned Lesy a Ph.D.), *Wisconsin Death Trip* is a "fashionably pessimistic polemic, and totally whimsical as history" (Sontag, *On Photography*, 74). On Van Schaick, see Matthew D. Mason, "'Native in the Frame': Viewing the Ho-Chunk Nation in Black River Falls, Wisconsin, 1870–1930" (paper presented at the Annual Meeting of the Association of American Geographers, Los Angeles, 2002). An interesting review of the 1999 film is Greil Marcus, "A Record of Despair Born of a Single Image," *New York Times*, 28 November 1999.

18. Indeed, as Bennett himself was to write, rather condescendingly, to a Milwaukee correspondent: "The dress of these people is partly Indian and partly civilized (the women). The men dress about the same as the whites." H. H. Bennett to Gimbel Brothers (department store in Milwaukee), Indian Bead Work Department, 29 April 1903, Reel 4, HHBP. Mountain Wolf Woman is the narrator of an important autobiography edited and collected by Nancy Lurie: *Mountain Wolf Woman, Sister of Crashing Thunder: The Autobiography of a Winnebago Woman* (Ann Arbor: University of Michigan Press, 1961).

19. Martha A. Sandweiss, "'Momentoes of the Race': Photography and the American Indian," in her *Print the Legend*, 207–73, quote on page 217. Abigail Solomon-Godeau makes a similar point when she argues that fundamental to any understanding of photography is an understanding of "the history of photographic uses." Solomon-Godeau, *Photography at the Dock: Essays on Photographic History, Institutions, and Practices* (Minneapolis: University of Minnesota Press, 1991), xxiv. Pierre Nora, "Between Memory and History: *Les Lieux*

de Mémoire," Representations 26 (1989): 7–25; Marianne Hirsch, *Family Frames: Photography, Narrative, and Postmemory* (Cambridge, MA: Harvard University Press, 1997).

20. Several important sources are central to the discussion of anthropometric photography. See, for example, Curtis Hinsley and Martha Banta, *From Site to Sight: Anthropology, Photography, and the Power of Imagery* (Cambridge, MA: Harvard University Press, 1986); Elizabeth Edwards, "Photographic 'Types': The Pursuit of Method," *Visual Anthropology* 3, no. 2–3 (1990): 235–58; Elizabeth Edwards, ed., *Anthropology and Photography, 1860–1920* (New Haven, CT: Yale University Press, 1994); and Cory Willmott, "The Lens of Science: Anthropometric Photography and the Chippewa, 1890–1920," *Visual Anthropology* 18 (2005): 309–37.

21. F. V. Hayden, "Prefatory Note," in *Descriptive Catalogue of Photographs of North American Indians by W. H. Jackson, Photographer of the Survey*, Miscellaneous Publications, no. 9, Department of the Interior, United States Geological Survey of the Territories (Washington, DC: G.P.O., 1877), iii–iv.

22. Holmes, quoted in *Twenty-Third Annual Report of the Bureau of American Ethnology to the Smithsonian Institution, 1901–1902, J. W. Powell, Director* (Washington, DC: G.P.O., 1904), xviii–xix. (Available online via Gallica: Bibliothèque nationale de France, http://gallica.bnf.fr/ark:/12148/bpt6k27635c/f18.table; last accessed 16 March 2007.)

23. Jon Tagg, *The Burden of Representation: Essays on Photographies and Histories* (Minneapolis: University of Minnesota Press, 1993). Although he never thought of himself first as a photographer, De Lancey Gill was, by far, the most active of all BAE photographers, producing between 2,000 and 3,000 Native American portraits. James R. Glenn, "De Lancey W. Gill: Photographer for the Bureau of American Ethnology," *History of Photography* 7, no. 1 (January 1983): 7–22.

24. H. H. Bennett, *The Wisconsin Dells* (Milwaukee: Evening Wisconsin, 1900), 4.

25. William Henry Jackson, describing the technique of producing the then universal wet-collodion negatives used by Bennett, noted that average exposure time on a bright, clear day took five to fifteen seconds, depending on light conditions and the chemicals used. Jackson quoted in Robert Taft, *Photography and the American Scene* (New York: Dover, 1964 [1938]), 310.

26. Lurie, "Winnebago," 702–5; Bieder, *Native American Communities in Wisconsin*, 171. As Tim Cresswell has shown, governing elites in many contexts have equated mobility with transgression and have frequently undertaken strenuous efforts to keep moving people fixed in place. Cresswell, *On the Move: Mobility in the Modern Western World* (New York: Routledge, 2006).

27. That is, until African Americans chose to leave the region entirely, as they did in droves during various phases of the Great Black Migration. James R. Grossman, *Land of Hope: Chicago, Black Southerners, and the Great Migration* (Chicago: University of Chicago Press, 1989). For two useful accounts of sharecropping in the Jim Crow South, with an especial focus on the vexing problem of mobility, see Leon F. Litwack, *Trouble in Mind: Black Southerners in the Age of Jim Crow* (New York: Vintage Books, 1998); and Charles S. Aiken, *The Cotton Plantation South since the Civil War* (Baltimore: Johns Hopkins University Press, 1998).

28. *Black River Falls Badger State Banner* quoted in Arndt, "No Middle Ground," 205. On Robert Charles Gebhart, see the *Badger State Banner Semi-Centennial Anniversary: Fifty Years Ago and To-Day Commemoration, 1856–1906* (Black River Falls, WI: Banner, 1906), n.p., from the Visual Materials Section of the Wisconsin Historical Archives, 3–2244. I thank Matthew Mason for this reference.

29. Radin, *Winnebago Tribe*, 121–22.

30. H. H. Bennett to R. N. Bunn, Chicago, 24 June 1904, Reel 4, HHBP.

31. Ibid.

32. Here and elsewhere, I allow the outdated and derogatory term "squaw" to remain in the text when it is used as part of a photographic caption or direct quotation. I do this with trepidation. Although widely understood as an insulting expression, its use by Bennett and his contemporaries is part of the historical record. I thank several people, including Susette LaMere, Paul Arentz, and Thomas Hopinkah, for calling my attention to this important point.

33. Radin, *Winnebago Tribe*, 136–38. The idea that this could be a menstrual lodge is Nancy Lurie's. Lurie, interview with author, 1 July 2002.

34. The sole exception is a Bennett photograph that displays an abandoned Medicine Lodge. Due to its sacred nature, this photograph was returned to the Ho-Chunk Nation when the Wisconsin Historical Society acquired the Bennett Collection and Studio in 1999. In addition to this photograph, the previous owners of the Bennett Studio, Oliver and Jean Reese, also gave a series of 5 × 8 inch negatives depicting the Medicine Dance to the Ho-Chunk Nation. They were part of the Bennett Collection, but not attributed to H. H. Bennett himself. After reviewing prints of these photographs, it is my conclusion that Bennett did not take the photographs, but instead either he or his heirs acquired them from another photographer. This conclusion is based on three observations: the look or appearance of being taken at long range is entirely different from Bennett's style; nowhere in Bennett's correspondence does he mention these photographs or try to print them; and it was a common practice among photographers of the day to swap or purchase negatives as a way to enlarge one's collection. With the beginning of tourist and local interest in Ho-Chunk ceremonies, including interest from the Smithsonian's Bureau of American Ethnology, numerous photographers documented Ho-Chunk celebratory life around the time of Bennett's death. See National Anthropological Archives, Smithsonian Institution, BAE GN 4400–4420. For a discussion of the Ho-Chunk celebrations, or powwows, at this time, see Arndt, "Ho-Chunk 'Indian Powwows.'" I thank Tom Jones for allowing me to view these interesting photographs.

35. Mason, "Native in the Frame," 5. H. H. Bennett to R. N. Bunn, Chicago, 13 April 1905, Reel 5, HHBP.

36. Moses Paquette, a federal government interpreter for Wisconsin Ho-Chunk people, described how Black River Falls became the "chief rallying point" for the collection of annuity payments. His interview with Reuben Gold Thwaites richly documents this event, as well as his own prejudices. Van Schaick's photograph of the neatly dressed group amid a litter-filled street contradicts Paquette's own jaundiced description: "Some of the sights behind the scenes, at an Indian payment, are enough to make one's heart bleed for the poor wretches who are too simple to take care of themselves, and need a firm, wise friend as badly as any lot of foolish boys ever did." Paquette, "Wisconsin Winnebagoes," 420–21.

37. Gidley, *Edward S. Curtis and the North American Indian, Incorporated*, 71–72. The "picturesque" aesthetic and "pictorialist" photographic technique are extremely large and complex topics, but several introductory sources are John Taylor, *A Dream of England: Landscape, Photography, and the Tourist's Imagination* (Manchester, UK: Manchester University Press, 1994); Szarkowski, *Photography until Now*; and Orvell, *American Photography*. Theresa Harlan, "Indigenous Photographies: A Space for Indigenous Realities," in Alison, *Native Nations*, 233–45, quote on page 234.

38. J. E. Jones, *A Description of a Noted Western Summer Resort: A Trip through the Dells of the Wisconsin River* (Kilbourn City, WI, 1887), n.p., Box 28, Folder 1, HHBP. Maitland, *Golden Northwest*, 29.

39. Martha A. Sandweiss makes a strong case for the relationship between text and image in "Undecisive Moments: The Narrative Tradition in Western Photography," in *Photography in Nineteenth-Century America*, 98–129; see also the more recent and complete statement in her *Print the Legend*. Susan Sontag, *Regarding the Pain of Others* (New York: Farrar, Straus and Giroux, 2003), 29.

40. Donan, *Tourists' Wonderland*, 7.

41. Bennett letter to Gaylord, 1 October 1892, Reel 1, HHBP.

42. A nice print of a panorama with the canoe is in New York as part of the Museum of Modern Art's collection and reproduced on pages 294 and 295 of Sandweiss, *Photography in Nineteenth-Century America*. That Bennett, among others, expected such landscape views to convey a sense of the Indian past is revealed in a letter to one Chicago client who had asked about his stereo view offerings of the Dells' Ho-Chunk. In response, Bennett noted his photographs of the moccasin game, the woman tanning a deerskin, many portraits, and "some Dells views showing birch canoe—Chippewa made." Bennett to R. S. Bunn, Chicago, 24 June 1905.

43. Jones, *Description of a Noted Western Summer Resort,* n.p. Elsewhere, Jones makes the spurious claim that an "earlier superior race" existed in the valleys of the Wisconsin River and was "driven away, doubtless, by the savages found here by the first white men to visit Wisconsin." James E. Jones, "The Story of the Wisconsin River: Prehistoric and Indian Period," *Kilbourn City Illustrated Events,* November 1903, 1–6. Jones, it should be noted, was an influential community member who, in addition to piloting tour boats, published this newspaper from 1903 to 1909.

44. *The Great West* (Chicago: Rollins, 1880), 85–86. The anonymous author goes on to suggest: "We can readily imagine this as the abode of witches and devils; we are reminded of all the Indian tales of Cooper, and those susceptible to superstitious influences will hear the wailing of the braves who died on the field of battle, in the rustlings of the trees and branches above." For what is now a classic interpretation of these materials, see Henry Nash Smith, *Virgin Land: The American West as Symbol and Myth* (Cambridge, MA: Harvard University Press, 1950). Alan Trachtenberg's *Shades of Hiawatha* (51–97) offers a richly detailed interpretation of Longfellow's epic-romance, *The Song of Hiawatha* (1855).

45. Werner Sollors, *Beyond Ethnicity: Consent and Descent in American Culture* (New York: Oxford University Press, 1986), 102–30.

46. Frank O. Wisner, *The Tourist's Guide to the Wisconsin Dells, and an Illustrated Handbook Embracing the Prose, Romance, and Poetry of This Wonderful Region* (Kilbourn City, WI: n.p., 1875), 48–61.

47. Sollors, *Beyond Ethnicity,* 129. For a useful comparison set in a different context, see Judith Richardson, *Possessions: The History and Uses of Haunting in the Hudson Valley* (Cambridge, MA: Harvard University Press, 2003).

48. Wisner, *Tourist's Guide to the Wisconsin Dells,* 50.

49. A. C. Bennett, "Wisconsin Pioneer in Photography," 268–79, quote on page 278. Among many other sources that corroborate this claim are J. J. Brown, *Tourist's Guide to and through the Dells;* and Frank H. Taylor, *Through to St. Paul and Minneapolis in 1881: Random Notes from the Diary of a Man in Search of the West* (Chicago: Chicago, Milwaukee, and St. Paul Railway, 1881), 17. More accurately, it should be noted that Bennett *renamed* many of these features that, of course, had long held Ho-Chunk significance. This is a key point, for as Alan Trachtenberg notes, "naming and viewing complement each other." Bennett's new and fanciful names for the sights in the Dells, no less than similar names in Yosemite Valley, which displace Native names, "brought the alien and unfamiliar into a familiar system of knowledge." In Bennett's case, that system was based on tourist knowledge and desire. Trachtenberg, *Reading American Photographs,* 126–27.

50. Both Roger Nichols and Nancy Lurie concur that Black Hawk found refuge among the Ho-Chunk near present-day Tomah, well north of the Wisconsin River Dells, and traveled to Prairie du Chien without coercion, but with Ho-Chunk protection. Roger L. Nichols, *Black Hawk and the Warrior's Path* (Arlington Heights, IL: Harlan Davidson, 1992), 137–39; Nancy O. Lurie, "In Search of Chaeter: New Findings on Black Hawk's Surrender," *Wisconsin Magazine of History* 71, no. 3 (1988): 353–64.

51. Bennett to Edmund Andrews, Chicago, 21 January 1899, HHBP, Reel 2. Although Bennett clearly understood *Romance of the Cliff* to be a story "without foundation in facts," he nonetheless included it in his own guidebooks. Bennett to F. A. Messerschmidt, Naperville, IL, 25 December 1904, HHBP, Reel 4. Even before boosters in the Dells pursued tourism development, white residents told stories about Black Hawk's capture there. H. H. Bennett's father, George, wrote to his family in Vermont that during a pleasant boat excursion up the river, "we saw where Black Hawk the Indian warrior hid himself when he was pursued by the soldiers and he was taken but a few miles from here." George Bennett to family, 26 July 1857, Box 1, Folder 1, HHBP. And the budding State Historical Society of Wisconsin very early described "Black Hawk's Cave [as the place where] Black Hawk once secreted himself to avoid pursuers." "Dells of the Wisconsin: Black Hawk's Cave," *Wisconsin Historical Collections* 5 (1867): 298–99.

52. "Dells of the Wisconsin," *Wisconsin Mirror,* 25 June 1875.

53. Travel account by Jas. Ross, published in *Madison Journal* and reprinted in the *Wisconsin Mirror*, 23 August 1875.

54. Fanny Kennish Earl, "The Dells of the Wisconsin," *Midland Monthly*, August 1895, 99–105, quote on page 103.

55. "A Farewell to the Dells, by Elizabeth B. Beebe of Chicago," unidentified newspaper, no date, circa 1900. From clipping scrapbook of newspaper articles from HHBP, Box 92.

56. Gidley, *Edward S. Curtis and the North American Indian, Incorporated*, 75. Although no evidence exists that Bennett ever met Curtis, he was certainly well aware of the famous photographer and his "North American Indian" project. Kilbourn's most widely read newspaper, the *Mirror-Gazette*, covered Curtis's American Indian photography, noting "each year cuts down their number and soon these old fellows who know of the days before the coming of the white man will be no more, writes E. S. Curtis." *Mirror-Gazette*, 26 July 1906.

57. Harold Fulton Thompson "Fact vs. Tradition," *Milwaukee Free Press*, undated, ca. 1904, clipping from Reel 7, HHBP.

CHAPTER 5. PHOTOGRAPHIC PRACTICES AS PROFIT-DRIVEN EXCHANGES

1. William H. Metcalf, a wealthy Milwaukee businessman, became close friends with Bennett, loaning him funds to construct a new photographic studio in 1875, then writing off the loan in 1881. For a detailed discussion of Curtis's skills in raising money, most notably from the powerful banker and magnate J. P. Morgan, see Gidley, *Edward S. Curtis and the North American Indian, Incorporated*, 109–33.

2. When D. A. Kennedy, Bennett's most important canvasser, asked him to photograph the Sioux in South Dakota as a way to enhance sales, Bennett responded: "With regard to getting out a set of views of the Sioux and other points you mention, I cannot get away from here long enough this spring or summer to make the negatives and cannot trust that kind of work to any one else." Bennett to Kennedy, 27 April 1891, Box 4, HHBP.

3. H. H. Bennett to Will Holly, Los Angeles, 14 March 1903; Bennett to E. E. White, Milwaukee, 10 September 1904; both from Reel 4, HHBP.

4. Holman, "Photography as Social and Economic Exchange," 96.

5. Sandweiss, "'Momentoes of the Race,'" 207–73, quote on page 270.

6. Trachtenberg, *Reading American Photographs*, 29.

7. Unlike James C. Faris, who considers that payment and giving approval for having their "picture taken" "is surely not the issue" in Native American photography, the evidence from this research shows such negotiation to be highly relevant. Faris, *Navajo and Photography*, 34. As Mick Gidley points out, Native Americans who provided information to anthropologists and posed for photographers often received payment. Gidley, *Edward S. Curtis and the North American Indian, Incorporated*, 92. Also dissenting from Faris, Ira Jacknis notes that "permission and compensation were certainly real issues in the past, but historical records in photographic archives are often silent on these points." Fortunately, in the Ho-Chunk case, a rich historical record exists that allows us to investigate this important issue. Jacknis, "Photography of Native Americans," 6.

8. Cashbook, 1870–1875, entry for 16 May 1873, Box 35, Folder 5 HHBP.

9. Cashbook, 1876–1879, entry for 14 May 1878, Box 35, Folder 6; Cashbook 1880–1884, entries for 8 May 1880, 10 May 1880, 18 August 1880, 17 May 1881, Box 35, Folder 7, HHBP.

10. Ibid.

11. Susette LaMere, interview with the author, 12 July 2005, Tomah, WI; Chloris Lowe, interview with the author, 8 May 2006, Mauston, WI.

12. Indian Account Book, 19 June 1903, 1 February 1904, 10 March 1904, 26 August 1904, 29 September 1904, 7 October 1904, Box 33, Folder 1; Cashbooks, 2 January 1904, 2 June 1904, 18 July 1904, Box 36, Folder 6; Bennett to R. S. Bunn, Chicago, 24 June 1904, Reel 4, HHBP.

13. H. H. Bennett to Orville J. Greene, 7 September 1903, Reel 4, HHBP. Rick Hill reaches the same conclusion when viewing a remarkably similar photograph of Bone Necklace, a Dakota man. Hill, "High-Speed Film," 115.

14. H. H. Bennett to [Frank] Taylor, 3 February 1883, Box 3, Folder 4, HHBP.

15. H. H. Bennett to Mathew Mason, 7 February 1883, Box 3, Folder 5, HHBP.

16. H. H. Bennett, "Wanderings among the Wonders and Beauties of Western Scenery," 1883, Box 25, Folder 18, HHBP. Native resistance to photography was not limited to Bennett, and one wonders how many similar, but unrecorded, encounters took place. One year after Bennett's 1873 confrontation at the Ho-Chunk camp, William Henry Jackson received a similar reception among a group of Uncompahgre Utes who refused to give him permission to photograph their village. Writing about the encounter a half century later, Jackson notes that a group of four men was "detailed to get in my way. As I attempted to focus, one of them would snatch the cloth from my head; or toss a blanket over the camera; or kick one of the supporting legs." Jackson, *Time Exposure: The Autobiography of William Henry Jackson* (Albuquerque: University of New Mexico Press, 1986 [1940]), 227.

17. Tagg, *Burden of Representation*. Both De La Ronde, "Personal Narrative" (362) and Merrell, "Pioneer Life in Wisconsin" (393) independently describe Yellow Thunder's capture in 1840, his forced transportation "by ball and chain" across the Mississippi River, and eventual escape back to Wisconsin.

18. Theresa Harlan, "A Curator's Perspective: Native Photographers Creating a Visual Native American History," *Exposure* 29, no. 1 (1993): 12–22, quote on page 14.

19. H. H. Bennett to Gimbel Brothers department store, Indian Bead Work Department, Milwaukee, 29 April 1903, Reel 4, HHBP.

20. H. H. Bennett to R. N. Bunn, Chicago, 13 April 1905, Reel 5, HHBP.

21. "Nothing in the Mammoth Cave of Kentucky is more strikingly beautiful than some of the dimly lighted chambers and royal archways with their floors of liquid crystal, in this Cave of the Dark Waters, or as the Indians called it, "Place of the Nah-huh-nah." Donan, *Dells of the Wisconsin*, 23.

22. H. H. Bennett, *The Wisconsin Dells* (Milwaukee: Evening Wisconsin Press, 1900), Box 26, Folder 7; H. H. Bennett, *Wanderings by a Wanderer* (n.d. [1890]), Box 26, Folder 1, HHBP; and Copyrights granted to H. H. Bennett, HHBP, Box 15, Folder 6.

23. Yi-Fu Tuan, "Realism and Fantasy in Art, History, and Geography," *Annals of the Association of American Geographers* 80, no. 3 (1990): 435–46, quote on 443. Two important studies on the politics of "playing Indian" are Shari M. Huhndorf, *Going Native: Indians in the American Cultural Imagination* (Ithaca, NY: Cornell University Press, 2001); and Philip J. Deloria, *Playing Indian* (New Haven, CT: Yale University Press, 1998).

24. Mason, "Native in the Frame," 4.

CHAPTER 6. THE CHANGING POLITICAL ECONOMY OF INDIAN PHOTOGRAPHY AND ART

1. H. H. Bennett to Charles Zimmerman, St. Paul, 13 May 1904, Reel 4, HHBP.

2. H. H. Bennett to John Bennett, Altadena, CA, 14 July 1903; Bennett to Ed Bennett, Santa Fe, NM, 12 April 1903, Reel 4, HHBP.

3. Cashbooks, Box 35, HHBP.

4. H. H. Bennett to W. E. Holly, Los Angeles, 26 March 1906, Reel 5, HHBP. For a thorough discussion of these changes more generally, see Hales, "American Views," 205–57. For two complementary accounts of the changes in capitalist production at this time, and their attendant cultural repercussions, see David Harvey, *The Condition of Postmodernity* (Oxford, UK: Basil Blackwell, 1989); and Trachtenberg, *Incorporation of America*.

5. Cashbooks, Box 35; Eva M. Bennett to Charley and Ella Bennett, 5 August 1902, Reel 3, HHBP.

6. The concept of capitalism as a form of dynamic economic change that can never be stationary, as a process that simultaneous destroys old patterns and creates new ones, is derived from Joseph A. Schumpeter.

In *Capitalism, Socialism, and Democracy* (New York: Harper, 1975 [1942]), 82–85, Schumpeter called this process "creative destruction" and deemed it "the essential fact about capitalism."

7. H. H. Bennett to W. E. Holly, Los Angeles, 26 March 1906, Reel 5, HHBP.

8. Mick Gidley has documented the important point that such practices were hardly unique, but characteristic of professional photographers at this time. Edward S. Curtis, Adam Clark Vroman, and Roland Reed, among others, decorated their studios with Indian artifacts. Gidley, *Edward S. Curtis and the North American Indian, Incorporated,* 81, 297.

9. These items are thoroughly described in dozens of letters, including ones from H. H. Bennett to Ely Moore, North Conway, NH, 28 July 1903; D. H. Richardson, Belvidere, IL, 30 July 1905; J. D. Allan, Mandan, ND, 6 August 1905; Phoebe S. Acheson, Washington, PA, 10 September 1906; and Leo Blake, Grand Rapids, MI, 3 January 1907, Reels 4, 5, and 6, HHBP.

10. H. H. Bennett to John Bennett, Altadena, CA, 14 July 1903, Reel 4, HHBP.

11. H. H. Bennett to Tanner Basket Co., New York, 17 June 1900, Reel 2; Bennett to Ely Moore, North Conway, NH, 27 June 1903, 4 September 1903; Bennett to Will Holly, Los Angeles, 14 March 1903; Bennett to Ed Bennett, Santa Fe, NM, 4 February 1903, 20 April 1903, Reel 4, HHBP.

12. H. H. Bennett to Hyde Exploring Expedition Company, New York, 17 September 1903; Bennett to J. S. Candelario, Santa Fe, NM, 12 March 1904; Bennett to H. C. Youtz, Cerrillos, NM, 8 May 1903; Bennett to Orville J. Greene, Indian Day School, Manderson, SD, 26 May 1903; Bennett to J. D. Allan, Mandan, ND, 8 August 1902; Bennett to Harriet Arengie, Indian Agent, Greenwood, ND, 16 December 1902; Bennett to George Moe, Flagstaff, AZ, 7 June 1906; Bennett to Ashley Bennett, Hot Springs, MT, 7 September 1903, Reels 3 and 4, HHBP.

13. H. H. Bennett to Leo Blake, Grand Rapids, MI, 3 January 1907, Reel 6, HHBP.

14. T. J. Jackson Lears, *No Place of Grace: Antimodernism and the Transformation of American Culture, 1880–1920* (New York: Pantheon, 1981), 60–91. See also Robert W. Rydell, *All the World's a Fair: Visions of Empire at America's International Expositions, 1876–1916* (Chicago: University of Chicago Press, 1984); Curtis Hinsley, "The World as Marketplace: Commodification of the Exotic at the World's Columbian Exposition, Chicago, 1893," in *Exhibiting Culture: The Poetics and Politics of Museum Display,* ed. Ivan Karp and Stephen Levine (Washington, DC: Smithsonian Institution Press, 1991), 344–65.

15. Dilworth, *Imagining Indians in the Southwest,* 125–72, quote on pages 144–45. See also Sherry L. Smith, *Reimagining Indians: Native Americans through Anglo Eyes, 1880–1940* (New York: Oxford University Press, 2000); and Bsumek, *Indian-Made.*

16. H. H. Bennett to Ed Bennett, Santa Fe, NM, 20 April 1903, emphasis in original; H. H. Bennett to Orville J. Greene, Indian Day School, Manderson, SD, 26 May 1903, Reel 4, HHBP.

17. H. H. Bennett to Messrs Pell and Sons, 5 March 1904, Eureka Springs, AR, Reel 4, HHBP.

18. H. H. Bennett to Allen, 1 July 1905 and 29 July 1905, Reel 5, HHBP; Bennett to E. R. Walsh, 28 February 1904, Reel 4, HHBP; and Bennett to Orville J. Greene, 7 September 1903, Indian Day School, Manderson, SD, Reel 4, HHBP.

19. George Wharton James, *What the White Race May Learn from the Indian* (Philadelphia: Running Press, 1973 [1908]), 11.

20. Dilworth, *Imagining Indians in the Southwest,* 133–41; Bsumek, *Indian-Made,* 192–93.

21. On the "Indian hobbyists" and collector-connoisseurs of this time, see Sherry L. Smith, *Reimagining Indians;* Dilworth, *Imagining Indians in the Southwest;* and Bsumek, *Indian-Made.*

22. Cashbook, 1880–1884, Box 35, Folder 7, HHBP. It is possible that an earlier such transaction took place, but since Bennett's copious financial records do not reveal such an exchange, I find it unlikely.

23. H. H. Bennett to Ed Bennett, Santa Fe, NM, 4 February 1903; Bennett to Ed Bennett, 12 April 1903, Reel 4, HHBP.

24. Cashbook, 1902–1903, Box 36, Folder 5; Indian Account Book, Box 33, Folder 1, HHBP.

25. H. H. Bennett to E. Moore, New York, 29 April 1907, Reel 6, HHBP. This, apparently, was a common complaint for Bennett. His letter to Moore of New York repeats, nearly word for word, what he wrote to J. E. McCourt, of Ludington, MI, namely that, despite his best efforts, he could not "seem to learn them white man's methods in business." 31 May 1903, Reel 4, HHBP.

26. Bsumek, *Indian-Made.*

27. Sallie Wagner, *Wide Ruins: Memories from a Navajo Trading Post* (Albuquerque: University of New Mexico Press, 1997), 50.

28. Bsumek, *Indian-Made.*

29. H. H. Bennett to Mr. Choo-nah-hoo-kah (James Standing Water), 21 March 1905, emphasis in original; Bennett to Ed Bennett, Santa Fe, NM, 18 February 1903, Reel 4, HHBP.

30. H. H. Bennett to Orville J. Green, Indian Day School, Manderson, SD, 31 May 1903, Reel 4, HHBP.

31. Bsumek, *Indian-Made.*

32. H. H. Bennett to Brancel and Henry Co., Milwaukee, 22 July 1903, Reel 4, HHBP.

33. H. H. Bennett to Susie Redhorn, New Lisbon, WI, 19 March 1905. Susette LaMere, interview with the author, Tomah, WI, 12 July 2005.

34. H. H. Bennett to Ed Bennett, Santa Fe, NM, 12 April 1903; Bennett to Orville J. Green, Indian Day School, Manderson, SD, 7 September 1903; Bennett to J. E. McCourt, Ludington, MI, 31 May 1903, Reel 4, HHBP. Of course, when economists of the time did include discussions of Native Americans, the commentary was less than favorable. The Wisconsin economist Richard T. Ely reflects on the allegedly irrational character of Indigenous economic behavior when he wrote that "Savages/barbarians do not engage in commerce, they do not command a concept of private property, they do not have a cash economy, and they do not exhibit the typical features of nineteenth century capitalism." Richard T. Ely, *An Introduction to Political Economy,* quoted in Bsumek, *Indian-Made,* 20.

35. H. H. Bennett to Edmund Andrews, Chicago, 1 March 1899, Reel 2, HHBP. Ever the meticulous record-keeper, Bennett produced several handwritten notebooks documenting his language acquisition efforts. The result is a fascinating window into a dynamic and ever-changing set of social and economic relationships. Box 8, Folder 9, HHBP. Some notebooks are titled (such as "Exercises in Ho-Chunk-ah-rah Wong-chig-ah-rah"), while others bear no title and are simply collected as loose sheets of paper or written on stationery. The paragraphs that follow are based on these notebooks.

36. H. H. Bennett to Julia Lapham, Milwaukee, 10 March 1906, Reel 5, HHBP.

37. Radin, *Winnebago Tribe,* 145–47.

38. Preston Thompson, interview with the author, 11 January 2002, Wisconsin Dells; and Corina Lonetree, interview with the author, 11 January 2002, Wisconsin Dells.

39. I thank Janice Rice for bringing this important point to my attention. Rice, interview with the author, 9 January 2002, Madison.

40. Preston Thompson and Tom Hopinkah, 11 January 2002, interview with the author, Wisconsin Dells. H. H. Bennett described his frustrations with learning to speak Ho-Chunk this way: "I have not made the progress in learning to talk with them that I could wish. You see, about the time I get it fixed in my mind that Wah-nag-ink Soc-sic-x-rah, Mar-shunk-keen means 'bead belt very good' something comes up in my work about the studio that diverts my thoughts from such an interesting subject and in few minutes I have forgotten and would be as likely to say something like 'Winnebago Indian a rascal' or 'Squaw [sic] big fraud.' This of course would not be either polite or political in the presence of these people." Bennett to Will E. Holly, Los Angeles, 14 March 1903, Reel 4, HHBP.

41. Ruth Underhill, *The Navajos* (Norman: Oklahoma University Press, 1956), 180.

42. H. H. Bennett to Gimbel Brothers Department Store, Indian Bead Work Department, Milwaukee, 29 April 1903, Reel 4, HHBP.

43. H. H. Bennett to Ashley Bennett, Minneapolis, 21 April 1905; and Hot Springs, MT, 2 December 1903, Reels 5 and 4, HHBP. For one of the many instances in which Bennett describes his Ho-Chunk

"friends," see his 2 May 1905 letter to Augusta M. Witmore of Chicago (Reel 5, HHBP). In response to a query about his relationship with Indians, Bennett wrote that "I have known these people (Winnebagos) since my boyhood, talk their language a little, and they call me their friend."

44. Diary entry, 3 June 1907. See also entries on 13 January 1904, 26 May 1907, and 4 August 1907, Box 8, Folder 9. In a 2 May 1905 letter to Augusta M. Witmore, Chicago, H. H. Bennett wrote, "I have no book of the Indian legends of this region, but hope sometime to publish what I have got of their stories about the Dells and surrounding country." Reel 5, HHBP.

45. H. H. Bennett to E. E. White, Milwaukee, 10 September 1904, Reel 5, HHBP.

46. Paul Radin, *Crashing Thunder: The Autobiography of an American Indian* (Lincoln: University of Nebraska Press, 1983 [1920]), xxii, xxvi, 135. A useful reading of this classic text may be found in Michelle Burnham, "'I Lied All the Time': Trickster Discourse and Ethnographic Authority in *Crashing Thunder*," *American Indian Quarterly* 22, no. 4 (1998): 469–84.

47. H. H. Bennett to Dr. Edmund Andrews, Chicago, 21 January 1899, Reel 2; Diary entry, 13 January 1904, in "Exercises in Ho-Chung-ah-rah Wong-chig-ah-rah," Box 9, Folder 9, HHBP.

48. Vizenor, *Fugitive Poses*, 15, 156. See also Vizenor, *Manifest Manners*, 1–44.

49. "Big Bear Was a Warwick," *Baraboo Republic*, 4 April 1905; from Reel 7 HHBP.

50. Philip J. Deloria, *Indians in Unexpected Places*, 138.

51. Harold Fulton Thompson, "Fact vs. Tradition," Reel 7, HHBP.

52. "The Passing of the 'Noble Red Man.'" *Kilbourn Weekly Illustrated Events*, 2 December 1905.

53. H. H. Bennett to E. Moore, New York, 29 April 1907, Reel 6, HHBP.

54. H. H. Bennett to Sen. Robert M. LaFollette, Washington, DC, 20 January 1906; Bennett to Hon. H. C. Adams, Washington, DC, 2 February 1906; Bennett to Hon. J. H. Davidson, Washington, DC, 12 February 1906; Bennett to Charles A. Brown, Milwaukee, 21 May 1906; Bennett to E. M. Griffith, Madison, WI, 27 January 1906; F. A. Hutchins, Madison, 17 March 1906; Hon. J. A. Henry, Madison, 1 May 1905; Bennett to Capt. W. V. Judson, Washington, DC, 24 January 1906; Bennett to Julia A. Lapham, Milwaukee, 10 January 1906, 16 January 1906, 26 January 1906, 21 March 1906, 8 April 1906; and Evaline Bennett to H. H. Bennett, 5 March 1906, all from Reel 6, HHBP. The fascinating story of the Wisconsin Dells dam, and Bennett's lonely opposition to it, remains to be written. It should be observed that by promoting nature preservation in lieu of Native rights, Bennett was part of a much larger movement. In fact, as Mark David Spence has documented, it was often the case that Native Americans were *removed* from park areas to make them more "natural." Spence, *Dispossessing the Wilderness: Indian Removal and the Making of the National Parks* (New York: Oxford University Press, 2000).

55. Lurie, "Winnebago," 704; Lurie, "Winnebago Indians," 260.

EPILOGUE

1. Lucy R. Lippard, introduction to *Partial Recall*, 19, emphasis in original.

2. Powers, "Images across Boundaries," 135.

3. Rainbow Big Blackhawk, interview with the author, 11 January 2002, Wisconsin Dells. Such reactions are similar to those received by Monty Roessel when he asked Navajo to look at historic Navajo photographs. Roessel, "Navajo Photography," *American Indian Culture and Research Journal* 20 (1996): 83–91. The different readings of these views by Bennett's white audiences are thoroughly documented in the Kilbourn City newspapers, which often reprinted travel accounts.

4. Loew, *Indian Nations of Wisconsin*, 53. Montgomery Green Sr., interview with the author, 11 January 2002, Wisconsin Dells.

5. Chloris Lowe, telephone interviews with the author, 3 May 2006 and 8 May 2006; and personal interview, 7 August 2006, Mauston, WI.

6. Ibid. Vizenor, *Fugitive Poses*, 158.

7. Ibid. Paul Chaat Smith, "Every Picture Tells a Story," 97.

8. On the camera as a "technology of memory," see Marita Sturken, *Tangled Memories: The Vietnam War, the AIDS Epidemic, and the Politics of Remembering* (Berkeley: University of California Press, 1997), 19–45. The importance of photography to family history is provocatively explored in Marianne Hirsch, *Family Frames*.

9. This paragraph, and the ones that follow, are based on correspondence and a daylong interview with Tom Jones in Madison, 14 July 2005. For further background on Jones and his art, see Melanie Herzog, "Dancing in Two Worlds," *Wisconsin People and Ideas* (Spring 2006): 33–42; and Susan Applegate Krouse, "A Warrior Celebration: The Photographs of Tom Jones," *Visual Anthropology* 19, no. 3–4 (May–September 2006): 295–314.

10. Tom Jones, artist's statement for the photographic series "The Ho Chunk People."

11. Fleming and Luskey, *North American Indians in Early Photographs*, 47, 58.

12. The photographs of Jennie Ross Cobb, Richard Throssel, Horace Poolaw, and Lee Marmon are part of the collection titled *Native Nations: Journeys in American Photography*, edited by Jane Alison, 246–67. For Jean Fredericks, see Bush and Mitchell, *Photograph and the American Indian*, xxv. Of these Native photographers, only Richard Throssel has been described in detail. See Peggy Albright, *Crow Indian Photographer: The Work of Richard Throssel* (Albuquerque: University of New Mexico Press, 1997).

13. Tom Jones, e-mail to the author, 24 September 2005.

14. Hulleah J. Tsinhnahjinnie, quoted in Theresa Harlan, "Indigenous Photographies: A Space for Indigenous Realities," in Alison, *Native Nations*, 233–45, quote on page 234. The term "photographic sovereignty" comes from Tsinhnahjinnie's essay in *Native Nations*: "When Is a Photograph Worth a Thousand Words?" 41–55, quote on page 42.

15. Herzog, "Dancing in Two Worlds," 38.

16. Susette LaMere interview with the author, 12 July 2005, Tomah, WI. Philip J. Deloria, *Indians in Unexpected Places*, 134–82.

17. Tom Jones artist's statement for the digital series "Dear America." Set to a popular melody that has since become the tune for the British national anthem, the words to "America" ("My Country 'Tis of Thee") were written in 1831 by the Rev. Samuel Francis Smith; throughout most of the nineteenth century, the patriotic song served as the de facto U.S. national anthem. James Branham and Stephen J. Hartnett, *Sweet Freedom's Song: "My Country 'Tis of Thee" and Democracy in America* (New York: Oxford University Press, 2002).

18. Barthes, *Camera Lucida*, 26–27.

Selected Bibliography

Albers, Patricia C., and William James. "Tourism and the Changing Photographic Image of Great Lakes Indians." *Annals of Tourism Research* 10 (1983): 123–48.

Albright, Peggy. *Crow Indian Photographer: The Work of Richard Throssel.* Albuquerque: University of New Mexico Press, 1997.

Alison, Jane, ed. *Native Nations: Journeys in American Photography.* London: Barbican Art Gallery, 1998.

Arndt, Grant. "Ho-Chunk 'Indian Powwows' of the Early Twentieth Century." In *Powwow,* ed. Clyde Ellis, Luke Eric Lassiter, and Gary H. Dunham, 46–67. Lincoln: University of Nebraska Press, 2005.

Atalay, Sonya. "No Sense of Struggle: Creating a Context for Survivance at the NMAI." *American Indian Quarterly* 30, no. 3/4 (Summer and Fall 2006): 597–618.

Bamberger, Tom, and Terrance L. Marvel, eds. *H. H. Bennett: A Sense of Place.* Milwaukee: Milwaukee Art Museum, 1992.

Barthes, Roland. *Camera Lucida: Reflections on Photography.* Trans. Richard Howard. New York: Hill and Wang, 1981.

Benjamin, Walter. "The Work of Art in the Age of Mechanical Reproduction." In *Illuminations,* ed. Hannah Arendt. Trans. Harry Zohn. New York: Harcourt Brace Jovanovich, 1968 [1936].

Bennett, A. C. "A Wisconsin Pioneer in Photography." *Wisconsin Magazine of History* 22 (March 1939): 268–79.

Berkhofer, Robert F., Jr. *The White Man's Indian: Images of the American Indian from Columbus to the Present.* New York: Vintage Books, 1978.

Bieder, Robert E. *Native American Communities in Wisconsin, 1600–1960: A Study of Tradition and Change.* Madison: University of Wisconsin Press, 1995.

Bsumek, Erika M. *Indian-Made: The Production and Consumption of the Navajo, 1880–1940.* Lawrence: University Press of Kansas, forthcoming.

Bush, Alfred L., and Lee Clark Mitchell. *The Photograph and the American Indian.* Princeton, NJ: Princeton University Press, 1994.

Cresswell, Tim. *On the Move: Mobility in the Modern Western World.* New York: Routledge, 2006.

Deloria, Philip J. *Indians in Unexpected Places.* Lawrence: University Press of Kansas, 2004.

———. *Playing Indian.* New Haven, CT: Yale University Press, 1998.

Dilworth, Leah. *Imagining Indians in the Southwest: Persistent Visions of a Primitive Past.* Washington, DC: Smithsonian Institution Press, 1996.

Dippie, Brian W. "Photographic Allegories and Indian Destiny." In *Images of the Indian: Portrayals of Native Peoples*, ed. Joe Sawchuk, 49–81. Brandon, MB, Canada: Bearpaw, 1999.

———. *The Vanishing American: White Attitudes and U.S. Indian Policy*. Middletown, CT: Wesleyan University Press, 1982.

Earle, Edward W. "The Stereograph in America: Pictorial Antecedents and Cultural Perspectives." In *Points of View: The Stereograph in America—a Cultural History*, ed. Edward W. Earle, 9–23. Rochester, NY: Visual Studies Workshop Press, 1979.

Faris, James C. *Navajo and Photography: A Critical History of the Representation of an American People*. Albuquerque: University of New Mexico Press, 1996.

Fleming, Paula Richardson, and Judith Luskey. *The North American Indians in Early Photographs*. New York: Barnes and Noble Books, 1992 [1986].

Gidley, Mick. *Edward S. Curtis and the North American Indian, Incorporated*. Cambridge: Cambridge University Press, 1998.

———, ed. *Edward S. Curtis and the North American Project in the Field*. Lincoln: University of Nebraska Press, 2003.

Goetzmann, William H. *The First Americans: Photographs from the Library of Congress*. Washington, DC: Starwood, 1991.

Goldberg, Vicki. *The Power of Photography: How Photographs Changed Our Lives*. New York: Abbeville, 1993.

Goodyear, Frank H. "Directing the City to the Country: Henry H. Bennett in the Wisconsin Dells." *History of Photography* 24, no. 2 (2000): 163–68.

———. *Red Cloud: Photographs of a Lakota Chief*. Lincoln: University of Nebraska Press, 2003.

Green-Lewis, Jennifer. *Framing the Victorians: Photography and the Culture of Realism*. Ithaca, NY: Cornell University Press, 1996.

Grossman, Zoltan. "The Ho-Chunk and Dakota Nations." In *Wisconsin's Past and Present: A Historical Atlas*, ed. Wisconsin Cartographers Guild, 8–9. Madison: University of Wisconsin Press, 1998.

Hales, Peter Bacon. "American Views and the Romance of Modernization." In *Photography in Nineteenth-Century America*, ed. Martha A. Sandweiss, 205–57. Fort Worth, TX: Amon Carter Museum, 1991.

Harlan, Theresa. "A Curator's Perspective: Native Photographers Creating a Visual Native American History." *Exposure* 29, no. 1 (1993): 12–22.

Herzog, Melanie. "Dancing in Two Worlds." *Wisconsin People and Ideas* (Spring 2006): 33–42.

Hill, Rick. "High-Speed Film Captures the Vanishing American, in Living Color." *American Indian Culture and Research Journal* 20, no. 3 (1996): 111–28.

Hirsch, Marianne. *Family Frames: Photography, Narrative, and Postmemory*. Cambridge, MA: Harvard University Press, 1997.

Hoelscher, Steven. "The Photographic Construction of Tourist Space in Victorian America." *Geographical Review* 88, no. 4 (1998): 548–70.

———. "'A Pretty Strange Place': Nineteenth-Century Scenic Tourism in the Dells." In *Wisconsin Land and Life*, ed. Robert C. Ostergren and Thomas R. Vale, 424–49. Madison: University of Wisconsin Press, 1997.

Holman, Nigel. "Photography as Social and Economic Exchange: Understanding the Challenges Posed by Photography of Zuni Religious Ceremonies." *American Indian Culture and Research Journal* 20, no. 3 (1996): 93–110.

Hoxie, Frederick E. *A Final Promise: The Campaign to Assimilate the Indians, 1880–1920*. New York: Cambridge University Press, 1989.

Huhndorf, Shari M. *Going Native: Indians in the American Cultural Imagination*. Ithaca, NY: Cornell University Press, 2001.

Jacknis, Ira. "Preface to Special Issue on the Photography of Native Americans." *American Indian Culture and Research Journal* 20, no. 3 (1996): 1–14.

Johnson, Tim, ed. *Spirit Capture: Photographs from the National Museum of the American Indian.* Washington, DC: Smithsonian Institution Press, 1998.

Kasson, Joy S. *Buffalo Bill's Wild West: Celebrity, Memory, and Popular History.* New York: Hill and Wang, 2000.

Katakis, Michael, ed. *Excavating Voices: Listening to Photographs of Native Americans.* Philadelphia: University of Pennsylvania Museum, 1998.

Krauss, Rosalind. "Photography's Discursive Spaces: Landscape/View." *Art Journal* 42, no. 4 (Winter 1982): 311–19.

Krouse, Susan Applegate. "A Warrior Celebration: The Photographs of Tom Jones." *Visual Anthropology* 19, no. 3–4 (May–September 2006): 295–314.

Limerick, Patricia. *The Legacy of Conquest: The Unbroken Past of the American West.* New York: Norton, 1987.

Lippard, Lucy R., ed. *Partial Recall: Photographs of Native North Americans.* New York: New Press, 1992.

Loew, Patty. *Indian Nations of Wisconsin: Histories of Endurance and Renewal.* Madison: Wisconsin Historical Society Press, 2001.

Lonetree, Amy. "Missed Opportunities: Reflections on the NMAI." *American Indian Quarterly* 29, no. 3/4 (Summer/Fall 2005): 632–45.

Lurie, Nancy Oestreich. *Mountain Wolf Woman, Sister of Crashing Thunder: The Autobiography of a Winnebago Woman.* Ann Arbor: University of Michigan Press, 1961.

———. "Winnebago." In *Handbook of North American Indians,* ed. Bruce Trigger, 690–707. Washington, DC: Smithsonian Institution Press, 1978.

———. "The Winnebago Indians: A Study in Cultural Change." Unpublished Ph.D. diss., Northwestern University, 1952.

———. *Wisconsin Indians.* 2nd ed. Madison: Wisconsin Historical Society Press, 2002.

Lyman, Christopher M. *The Vanishing Race and Other Illusions: Photographs of Indians by Edward S. Curtis.* Washington, DC: Smithsonian Institution Press, 1982.

Masteller, Richard N. "Western Views in Eastern Parlors: The Contribution of the Stereograph Photographer to the Conquest of the West." *Prospects* 6 (1981): 55–71.

Meinig, D. W. *The Shaping of America: A Geographical Perspective on 500 Years of History.* Vol. 2, *Continental America, 1800–1867.* New Haven, CT: Yale University Press, 1993.

Mihesuah, Devon, ed. *Natives and Academics: Researching and Writing about American Indians.* Lincoln: University of Nebraska Press, 1998.

Mitchell, W. J. T. *Picture Theory: Essays on Verbal and Visual Representation.* Chicago: University of Chicago Press, 1994.

Moses, L. G. *Wild West Shows and the Images of American Indians, 1883–1933.* Albuquerque: University of New Mexico Press, 1996.

Naef, Weston J., and James N. Wood. *Era of Exploration: The Rise of Landscape Photography in the American West, 1860–1885.* Boston: New York Graphic Society, 1975.

Onsager, Lawrence. "The Removal of the Winnebago Indians from Wisconsin in 1873–74." Unpublished M.A. thesis, Loma Linda University, 1985.

Ortiz, Simon J. *Beyond the Reach of Time and Change.* Tucson: University of Arizona Press, 2004.

Orvell, Miles. *American Photography.* New York: Oxford University Press, 2003.

Powers, Willow Roberts. "Images across Boundaries: History, Use, and Ethics of Photographs of American Indians." *American Indian Culture and Research Journal* 20, no. 3 (1996): 129–36.

Pratt, Mary Louise. *Imperial Eyes: Travel Writing and Transculturation.* New York: Routledge, 1992.

Prucha, Francis Paul. *The Great Father: The United States Government and the American Indians.* Vol. 1. Lincoln: University of Nebraska Press, 1984.

Radin, Paul. *The Winnebago Tribe.* Thirty-Seventh Annual Report of the Bureau of American Ethnology to the Secretary of the Smithsonian Institution, 1915–1916. Lincoln: University of Nebraska Press, 1990 [1923].

Roessel, Monty. "Navajo Photography." *American Indian Culture and Research Journal* 20 (1996): 83–91.

Ryan, James R. *Picturing Empire: Photography and the Visualization of the British Empire*. Chicago: University of Chicago Press, 1997.

Sandweiss, Martha A., ed. *Photography in Nineteenth-Century America*. Fort Worth, TX: Amon Carter Museum, 1991.

———. *Print the Legend: Photography and the American West*. New Haven, CT: Yale University Press, 2002.

Satz, Ronald N. *American Indian Policy in the Jacksonian Era*. Lincoln: University of Nebraska Press, 1975.

Schwartz, Joan M., and James R. Ryan, eds. *Picturing Place: Photography and the Geographical Imagination*. London: I. B. Tauris, 2003.

Shortridge, James R. *Our Town on the Plains: J.J. Pennell's Photographs of Junction City, Kansas, 1893–1922*. Lawrence: University Press of Kansas, 2000.

Smith, Paul Chaat. "Every Picture Tells a Story." In *Partial Recall: Essays on Photographs of Native North Americans*, ed. Lucy R. Lippard, 94–99. New York: New Press, 1992.

Smith, Shawn Michelle. *Photography on the Color Line: W. E. B. Du Bois, Race, and Visual Culture*. Durham, NC: Duke University Press, 2004.

Smith, Sherry L. *Reimagining Indians: Native Americans through Anglo Eyes, 1880–1940*. New York: Oxford University Press, 2000.

Sollors, Werner. *Beyond Ethnicity: Consent and Descent in American Culture*. New York: Oxford University Press, 1986.

Solomon-Godeau, Abigail. *Photography at the Dock: Essays on Photographic History, Institutions, and Practices*. Minneapolis: University of Minnesota Press, 1991.

Sontag, Susan. *On Photography*. New York: Farrar, Straus and Giroux, 1977.

Sturken, Marita, and Lisa Cartwright. *Practices of Looking: An Introduction to Visual Culture*. Oxford: Oxford University Press, 2001.

Szarkowski, John. *Photography until Now*. New York: Museum of Modern Art, 1989.

Tagg, John. *The Burden of Representation: Essays on Photographies and Histories*. Minneapolis: University of Minnesota Press, 1993.

Taylor, John. *A Dream of England: Landscape, Photography, and the Tourist's Imagination*. Manchester, UK: Manchester University Press, 1994.

Trachtenberg, Alan. *The Incorporation of America: Culture and Society in the Gilded Age*. New York: Hill and Wang, 1982.

———. *Reading American Photographs: Images as History, Mathew Brady to Walker Evans*. New York: Hill and Wang, 1989.

———. *Shades of Hiawatha: Staging Indians, Making Americans, 1880–1930*. New York: Hill and Wang, 2004.

Tsinhnahjinnie, Hulleah J. "Compensating Imbalances." *Exposure* 29, no. 1 (1993): 29–30.

Vizenor, Gerald. *Fugitive Poses: Native American Scenes of Absence and Presence*. Lincoln: University of Nebraska Press, 1998.

———. *Manifest Manners: Postindian Warriors of Survivance*. Hanover, NH: Wesleyan University Press, 1994.

Wexler, Laura. *Tender Violence: Domestic Visions in an Age of U.S. Imperialism*. Chapel Hill: University of North Carolina Press, 2000.

White, Richard. *The Middle Ground: Indians, Empires, and Republics in the Great Lakes Region, 1650–1815*. Cambridge: Cambridge University Press, 1991.

Williams, Carol J. *Framing the West: Race, Gender, and the Photographic Frontier in the Pacific Northwest*. Oxford: Oxford University Press, 2003.

Wyatt, Victoria. "Interpreting the Balance of Power: A Case Study of Photographer and Subject in Images of Native Americans." *Exposure* 28, no. 3 (1992): 23–33.

Index

NOTE: *Italicized page numbers refer to illustrations. "Wisconsin Dells" refers to the town formerly known as Kilbourn City. "Dells of the Wisconsin River" refers to the specific area of scenic rock formations along the Wisconsin River.*